THE ART OF THE FILM

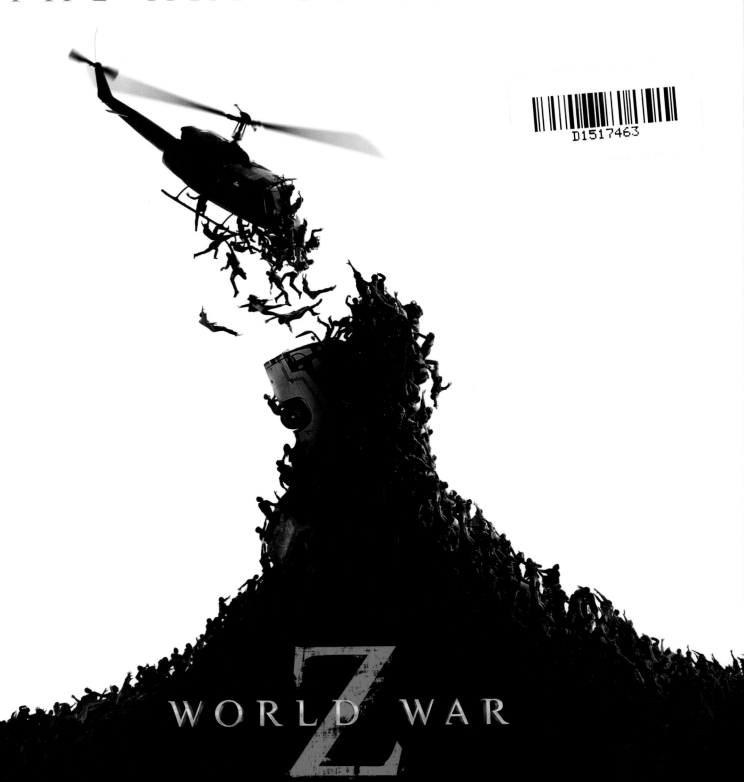

WORLD WAR Z

World War Z: The Art of the Film
standard ISBN 9781781168851

Published by
Titan Books
A division of Titan Publishing Group Ltd.
144 Southwark St
London
SE1 0UP

First edition: June 2013
10 9 8 7 6 5 4 3 2 1

Did you enjoy this book? We love to hear from our readers. Please e-mail us at: readerfeedback@ titanemail.com or write to Reader Feedback at the above address.

To receive advance information, news, competitions, and exclusive offers online, please sign up for the Titan newsletter on our website: www.titanbooks.com

A CIP catalogue record for this title is available from the British Library.

Printed and bound in the United States of America at Lake Book Manufacturing, Inc.

PUBLISHER'S NOTE: THE SCREENPLAY INCLUDED IN THIS BOOK IS THE CORRECT VERSION AS OF OUR PRESS DATE.

THE ART OF THE FILM

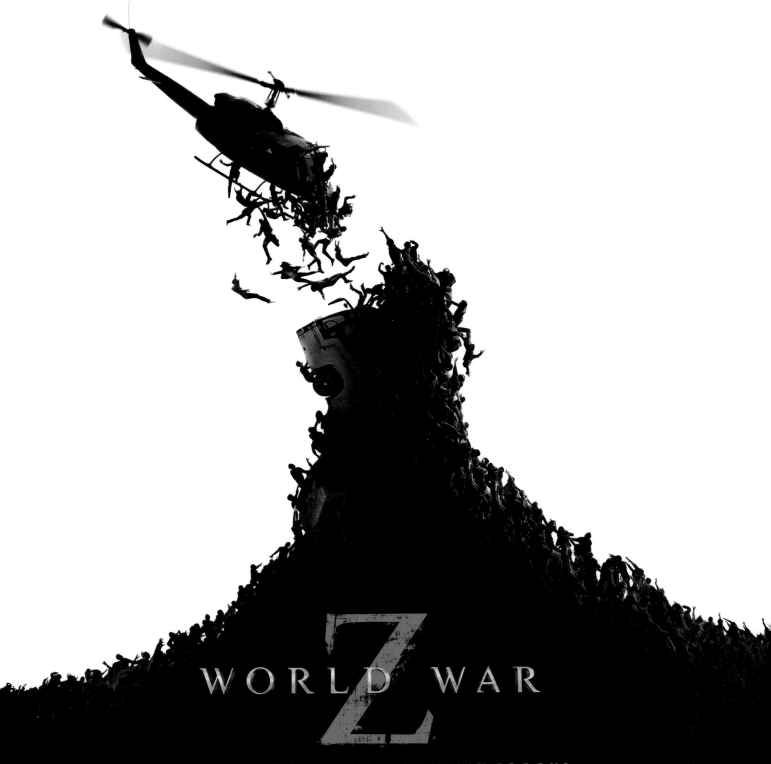

WORLD WAR Z

BASED ON THE NOVEL BY MAX BROOKS

SCREENPLAY BY

MATTHEW MICHAEL CARNAHAN AND DREW GODDARD & DAMON LINDELOF

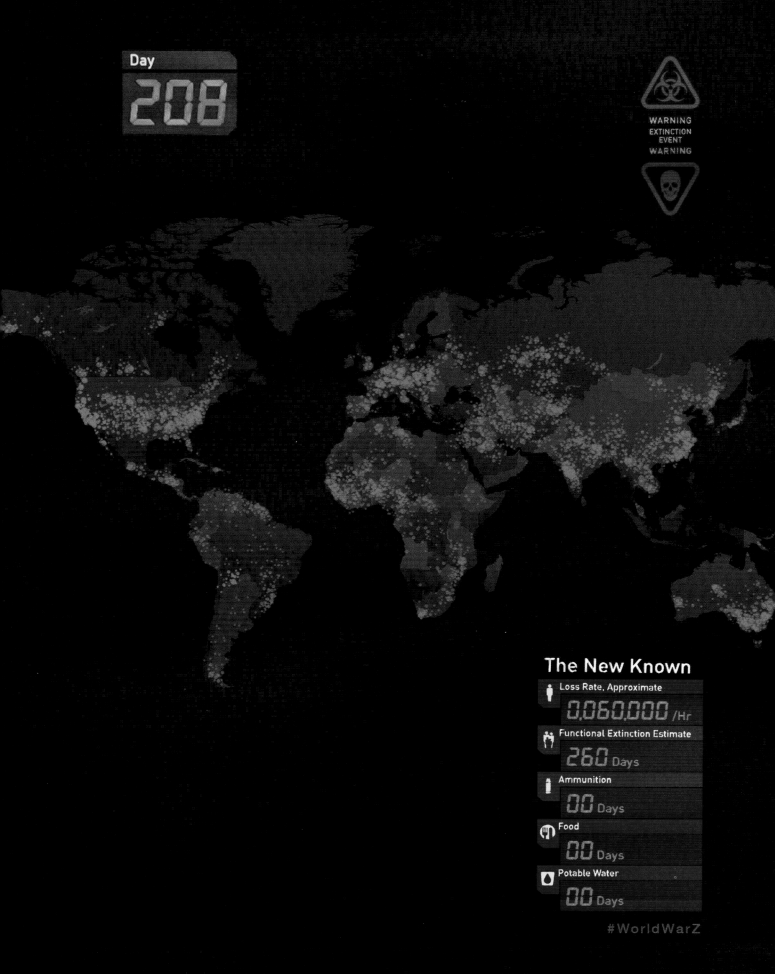

BLACK

And a pair of eyes fill the screen, snapping open-

INT. CONFERENCE ROOM/MAKESHIFT ER - DAY

-as if waking from a terrible dream, adjusting to the light. The eyes look around, stare up at the ceiling, slowly finding focus. PULL BACK TO REVEAL this man's unshaven face bruised and abrased, aged 43.

His name is GERRY LANE. He's been through hell.

He tries to lift one hand, then the other, realizing they are bound loosely to his sides, presumably for his own safety. His mid-torso is bandaged.

Sensing something, he turns his head to find A LEAN, INTENSE LOOKING MAN we'll call THE BRIT. He stands without a word and walks out of the room.

We hear him whispering to someone O.S. In another language (Italian).

Gerry looks around, sees he is in a repurposed conference room. Scavenged plywood covers the windows, letting in slashes of daylight.

The door opens as the Brit returns with A MAN WITH A THICK BEARD (JAVIER). The Brit sits across from Gerry in a metal chair. Javier lingers patiently by the door.

> **BRIT**
> (re: Gerry's wound)
> You're a tough bastard. And a lucky one.
> Who are you?

Gerry addresses Javier, ignoring the Brit.

> **GERRY**
> I was with a woman. Where is sh-

> **BRIT**
> Were you on that plane?

Still groggy, Gerry is taken back to that dark trauma.

> **BRIT (CONT'D)**
> Were you. On. The plane-

> **GERRY**
> I was

> **BRIT**
> How did it go down?

Gerry thinks about how to answer. Too long.

> **BRIT (CONT'D)**
> What caused that plane to go down-

> **GERRY**
> There was an outbreak. On approach.

Whatever outbreak means to them, it's pretty serious.

> **BRIT**
> Yet somehow you survived.

> **GERRY**
> I guess so.

The Brit leans in.

> **BRIT**
> (re: JAVIER)
> Why are you looking at him?

> **GERRY**
> Because he's in charge.

The Brit's look tells us Gerry is right. He sees Gerry's eyes are focused now, ready. Angry.

> **BRIT**
> You know what this place is.

> **GERRY**
> Of course I do. That's why I'm here.

> **BRIT**
> Then you understand how that must look to us.

Gerry addresses Javier in Italian.

> **GERRY**
> [My name is Gerry Lane. Former specialist with the U.N. They told me where to find you. I need to-]

Javier reaches into his coat pocket and produces A BLACK SATPHONE. Gerry freezes, suddenly tense.

> **JAVIER**
> This is important to you.

Javier powers it up. This seems to surprise Gerry. He leans forward ever so slightly. The display shows a string of numbers and one SINGLE WORD:

> **JAVIER (CONT'D)**
> Where exactly... is "Home?"

PUSH IN ON Gerry. Obviously a very emotional question for him. An answer he does not want to give them but clearly has to...

"ZOMBIES ARE AN INTERESTING METAPHOR... THE DARK SIDE OF OUR OWN HUMANITY."

MARC FORSTER, DIRECTOR

INT. LANE HOUSE - MORNING

Gerry wakes from a sound sleep in his bed. His face bears none of the wounds we saw in the previous scene. We're clearly in happier times. Dawn creeps through the windows. Gerry pulls his wife, KAREN, 38, closer to him.

INT. LANE HOUSE - CORRIDOR - CONTINUOUS

Low angle, moving slowly down the hall toward the bedroom door, partially open. We can see the bed, the sheets moving...

The door is pushed open by an unseen hand...

INT. LANE BOUSE - MORNING

Look straight down on the bed, on this moment; peaceful, serene, slowly intensifying. Then:

THUD. A small body lunges between them, shattering the moment. Another body quickly follows. Gerry and Karen's DAUGHTERS - RACHEL, 10, and CONNIE, 6 - burrow under the blankets between their parents.

Karen and Gerry share a smile over their children's heads. "So much for that." Gerry sighs.

> GERRY
> French toast?

The kids shout approval from under the blankets.

INT. KITCHEN - MORNING

Gerry sips coffee, watching the girls dig in to their stacks of French toast, each reading some sort of tween trash, ignoring Gerry.

His eyes shift to a small TV on the counter, the sound very low. BREAKING NEWS reports:

> REPORTER (ON SCREEN)
> ...of gunfire amidst the escalating troop movement remain unconfirmed as China appears to have instituted a media blackout and declared martial law...

CLOSE ON Gerry. Something in the way he watches the report. He shakes it off, looks back at his children, totally oblivious to him.

> GERRY
> Kids excited about the museum?
> (no answer)
> What are you reading?
> (no answer)
> More French toast?
> (no answer)
> I'm glad we had this little chat.

Karen enters in a robe, finds the kitchen counter devastated with the makings of breakfast. A complete disaster area. Gerry gestures to the mess.

> GERRY (CONT'D)
> Get that, would you dear?

She sighs, shakes her head, shuts off the TV as she approaches the table. Gerry holds up a cup of hot coffee for her as she sits.

> KAREN
> Kids all packed? Everything you need?

They nod, make affirmative noises.

> KAREN (CONT'D)
> Rachel, where's your inhaler?

Rachel looks up suddenly.

> KAREN (CONT'D)
> Bathroom sink. Go get it.

> RACHEL
> In a minute.

Karen stares. Rachel sighs, leaves the room. Karen looks at Connie, leans down, looks under the table.

> KAREN
> Connie, we're not wearing pajama pants to the museum.

> CONNIE
> Daddy, what's martial law?

Karen cocks her head at Gerry. He throws back a shrug: "What? I didn't do anything."

> GERRY
> It's like our house, but the rules apply to everybody.

Karen smiles, shakes her head, sips her coffee.

> CONNIE
> Were you ever in places like that? With your old job?

> GERRY
> Lots of times.

> CONNIE
> Did you like it?

> GERRY
> I didn't like my job so much... I just liked the way I did it.

> CONNIE
> Do you miss it?

Karen's smile fades as her eyes meet Gerry's. She waits for his answer. Gerry smiles.

> GERRY
> I have a more important job now.

> CONNIE
> All you do is make French toast, Dad.

Karen stifles a smile. Before Gerry can respond, a loud cackle O.S. turns all eyes to the doorway. Rachel enters carrying an annoying stuffed toy.

She holds up her other hand, showing Karen AN ASTHMA INHALER. "Found it." She sits, hands the loud toy to a happy Connie as it counts out loud.

> GERRY
> Oh. Good. You... found Subway Sam.

> RACHEL
> At least now we'll have some peace in the car.

Connie pulls a string in Sam's side. He cackles some more. Karen and Gerry share another look. Karen checks the clock stands.

> KAREN
> Okay, brush and flush. Dressed and ready in ten minutes.

As the kids get up, tossing their napkins on the table:

CONNIE
Do they have rides at the museum?

GERRY
Learning is the most important ride.

The girls shake their heads and groan as Karen ushers them out of the kitchen, looking back to add:

KAREN
Get that, would you dear?

She points to the mess on the counter. Gerry sighs, sips his coffee, pulls himself up - weary, blessed.

We linger at the breakfast table, FOCUSING ON:

Rachel's inhaler under her napkin - unnoticed. Forgotten.

CUT TO:

INT. VOLVO WAGON - MORNING

CHILDREN'S SONG (ON RADIO)
"Turn around-turn around-turn around Rover-turn around..."

In white font: Philadelphia

American gridlock with the Lane family in their car. Connie wears headphones, watches cartoons on a roof-mounted TV, half-dozen dolls on her lap. Rachel reads until she gets too nauseous - looks out the window until she feels better - then keeps reading. Gerry and Karen slack-jawed at the monotony.

KAREN
Why are we listening to this? Connie's wearing headphones.

CONNIE
(way too loudly)
WHAT'D I DO?

KAREN
TAKE YOUR HEADPHONES OFF, GIRL.

GERRY
How is it she still hears everything even with them on?

CONNIE
(headphones off)
What?

GERRY
Except her Dad of course.

Karen turns off the music. Relieved exhale. *Just as a bright red News Helicopter passes.* LOUD, LOW. Gerry and Karen watch it through the windshield - nothing better to look at. 5 seconds pass as the echoes of the Chopper fade.

KAREN
This is really brutal.

GERRY
Has to be an accident.

KAREN
Can we get off this road?

GERRY
(good natured)
You wanna take the wheel?

KAREN
I'm not attacking your manhood-

GERRY
-actually this is about how fast you drive anyway-

KAREN
-just your decision-making.

A 2nd Helicopter thumps past. This one official olive-drab. Gerry stares more intently at it. Connie, headphones back on:

CONNIE
I'M HUNGRY.

Rachel now tries to pull Connie's headphones off - annoyed with her little sister's yelling. Connie swats Rachel's hand without taking eyes off the cartoon. Karen hands Connie a packet of *Goldfish*. Again, Connie takes them without averting her gaze. Karen turns back as Gerry reaches for the Radio:

KAREN
I can't do NPR. Seriously. I'll nod off and you always give me grief for sleeping while you drive. At least put it on BBC-

GERRY
-you're not British anymore, Babe. I only ever hear the accent now after a few glasses of wine-

RACHEL (O.C.)
-am I British?

KAREN **GERRY**
Yes. No.

The sudden, abrasive, dial up Internet-like tones of *the EMERGENCY ALERT SYSTEM.* Gerry and Karen get quiet...

EAS (ON RADIO)
This is a test of the Emergency Alert System...

The sounds of more Helicopters we can't see now. Gerry and Karen share a look: *first hint of something amiss.* 3 seconds. The EAS tones squawk anew - and from nowhere a MOTORCYCLE COP rips into frame like a banshee, weaving through traffic the wrong way, passing us head-on, *shattering the Volvo's sideview mirror with his handle bar.* Gerry's whole family yelps. He blinks back the shock, leans out the window:

"WE CRASH OVER 40 DIFFERENT CARS."

SIMON CRANE, 2ND UNIT DIRECTOR

GERRY
YO!

RACHEL (O.C.)
He's just gonna keep going Daddy?

Gerry watches the Motorcycle get smaller. Samaritan motorists honk, point toward Gerry's station wagon: *look what you did!* But to no avail: Cop never looks back. Gerry's attention pulled right now: *3 more MOTORCYCLE COPS roar past on the right shoulder, heading the opposite direction.* Crosses Gerry's mind that maybe that first Cop was FLEEING. Karen wipes wet palms on jeans. Gerry puts it in park. Gets out.

EXT. GRIDLOCK - NEXT MOMENT

RACHEL
Daddy, careful in the road.

Picks up the broken sideview, dumps it in back. Eyes drawn to the near distance: what looks like a FIRE DRILL. *People pouring from an Office Building.* Squinting at this when a rhythmic series of LOUD, deep THUMPS come to life: like very large FIREWORKS detonating in rapid succession. Gerry's head on a swivel now, trying to spot from where this sound came.

KAREN (O.C.)
Gerry?

2 seconds. Then just above the building

tops, maybe 2 miles off, the brown-black tips of a line of large explosions...

INT. VOLVO WAGON - SAME MOMENT

Karen sees it too, eyes widening, alarm now:

KAREN
Get back in here!

EXT. VOLVO WAGON - NEXT MOMENT

Another Motorcycle Cop zips by on the shoulder, following the first 3. This COP though brakes hard, yells:

COP
GET BACK IN YOUR CAR RIGHT NOW!

INT. VOLVO WAGON - SAME MOMENT

Gerry does - just as a garbage truck moving 80 MPH on the same shoulder, so fast it's almost silent, barrels ahead HEEDLESS, the Cop directly in it's path. *We look away an instant before the inevitable collision - but we do hear it.*

Gerry stomps the gas before he even comprehends what he's doing, pulls right onto that same shoulder, FOLLOWING the insane Garbage Truck suddenly-

KAREN
OK-OK-WHAT ARE WE DOING?

GERRY
We're Moving-

-something unknown HITS the windshield with massive SPEED, SOUND. Shatters in its frame, immediately obscuring POV-

CONNIE (O.C.)
-I WANT MY BATHROBE!

Karen turns off the incessant, repetitive squawk of the EAS.

KAREN
It's packed Baby - snuggle with Subway Sam instead-

-Gerry reaches a hand back, pats Connie's foot as he tries to find a clear spot in the starred/scarred glass:

GERRY
We're okay - Rach, you buckled up?

No answer. From this following POV, and because of the damaged windshield, we HEAR more than see the Garbage Truck hammering through anything and everything on the shoulder.

GERRY (CONT'D)
Rachel, baby, are you-

CONNIE (O.C.)
-MY ROBE-

GERRY
-CONNIE! SUBWAY SAM DAMN IT!

Connie's crying redoubles, hugs a plush mouse in a business suit. The toy talking in a goofy voice:

SUBWAY SAM
Here comes the #12 Train! Let's count! 1, 2, 3-

-suddenly we're only inches from the Garbage Truck - no brake lights but it's slowing rapidly as the sounds of COLLISIONS get closer and closer together. Gerry slams the brakes, turns off this road, *seems smart:* the road he turns onto is open. A line of cars even following him now. Karen dealing with the immediate as best she can.

KAREN
Are we still heading toward 95?

GERRY
I don't know – I don't know Philly-

KAREN (O.C.)
-RACHEL! JESUS BABY-

-Gerry snaps around in a panic prompted by his wife's tone: Rachel not in her seat - *balled up in the footwell.*

GERRY
YOU GOTTA BUCKLE UP RACH-

KAREN
-GERRY I'M DEALING-

-*blindsided by an AMBULANCE on the Driver's side.* Airbags burst. Underwater half-silence of ringing ears. Gerry blinks airbag dust...the penetrating sound of his family crying...

GERRY
OUT-OUT-OUT-

-pile out the Passenger's side.

EXT. PHILADELPHIA - NEXT MOMENT

Karen first, then Gerry, punch-drunk from the impact, sprawls into rivers of anti-freeze, transmission fluid. Scrambles back up. Leans into the backseat and snatches Rachel out, flips her all around in a panic to see if she's hurt. Hugs her to his shoulder, mumbling phonetic sweetness to her.

Sees Karen holding Connie, her eyes locked onto something, mouth agape with shock. Gerry turns to take in the same scene: everywhere Office Workers pile out of buildings. Too many take photos/videos with phones. Reporters going live. Officers scream orders at half-dressed SOLDIERS in a mufti of running shoes, jeans, and bits of official kit running past.
Cop cars, news vans, civilian vehicles, and Humvees all teem and tangle at a large

intersection directly in front of us. 1 MILE BEHIND THAT: a Marathon-sized mass of very dark *FORMS.* THOUSANDS. *Riots?*

Gerry focuses on the Soldiers again: despite their halfdressed hodge podge, *each carry identical green vinyl bags.*

Gerry stops one of these Soldiers, and without asking opens the green bag: *A GAS MASK.* Soldier shoves him away.

KAREN (O.C.)
What? What's in the bags-

-another baseline of one dozen very deep, very loud staccato thumps from somewhere very nearby lets loose. *Seemingly everybody everywhere flinches at once.* Rachel howls.

CONNIE
Mommy I can feel those fireworks in my heart.

These thumps are 155mm ARTILLERY SHELLS being fired. *And hammering into that marathon-sized mass 1 mile off.* Gerry's eyes wide, clear, unblinking. Hand on baffled head: *this can't be happening in Philadelphia.* The sound and shockwaves of the detonations take a second to travel back to us, then register with delayed roars that blow our hair, shirt tails.

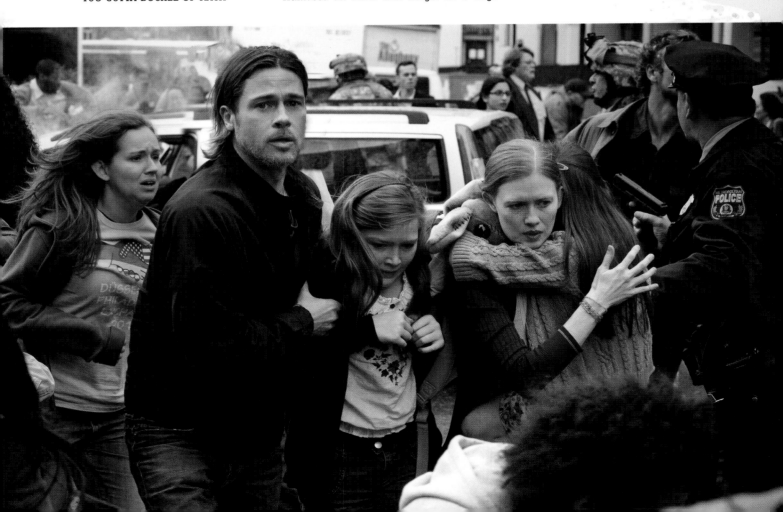

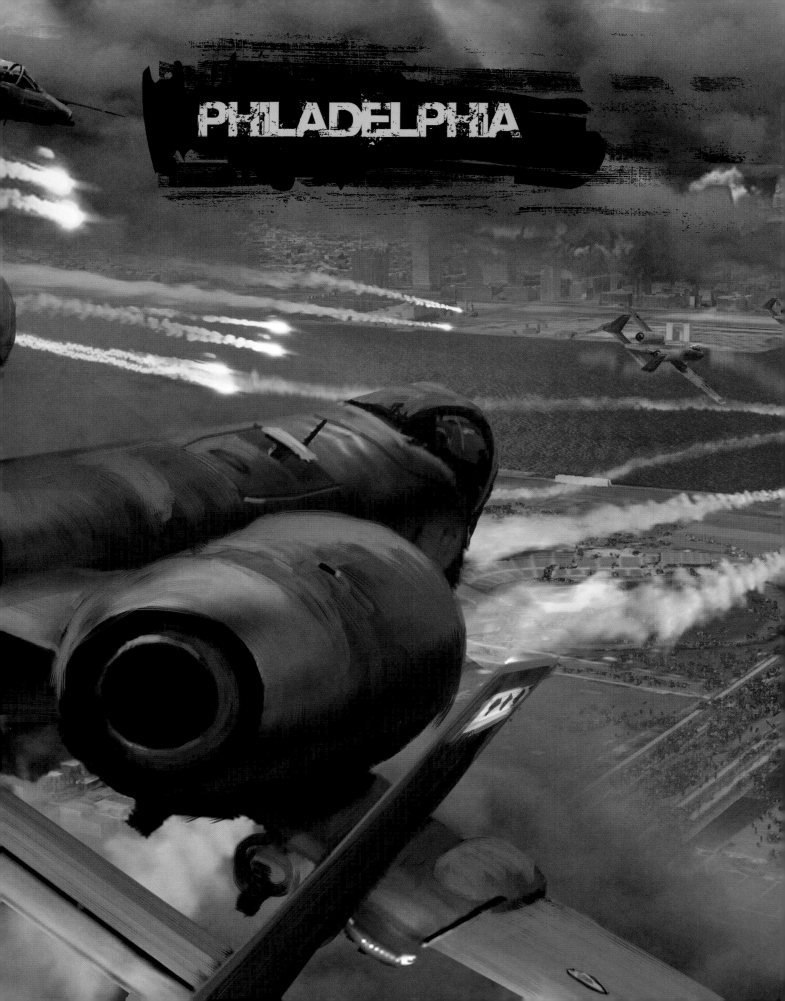

PHILADELPHIA

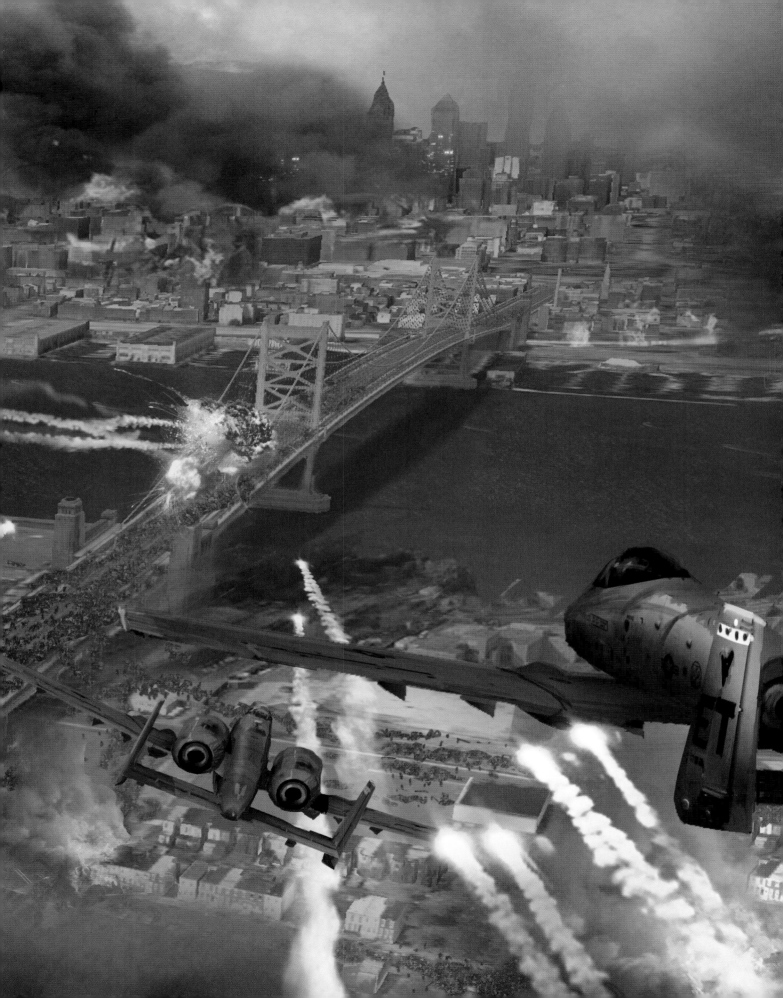

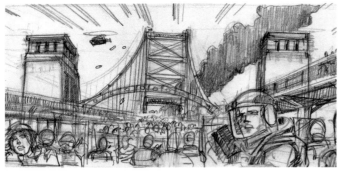
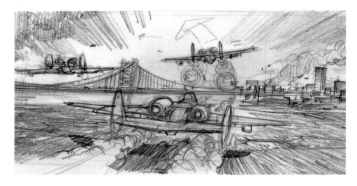
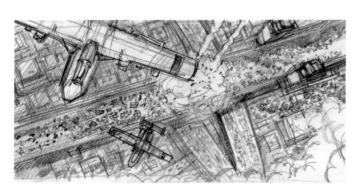
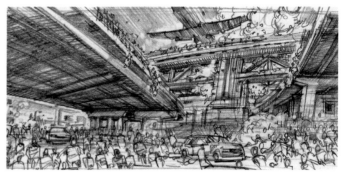
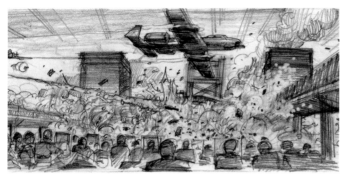
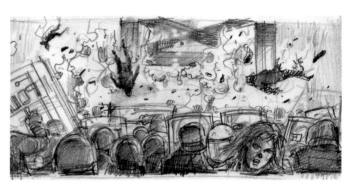
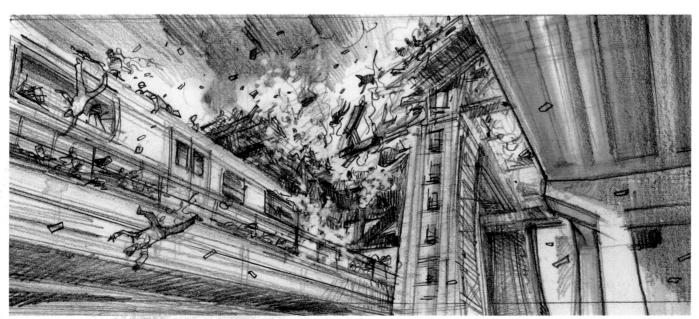

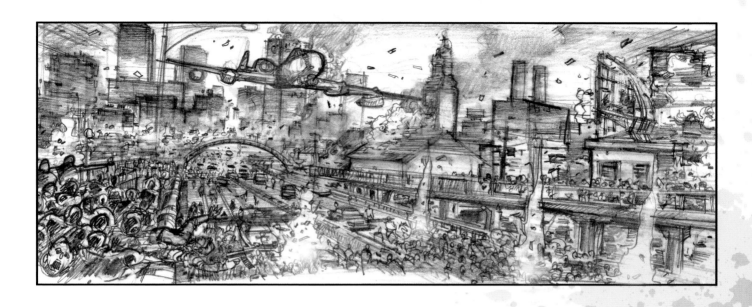

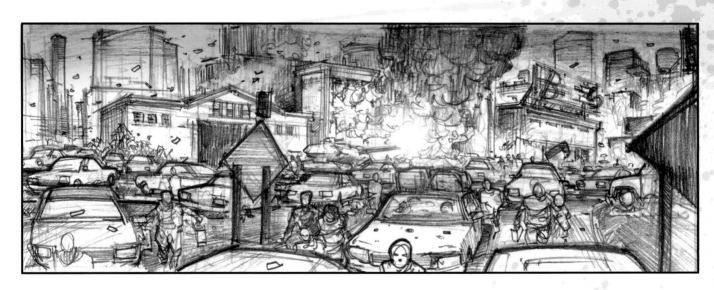

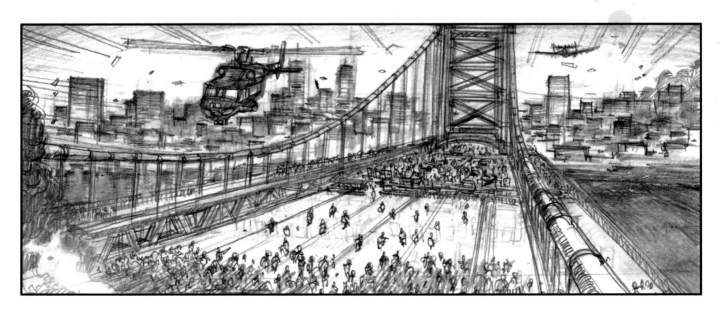

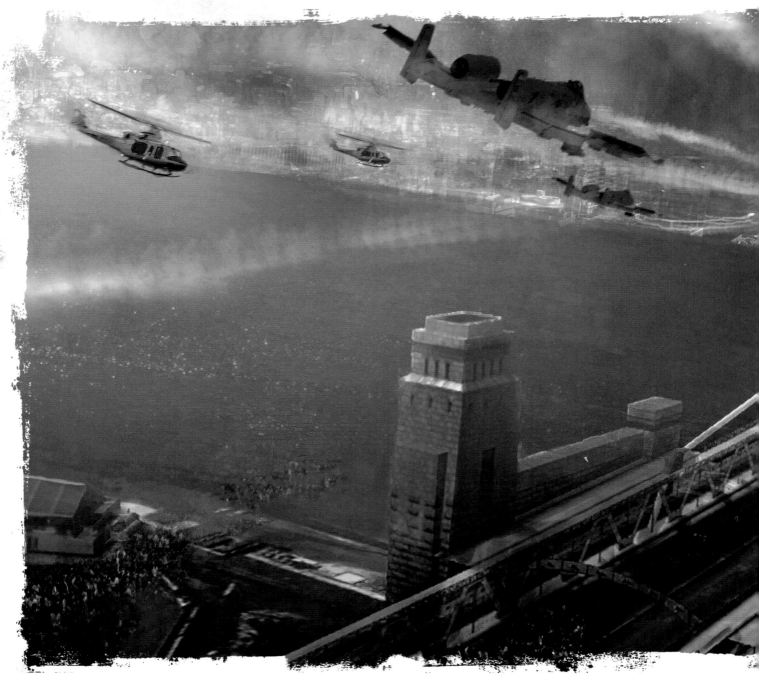

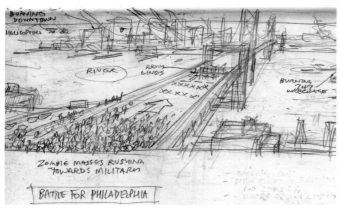

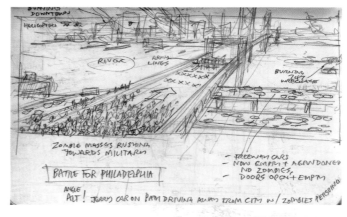

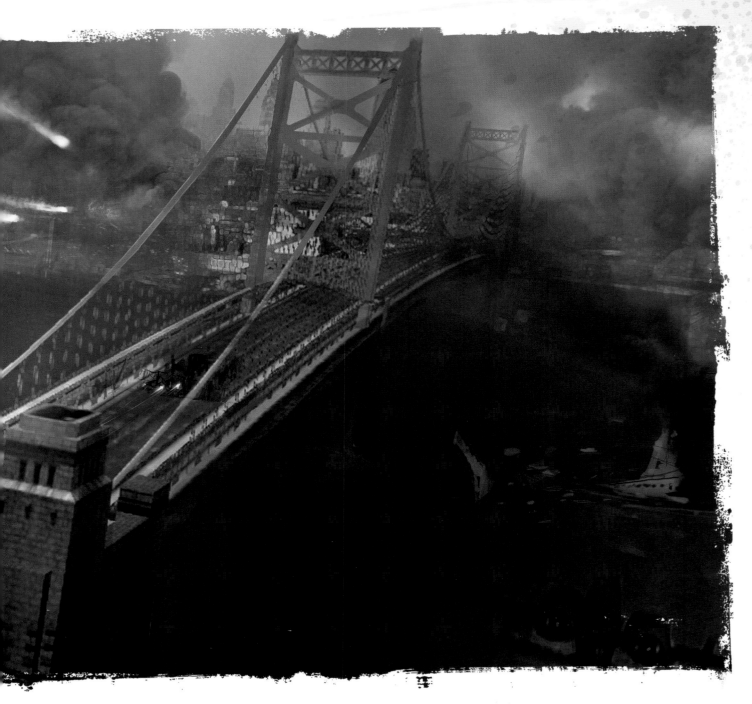

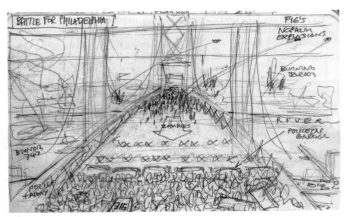

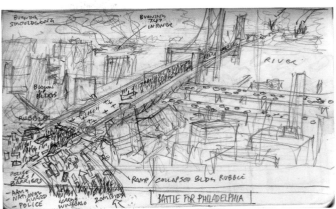

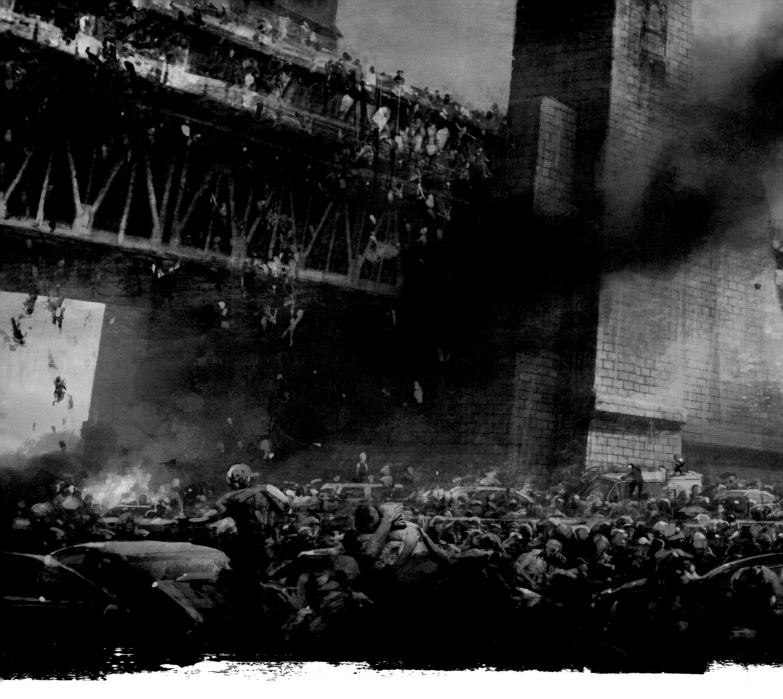

TRY TO MAKE A LOT BUSIER, MORE ENERGY

- VAN DENTED + ZOMBIE BLOOD SPLATTERED
- WINDSCREEN PARTLY SMATTERED
- ZOMBIES TEAR THROUGH FENCE LOADS OF

LARGER A10's + TRACER FIRE

- MORE DRAMATIC SMOKE FIRE + MORE SMOKE IN THE SKY

SPARKS FROM VAN
- MORE ZOMBIES ON PATH
- ZOMBIE BLOOD SPLATTERS ON VAN

18

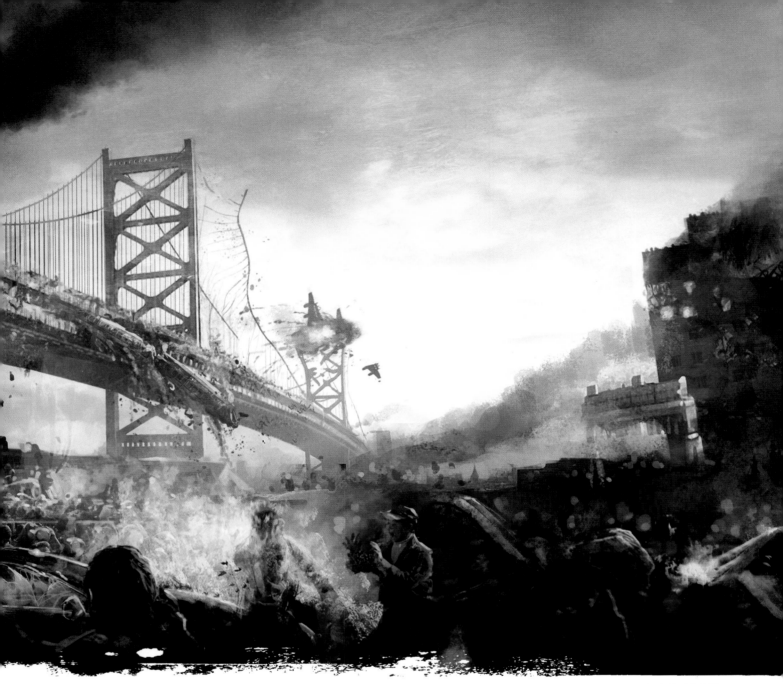

○ *This spread: Concept art showing the zombie attack on Philadelphia's Benjamin Franklin Bridge.*

Gerry follows the rise of the explosions into the air: *can actually see the largest bits of shrapnel and debris as it all arcs high into the morning in every direction.* Karen just as focused, just as aghast. And some of it actually begins landing on Troops, Reporters, Office Workers nearby. People hit, flattened, injured. Gerry's family running now. AWAY.

SOLDIER CHORUS (O.C.)
STOP SHELLS-DANGER CLOSE-CEASE FIRE-

-sudden, punctuated, abject screams now just behind us: like you'd hear in a stadium if the home team made a monumental error. Marred OFFICER stumbles from the intersection:

OFFICER
GO-GO-NOT DYING-BITING-BITING-

-a rifle shot. *Fog of War.* 3 more. *Then 20 more. Then a fusillade.* Gerry's girls cover their ears. He and Karen running upstream as Soldiers begin running toward the gunfire. Karen turns to her husband, terrified:

KAREN
DID YOU HEAR THE WORD 'BITING'-

-Gerry pivots behind: 2 blocks back, in the shadows of the buildings, *hundreds of FORMS swarm. Fast. Zombies.* No better description. Drawn from all ranks: rich/poor skinny/fat, male/female. No textbook moaning. Instead: just the friction and flex of their physical movements, and an almost mechanical sound made by their jaws and teeth when they BITE and miss.

In the relative open of this Boulevard we see how this melting pot moves more like a FLOCK of birds than a group of people. Almost synchronized. *Mother Nature is still at work here* - save for the fact we see dozens of these Zombies shot by Soldiers, and almost none go down, *stay down*.

Connie drops Subway Sam. Gerry, just behind with Rach, steps over it. Connie bawls louder, lunges for the toy, knocking her Mom off balance. Gerry growls, turns, reaches for the toy - and his eyes lock on a scene playing out 30 yards distant:

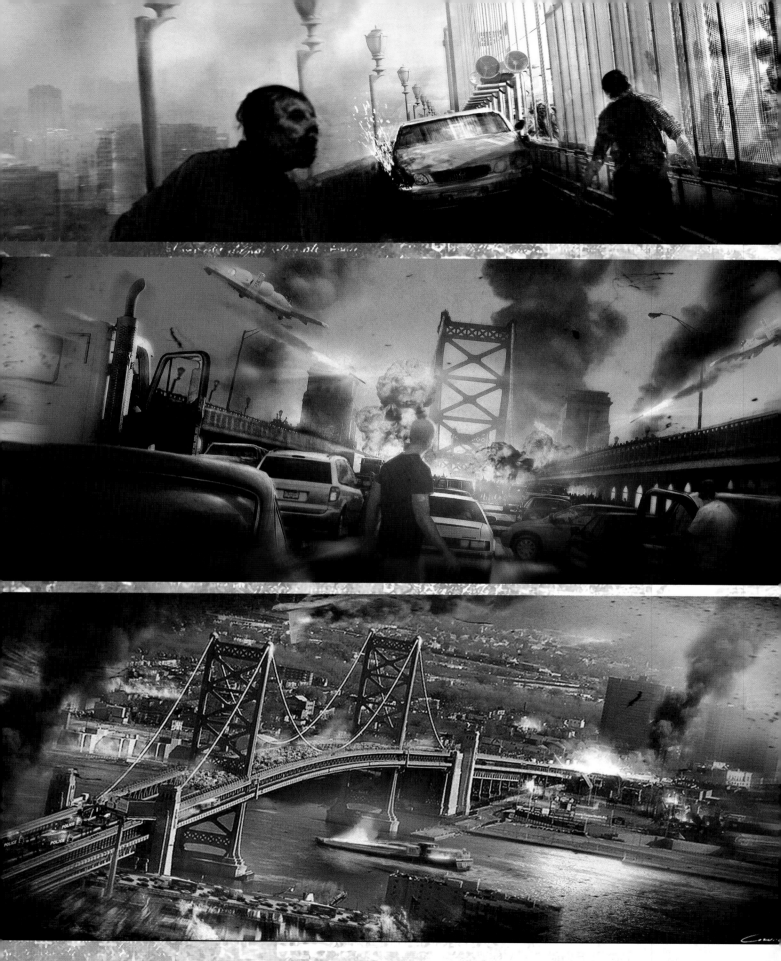

A Father outside his van, fighting for his family still inside: shrieking-yanking at several Zombies leaning into the vehicle through broken windows. Gerry scoops Subway Sam doll:

SUBWAY SAM
Here comes the #10 train!

Father's respite from being attacked ends suddenly as the Zombies turn, descend at once. Desperate to be first to BITE: like sperm competing to fertilize an egg. From the periphery, what used to be a 22 year-old woman launches like a German shepherd, arms splayed behind. *Bite Lands.*

Cued by the doll's counting, Gerry squints with a half-formed thought. Brings the doll to his ear while pressing Rachel's head into his shoulder with his other hand. Backpedaling now as the attack plays out in front of his eyes:

SUBWAY SAM (O.C.) (CONT'D)
Let's count! 1-

-Father still trying to fight-

SUBWAY SAM (O.C.) (CONT'D)
-2, 3, 4-

-Father up to his hands and knees. Zombies swarming as he crawls back toward his van. Falls into the quarter panel-

SUBWAY SAM (O.C.) (CONT'D)
-5, 6, 7, 8-

-that moment, all Zombies let go almost in unison, turn to new targets. Father stands, veins BLACKENING, and along with a dozen other Zombies now, *attacks another* car.

GERRY
8.

Catches up with Karen. Grabs Connie so he has both girls. Sounds of engines and squealing tires rip our POV left: an RV cutting off a Pick-Up to make it to a suddenly wide-open entrance ramp up onto an elevated freeway: *a Military Blockade in the process of abandoning their post.*

Pick-Up and RV CRASH. Jarring even from a distance. People onfoot nearby flinch/keep running. The Pick-Up roars, grinds through the rest of the RVs fender, accelerates up onto the freeway. *The RV doesn't move.* Gerry's eyes drop to the RV's exhaust: *still issuing gray wisps.*

EXT. RV - NEXT MOMENT

Gerry at the passenger door, into the Driver we never see:

GERRY
Sir, can you please help my-

-stops mid-sentence. A grimace. A pause. Then a hustle to the main camper door. Opens it, and quietly to Karen:

GERRY (CONT'D)
Turn the girls away.

Climbs inside. Karen keeps the kids away from the door as people stream past, starting to notice the RV-

KAREN
-Hurry Baby...

INT. RV - MOMENTS LATER

Gerry pulls his family in, locks the doors. Driver's side window shattered. Glance at the sideview: Zombies, many of the half-kitted Soldiers among their ranks now, 15 yards and closing. Humans smacking the sides of the vehicle. The desperate trying to shove pets/themselves into the hole where the window was. A heartbeat later, as the RV begins moving, *a Zombie pops into the vacancy of the driver's side window.*

A flinch that pulls muscles in his neck saves Gerry's life. A bite hits the head-rest: explosion of stuffing. Gerry leans over as far as he can, heedless of the RV's direction, speed. Zombie reaches, gropes the center console, *pulling itself inside. Karen* rears, uses her foot to kick the Z, ends up shoving the wheel with her other foot. RV swerves into a line of queued traffic: *Zombie caught between, gone.* But now Gerry has to throw it into reverse to get off this line.

KAREN
BABY! FORWARD-

-a half dozen appear at Karen's window. Using the butts of their fists to star/break the glass. Karen can't help but stare back at them...equal parts pity and horror.

Gerry puts the RV in drive, roars forward now, pushing a Prius ahead of him all the way onto the exit and up onto the almost empty elevated expressway. Keeps eyes straight ahead so nothing will contradict his temporary elation of having *maybe* escaped. Connie on the floor of the RV, crying. Gerry amped, sweating, mouth dry, i.e. not at his best...

GERRY
I can't take that right now.

Karen goes back, cooing Connie. Then over her shoulder:

KAREN
We going North or South?

Gerry scans for landmarks: the Delaware River on his right, *as well as a Boeing 757.* Very low like it's on final approach. Something not adding: *landing gear not down.* Banks right now so it seems as

though it's going to be moving away from us - *but it never stops banking until it's upside down,* streaking right at the RV, 500 feet up, engines deafening.

The 757 knifes beneath the elevated freeway, right next to us, *so impossibly close we don't actually see it hit River.* But a tsunami of muddy Delaware engulfs the RV. Shockwave pushes the RV across 2 lanes. Blood vessels pop in his eye.

Silent seconds. Smoke from 50 points on the horizon. Then without fanfare, *the starred safety glass of the passenger side window crumbles with an impotent 'pop.'* Half falling into the empty seat, the other half raining down on asphalt. Gerry looks over: divining deeper meanings from the timing.

EXT. INTERSTATE OUT OF PHILLY - DAY

THE RV SPEEDS down the HIGHWAY as -

INT. RV - DAY

We SLAM back into the CHAOS of the RV. HANDHELD - OUT OF CONTROL as we FIND -

RACHEL - GULPING FOR AIR IN DEEP WHEEZING BREATHS - Gerry's at the wheel-trying to get them away from Philly as fast as he can while:

KAREN
My purse... It's back in the car.

GERRY
Spare?

KAREN
Her backpack-

She grabs Rachel's backpack, dumps it. But, of course, the inhaler isn't there.

Karen and Gerry share a look. This is bad. Then.

KAREN (CONT'D)
Rachel. RACHEL-

Rachel gasps, eyes wide with terror as she fights a fullblown ASTHMA ATTACK. PANICKED.

Gerry pulls over, the crappy engine stalls. He slides out of the Driver's seat, moves back to Rachel. Her neck muscles bulge as she gasps for air.

GERRY
Rach - Rachel - look at me.

Gerry takes both her hands in his, surprisingly calm...

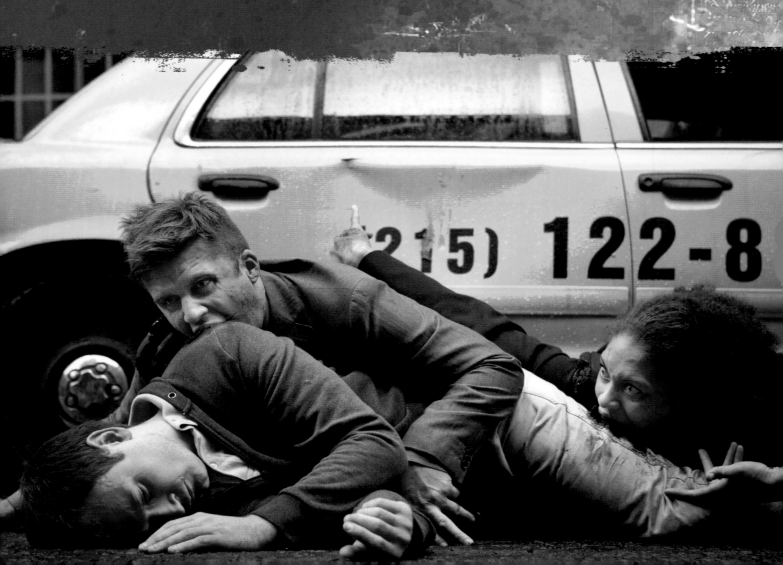

"GLASGOW AS A WHOLE IS LAID OUT IN BLOCKS... WE THEN LOOKED AT HOW WE'RE GONNA EXTEND THE BUILDINGS, THE SKYSCRAPERS... THIS IS ENORMOUS AND IT'S NEVER BEEN DONE IN THE UK BEFORE."

MICHAEL HARM, LOCATION MANAGER

"GLASGOW REALLY GAVE US THE SCALE WE WERE LOOKING FOR. IT'S A LARGE, INDUSTRIAL CITY."

MARC FORSTER, DIRECTOR

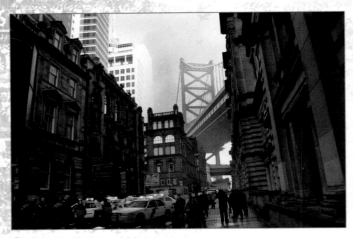

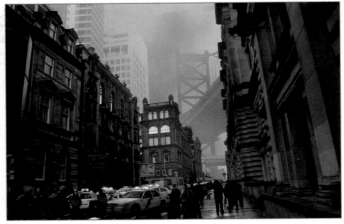

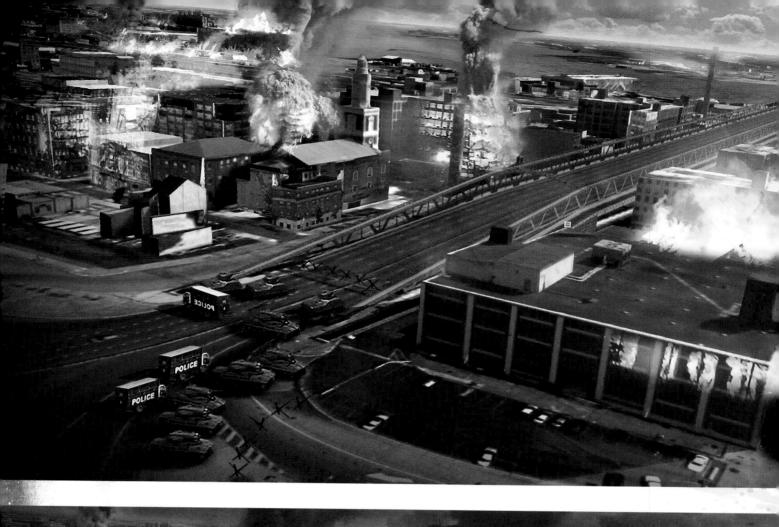
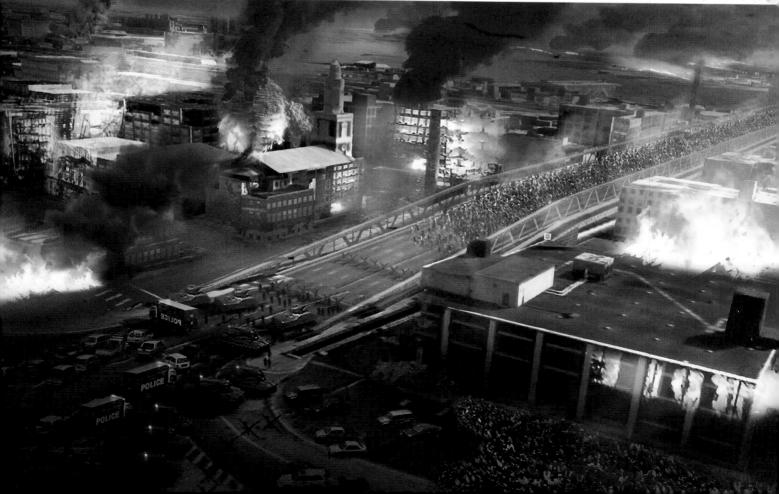

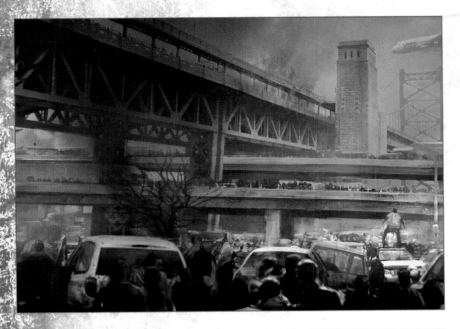

GERRY (CONT'D)
Listen to my voice. We're gonna breathe together, all right? Deep breath in...
(breathes)
And out. Just look at me. Deep breath in...
And out. I'm not going anywhere. I'm right here with you.

CONNIE
Daddy, what were those things?

GERRY
(without taking his eyes off Rachel)
Connie, I need you to go in the back and look through those cabinets, see if you can find water... anything to drink, okay?

Rachel gasps. Connie hesitates, clearly freaked out.

GERRY (CONT'D)
Connie.

Connie swallows, gets to work. Gerry keeps his focus on Rachel as he breathes with her.

GERRY (CONT'D)
That's good, you're doinq great.

And it's working. Slowly but surely, Rachel's breathing stabilizes as she stares at her father.

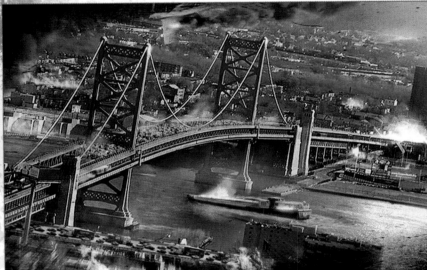

GERRY (CONT'D)
I'm right here. You're okay...
(to Karen, maintaining tone)
Keep moving, find a drugstore...

Karen jumps in the driver's seat, turns the key. Now that damn RV won't start.

KAREN
Not, now... C'mon-c'mon...

GERRY
(back to Rachel)
In and out... In... And out...

ON THE DASHBOARD, Gerry's phone rings. Karen sees the screen -

KAREN
Thierry.

Gerry puts a hand out. Karen tosses him the phone. Gerry answers, rubbing Rachel's back.

GERRY
Where are you?

INT. HELICOPTER/RV INTERCUT - DAY

A helicopter arcs away from lower Manhattan. THIERRY UMUTONI sits in the cabin, surrounded by AIDES in every free seat. Everyone is on cell phones, talking with urgency.

THIERRY
Airborne. The lower east side, Turtle Bay - it's all gone. We barely made it out.
(shouts to the Pilot)
SOUTH. Get across the river.

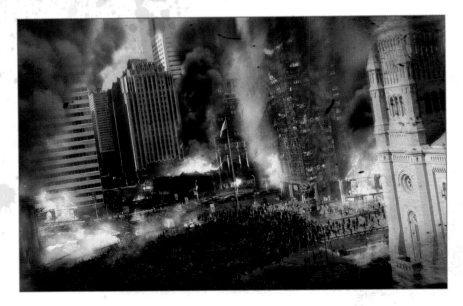

We hear bits of the aides' telephone conversations:

AIDE #1
-patch us into the Secretary of Transpo... *I don't care- break the line if you have to-*

AIDE #2
-visual confirmation... Who do we have on the ground? *What do you mean we've lost Boston?*

GERRY
What is this?

THIERRY
... I don't know. How close were you...

GERRY
Face to face.

THIERRY
Is it true... Are they......

GERRY
Connie-

REVEAL: Connie has opened a cabinet and found A HUNTING RIFLE. Gerry leaps up, grabs the rifle just as his daughter is reaching for it.

THIERRY
Where are you now?

He looks to Karen, still trying to start the RV, unsure when he says:

GERRY
95. Headed north.

THIERRY
I'll try to get a helicopter to you. I'll call you back with an extraction point. Can you hold out for another hour?

GERRY
You forget who you're talking to.

ON THE HORIZON: Thierry sees black smoke billowing from the center of Manhattan.

THIERRY
This isn't for old time's sake, my friend...
I'll need you.

CLOSE ON: Gerry, looking at his wife, his children, their desperate situation.

The RV engine starts. Karen stifles a shout of relief.

GERRY
Just get me a ride.

THIERRY
Good luck, Gerry.

Gerry hangs up, kneels next to Rachel, rubs her back as she struggles to inhale. He looks up front, sees Karen's eyes staring back at him in the rearview.

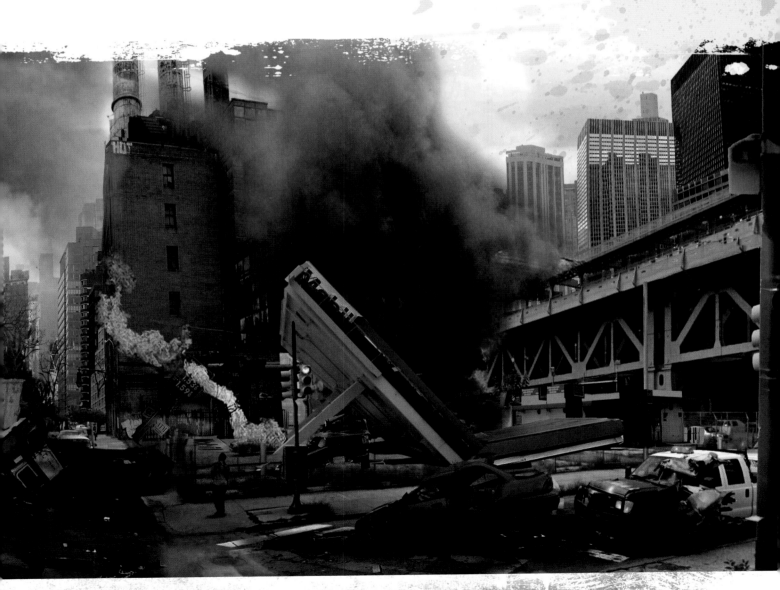

"YOU'RE WALKING A FINE LINE WHEN YOU SET OUT TO TELL A STORY THAT IS BOTH PURE ENTERTAINMENT AND GROUNDED IN REALITY."

MARC FORSTER, DIRECTOR

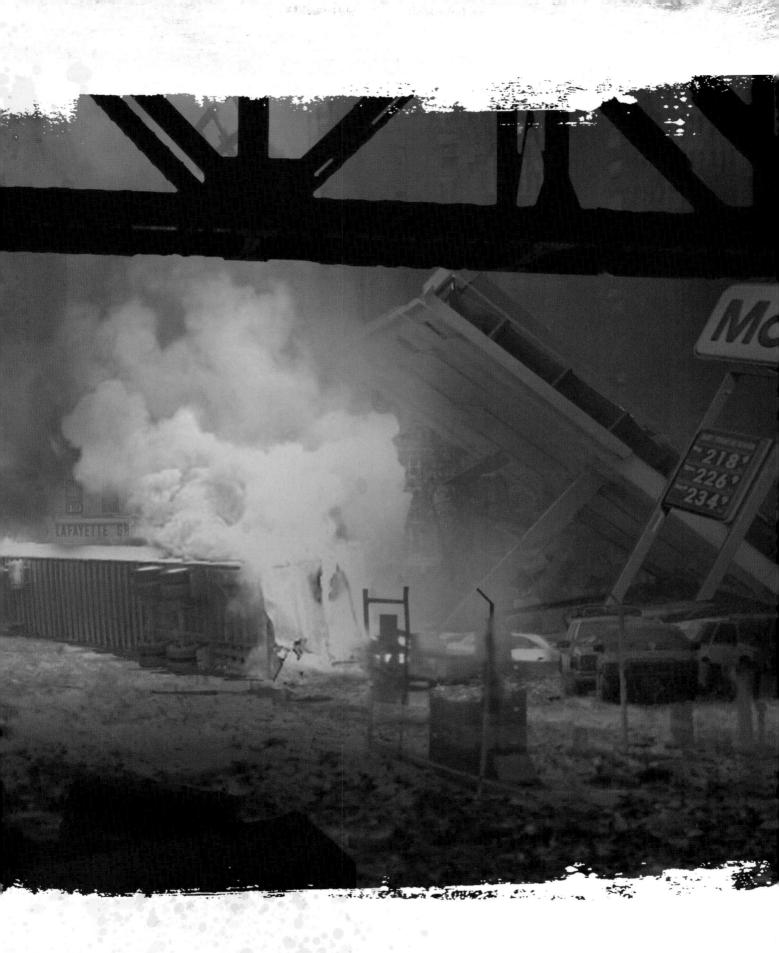

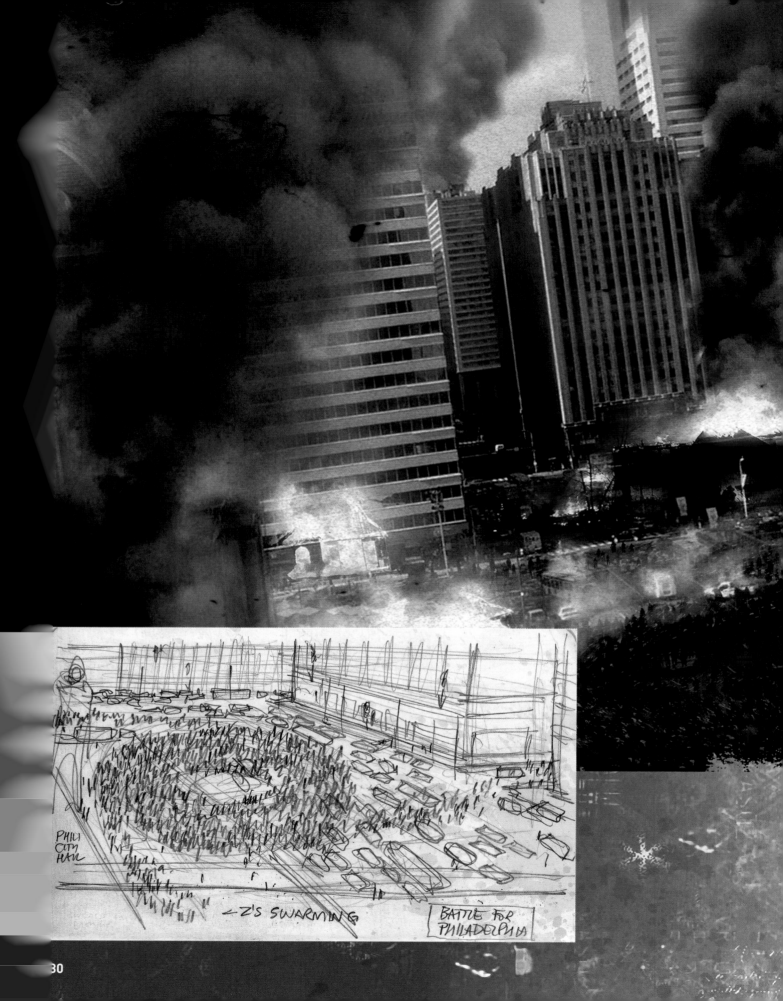

PHILI
CITY
HALL

← Z'S SWARMING

BATTLE FOR
PHILADELPHIA

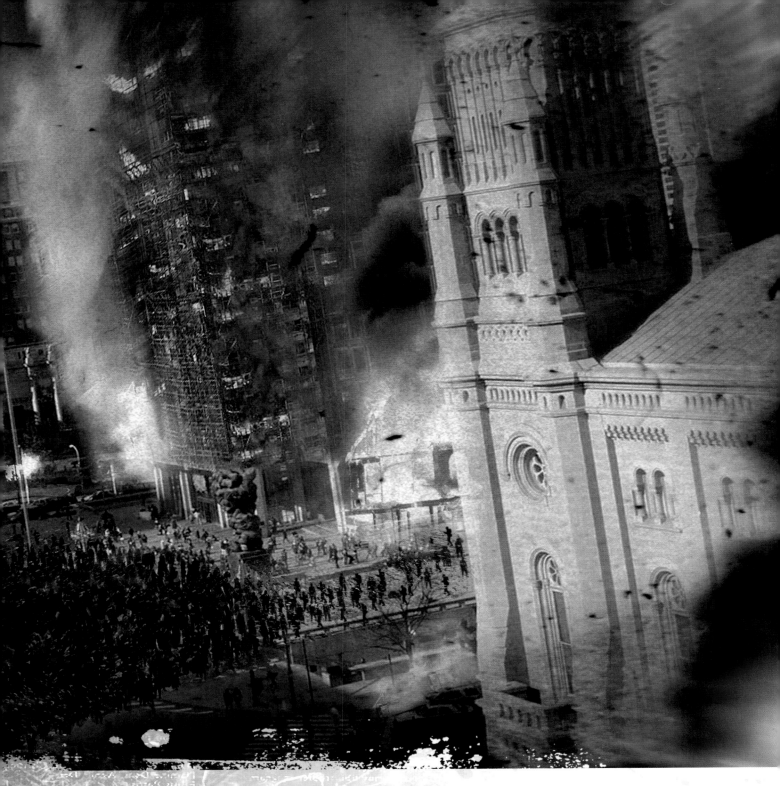

"THERE'S THOUSANDS OF ZOMBIES AND THEY'RE KILLING A LOT OF PEOPLE."

SIMON CRANE, 2ND UNIT DIRECTOR

EZ SAVE

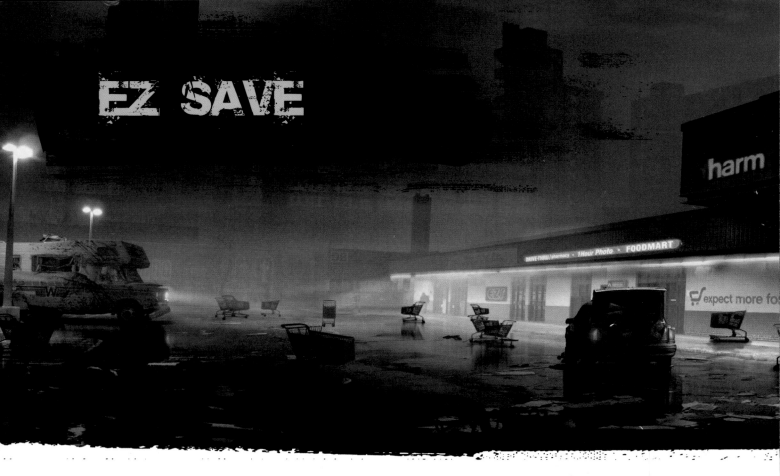

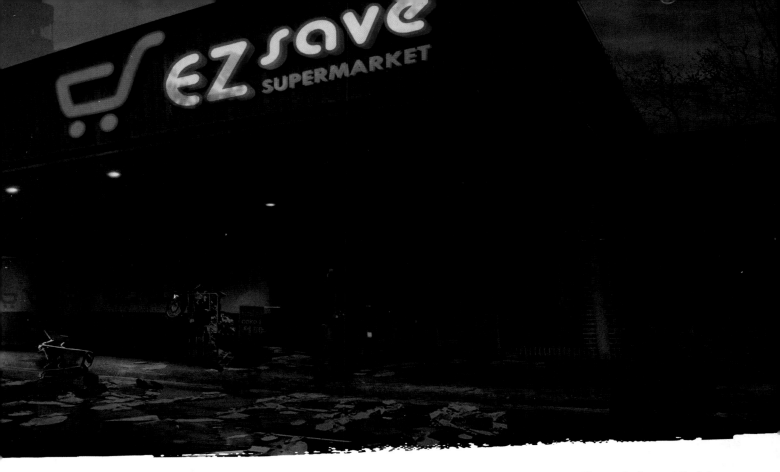

EXT. COOKIE-CUTTER NEW JERSEY SUPER STORE - DUSK

People smashing in and out of the doors and broken windows, armfuls of things that will do them no good: cat litter, frozen food, flat screen TVs/XBOXs/all things electronic.

INT. RV - NEXT MOMENT

Parked in the lot, looking out at this. Karen hands Gerry the rifle. He handles it like he's actually hunted in his life.

> **GERRY**
> I'm not leaving you guys…you're not going in alone…and we're obviously not leaving the babies…

INT. SUPER STORE - DUSK

Emergency lights and the remaining day illuminate. Karen pushes one cart with Connie sitting in the spot for kids and fruit. Gerry pushes another with Rachel inside, in her fetal ball. Hunting rifle slung over his shoulder. Stays down close to Rachel, whispering things we don't hear.

> **KAREN**
> Get her medicine. I'll get us something to eat - been 13 hours. Meet right back here in 3 minutes.

> **GERRY**
> (handing her the rifle)
> Have this.

> **KAREN**
> God no.

CUT TO:

Karen running with two carts: one pushed, one pulled. Each with dozens of water bottles, entire flats of tuna, loaves of bread. Snatches 2 backpacks off a rack. Then a nearby aisle heading catches her eye: flashlights, batteries, etc. Turns in: most of it gone. Scans, moves further down this aisle: automotive supplies. Grabs the last pack of road flares.

2 men run past, 1 in Dwight Shroot-style SHORT SLEEVES, the other in an APRON from the store. They're pushing a packed cart too, crap overflowing. Karen smiles small as they pass. They don't return it. Focus instead on the backpacks she just grabbed, and everything else in her cart they might want.

CUT TO:

Pharmacy. People ransacking. Gerry unslings the rifle: ready in case. Pulls Rachel out of the cart. She clings like a monkey. Gerry stares at shelves of impenetrably named drugs.

> **UNKNOWN VOICE (O.C.)**
> What you need?

Turn: a 20 year-old kid, METH, behind us. Loaded moment during which this encounter goes 1 of 2 ways. Gerry maintains eye contact. Then nods down at Rachel:

> **GERRY**
> Albuterol.

Meth sizes Gerry, turns, moves expertly through the shelves.

> **METH**
> They outgrow the asthma supposively (sic).

Scans, hones in, grabs a handful of inhalers, steps and dumps them into Gerry's cart for him.

> **METH (CONT'D)**
> This shit too. Magic for my Son.

Dumps an armful of Children's Motrin into the cart. Before he can say thanks, Gerry hears a cry. Parental 6th sense picks it up through looting din. Spins: *Connie in a cart, rolling past the end of an aisle. No Karen.* Gerry lays Rachel back in his cart, sprints…

> **GERRY**
> BABY?! Karen?!

Grabs the cart with Connie. Running. Panicked.

INT. AUTOMOTIVE SUPPLIES - NEXT MOMENT

Karen attacked by APRON as SHORT SLEEVES pillages her cart. Karen lands a punch on

"I'M REALLY PROUD TO HAVE BEEN INVOLVED IN THIS... THE FILM IS STRIVING FOR A KIND OF BASIS IN REALITY THAT IS FAIRLY UNUSUAL."

JEREMY KLEINER, PRODUCER

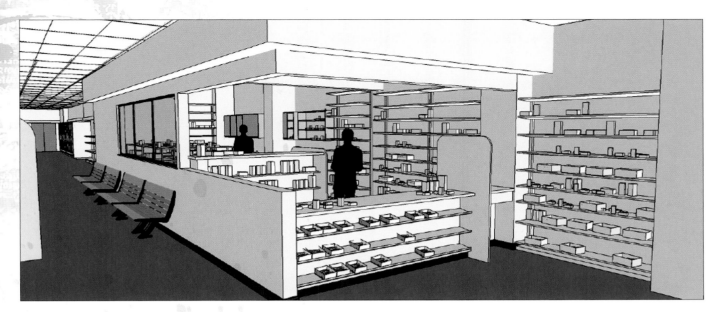

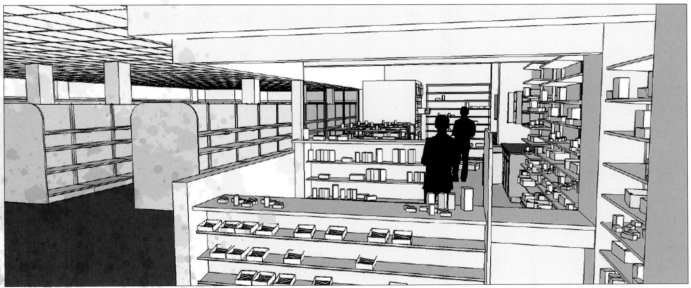

Apron's cheek. A Cop runs toward them. *Continues past as jars of baby food fall out of his pockets.* He runs past Gerry, who just now rounds the corner.

Gerry's face turns into a death mask now, rifle to shoulder. Both attackers see him at once - Apron shoves Short Sleeves toward Gerry just as Gerry FIRES - Gerry flinches with recoil, *and the surreal shock of where he is and what he's doing.* Short Sleeves collapses: an instant raggedy drop.

Apron fires a .38 at Gerry as he scrambles backward on his knees...*10 feet away.* Two shots rip holes in the air inches from Gerry's ear before Gerry works the bolt with shaky hands, chambers another round, fires a quick, errant shot.

People drop to bellies now. Apron fires 2 more wild shots, still scooting backward. Gerry, getting the hang of the bolt-action, sets his feet, fires a 3rd round that detonates bottles of anti-freeze. Apron, wiping his eyes, stands and charges, firing his last bullets blind-

-just as Gerry fires his 4th round: hits and spins Apron into the shelves. Gerry stares another second...eyes furious, exultant. Karen up, grabs the carts, pulls Gerry by the hand.

EXT. PARKING LOT - EARLY EVENING

Bright moon. Gerry and a shaken Karen stand motionless with their kids still in the carts. Staring at us. POV switches to theirs: *RV gone. Stolen.* Gerry sags under the weight of what feels like fate sentencing his family to drawn-out deaths.

Karen though begins rifling the groceries and supplies, grabs the critical stuff: road flares, medication, first aid, Power Bars, Gatorade. Quickly divides the load into the two backpacks. Shoulders one, scoops up Connie...

> **KAREN**
> Put the pack on, pick up Rachel.

> **GERRY**
> Walk where? Hide where?

> **KAREN**
> We're in Newark-

> **GERRY**
> -only a little more terrifying now than it was this time last week-

> **KAREN**
> -*get up right now baby.* Please.

Gerry looks up at his family - does as he's told. Karen smiles at him, then scans for cars. Gerry scanning now, spots what look like projects on the other side of the Store. Eyes fix on the tallest of the buildings.

Looks back at Karen: *she sees the buildings too - both have the same idea.* She just pulls his phone from her bag, hands it to him. He dials.

> **THIERRY (ON PHONE)**
> Gerry?

Thierry's line hard to hear: many loud voices in the b/g.

> **GERRY**
> Battery's dying. Can't get into the city. We're in Newark. Projects- (scans for a street sign) -off 23rd. Highest buildings for blocks. We have flares and we can get to the roof. *Can you?*

> **THIERRY (ON PHONE)**
> Not tonight.

> **GERRY**
> *Sunrise then?*

And now we hear screams, gunshots over Thierry's line.

> **GERRY (CONT'D)**
> *Thierry?*

Thierry screaming in French at his b/g. Then:

> **THIERRY (ON PHONE)**
> I'll move mountains to-

-call dies. Gerry looks down at his phone: battery dead.

EXT. NEWARK - EARLY EVENING

Double-time through an area of old buildings and decaying factories. Screams distant and not-so. Connie singing to herself, fast-walking beside her Dad who's carrying Rachel.

Sudden and massive sounds very close: what 100-lb bags of something might sound like if dropped from great heights. Karen immediately scoops Connie. Quiet.

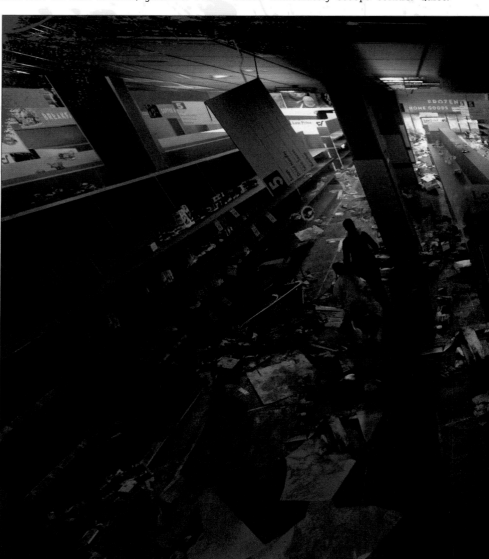

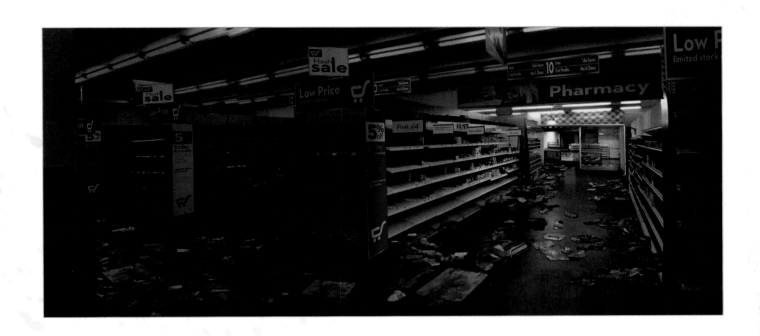

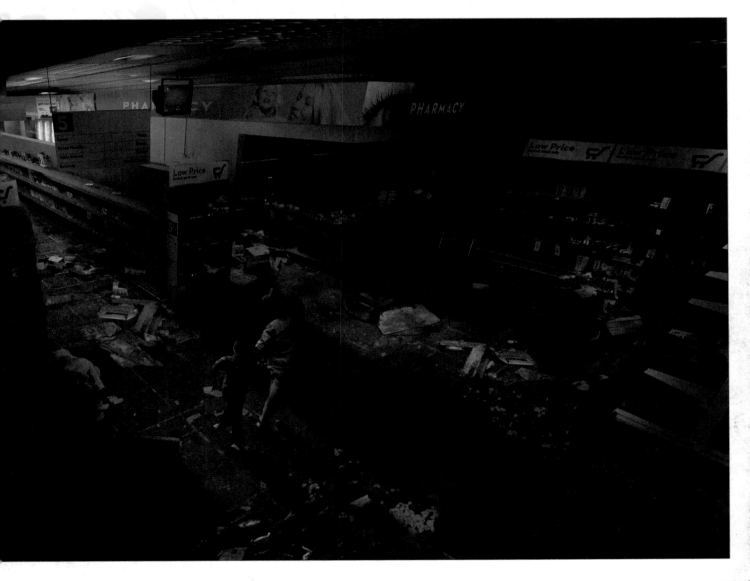

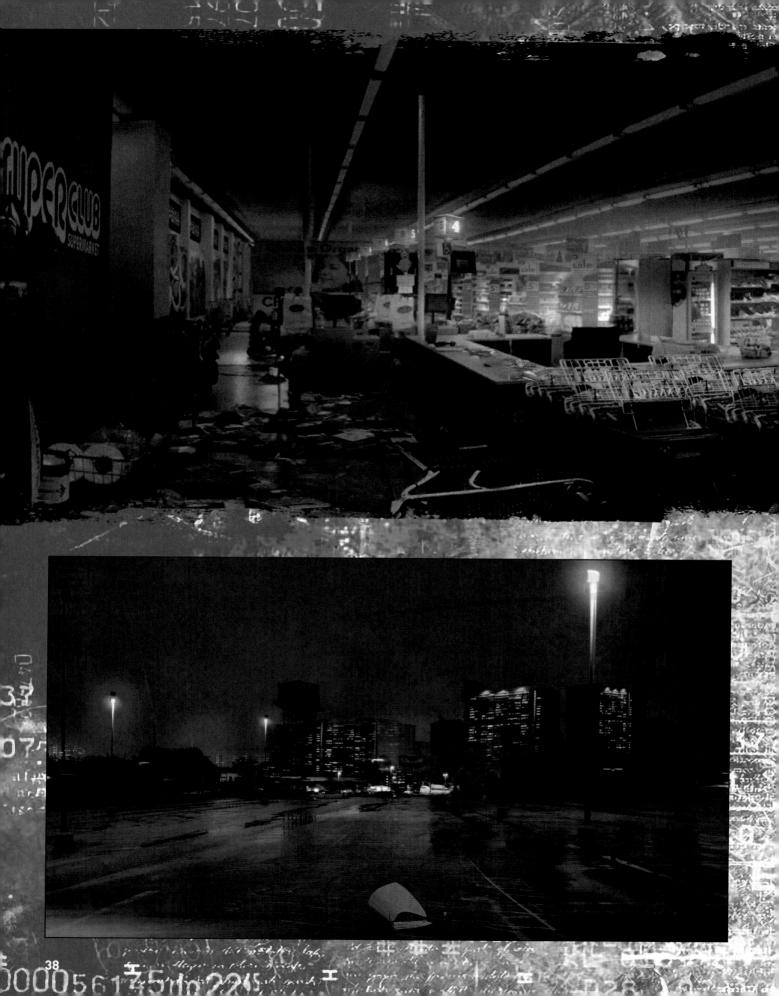

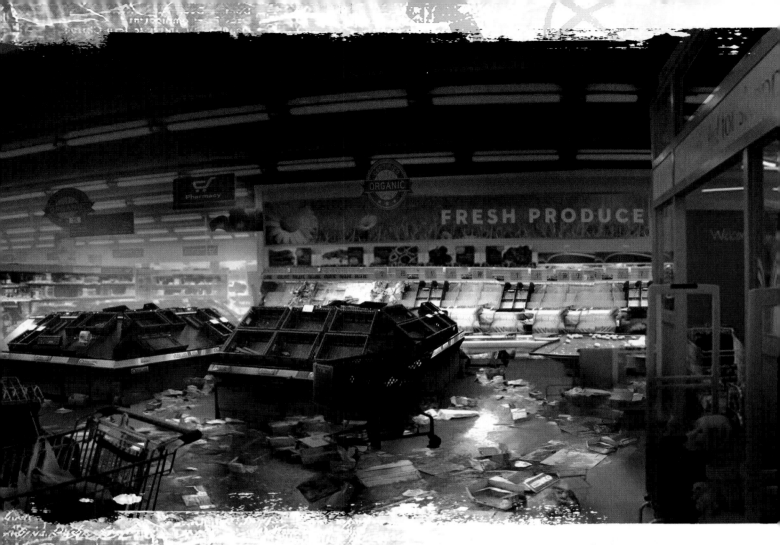

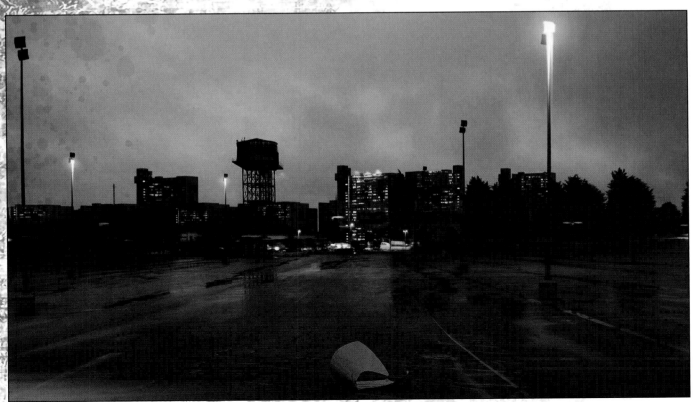

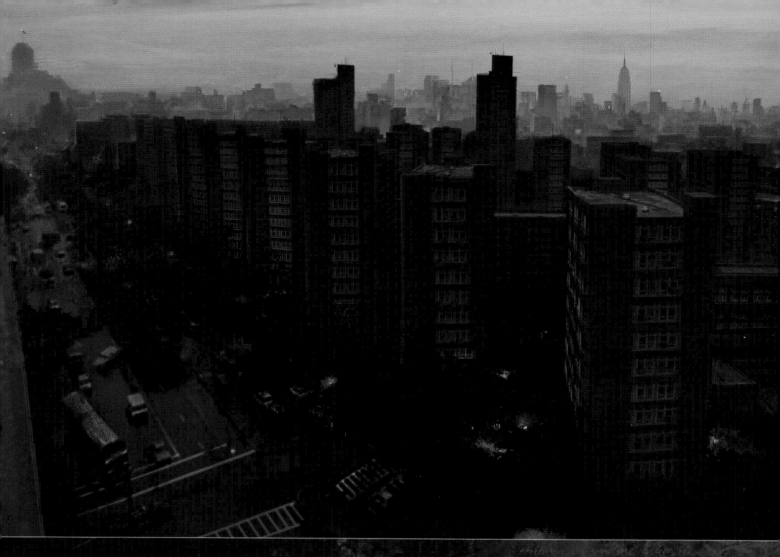

Then more impacts.

We look up: *framed against the darkening sky, Zombies on surrounding buildings launch themselves off to get at Gerry and his brood.* One hits, settles, then slowly begins using nothing but the balls of its feet to propel itself. Gerry and Karen simply stare down at the Thing, almost amazed. Dozens of footfalls from all directions now. *We sprint.*

A 50 year-old Zombie comes out of the dusk aimed right at them. Gerry fires, knocks it flat. It rolls in a panic to all fours, then crawls in a different direction. *Footfalls keep multiplying.* Gerry and his family sprint to the possible safety of the project interior.

And as we get closer to the lobby, we pass this older, rail-thin man wearing a knit skull-cap, sitting on a chair near the building facade, blowing into cold hands. *Seemingly waiting for the inevitable.* His presence, *his nonchalance,* startle us. He, Gerry, and Karen meet eyes for a heartbeat. And without a word, this man looks away again, ostensibly toward the approaching Zs, as Gerry and Karen make it inside.

INT. EMERGENCY STAIRWELL - NEXT MOMENT

"OUR MAIN GOAL WAS TO COME UP WITH A BEHAVIOR FOR THE ZS THAT PEOPLE HAVE NEVER SEEN BEFORE. THIS WAS A VERY CHALLENGING TASK INDEED."

ANDREW R. JONES, ANIMATION CONSULTANT

Looks down at his hands. Swipes black fluid from his face. Steps down, runs back toward the door. Stops a foot away. Levels his broken rifle/rigged bayonet, *waits*. Sounds in the stairwell behind the door: like dogs pawing at the knob.

Then it opens. Gerry immediately fighting with the first Z in the doorway, other Zombies piling up behind: *the second one in this line is Tommie's Dad...*

Karen, keeps all 3 kids close with one arm, waves the flare madly with the other. Watching Gerry. A preemptive good-bye:

KAREN
I love you kids-

-prop-wash from an unseen helicopter suddenly blows her hair. Gerry on the brink of collapse when that prop-wash hits him like Divinity. Steals a look back: *his family climbing onto a US NAVY Chopper hovering just off the roof.* Gerry gives a last Herculean shove, drops the rifle, turns to sprint - stumbles to a knee and elbow, pops back up...

Navy PARAJUMPER at the door of the Chopper fires an M4 at the Zombies on Gerry's heels. Bullets whine past. Chopper lifting off. Gerry jumps. Karen grabs him, gouging skin with her nails. Zombies continue up onto the ledge without stopping. Gerry gets into the passenger hold, immediately grabs shellshocked Tommie and hugs the little guy's face into

his chest so he won't have to see his Father jump, snap, fall...

EXT. US NAVY HELICOPTER - DAY

In sight of the Aircraft Carrier USS HARRY TRUMAN. Out of sight of land. Around the Carrier is this ad hoc FLOTILLA: 1 tanker, 1 cruise ship, 5 yachts, 1 cargo vessel, 3 commercial fishing ships, and another 2 Navy vessels. All-but-tying themselves to the Carrier, desperate for any Authority...

EXT. USS HARRY TRUMAN - MOMENTS LATER

Helicopter lands. Tattered *UN FLAG flying under a US FLAG*. Thierry waiting. Flight deck a frenetic beehive.

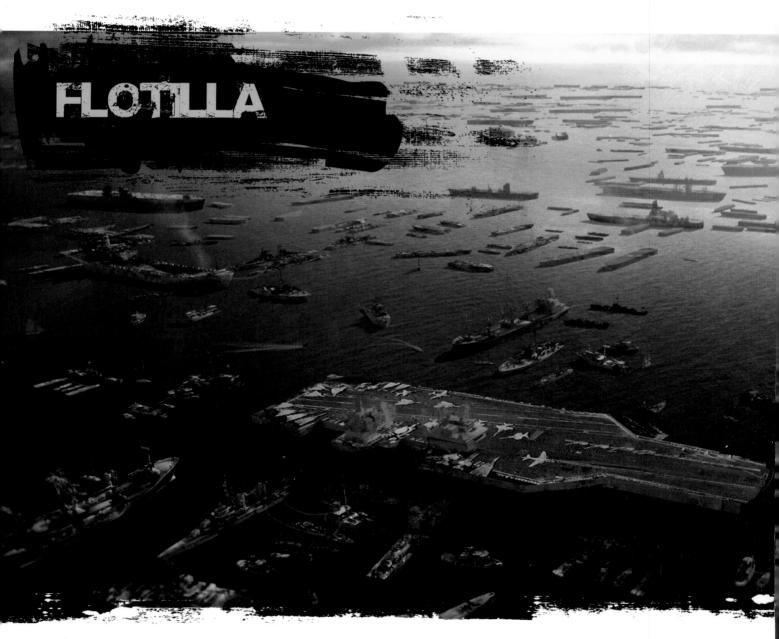

This spread: The last safe place on Earth? Artwork showing the Lane family's arrival at the flotilla.

More Navy SEALS hustle out of another Helicopter just landing. 3 carry paintings: Turner's *Snow Storm,* Pollock's *Lavender Mist #1,* Da Vinci's *Ginevra de'Benci.* 3 others carry clear, bulletproof boxes containing the US Constitution. The last two men carry boxes of sat-phones, laptops, routers.

Thierry embraces Karen. Gerry carrying Rachel. Tommie holds Connie's hand. Thierry and Gerry hug like brothers.

GERRY
What happened to Randall's Island?

THIERRY
They float.

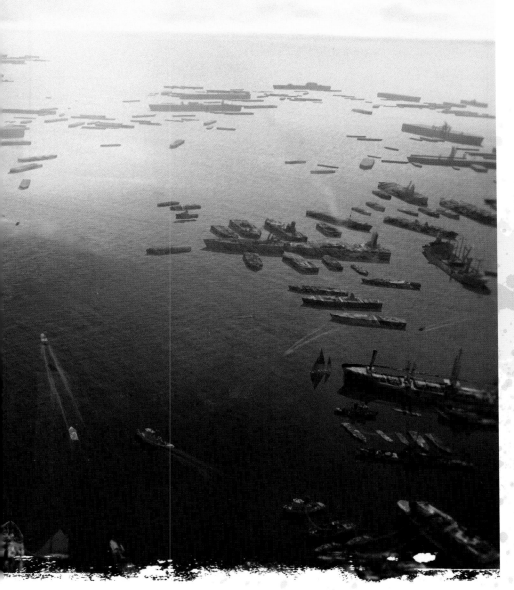

GERRY
(motioning to the Carrier)
How'd you do this?

THIERRY
Luck. A friendly ship almost home from the Gulf.

GERRY
What is it?

THIERRY
We don't know.

INT. USS HARRY TRUMAN, SLEEPING QUARTERS - LATER

Gerry's family sets-up on two bunk beds. No possessions except the clothes on their backs and Subway Sam. Karen, the girls, and Tommie stay huddled. Gerry remains standing: at least it's clean and quiet. Thierry wets a hand towel using a bottle of water and hands it to Gerry.

THIERRY
Meal times for this part of the ship are 7:35 AM, 1:20 PM, and 8:15. Showers are short, *but they're showers.*
(looks at Gerry now)
You can take your coat off.

Gerry makes a point of keeping it on. Quietly:

GERRY
They swim. We're on a boat.

THIERRY
(trying to be light)
I actually said they 'float.'

GERRY
And from what I've seen they could climb an anchor chain easy.

THIERRY
This ship's never dropping anchor again. *You're safe here-*

GERRY
-I'm not worried about me-

THIERRY
-they're safe.

Gerry locks eyes with Karen...this exhausted half-smile from her lets him know things are *okay.* The kids already falling asleep around her. She nods at their little corner:

KAREN
It's bigger than our old apartment on 72nd.

Smiles small, tired. Takes off the jacket. Thierry to Karen:

THIERRY
Need anything?

She points to his water bottle. Thierry hands it over.

GERRY
Is it world wide? Anybody doing better than we are?

Karen snaps her fingers to get their attention: *all three kids asleep, just like* that. Waves them away: talk elsewhere.

INT. USS HARRY TRUMAN HALLWAY - TIME UNKNOWN

Narrow. Packed. Thierry and Gerry navigate. Gerry has towelled off, but still has War stains on his neck, face.

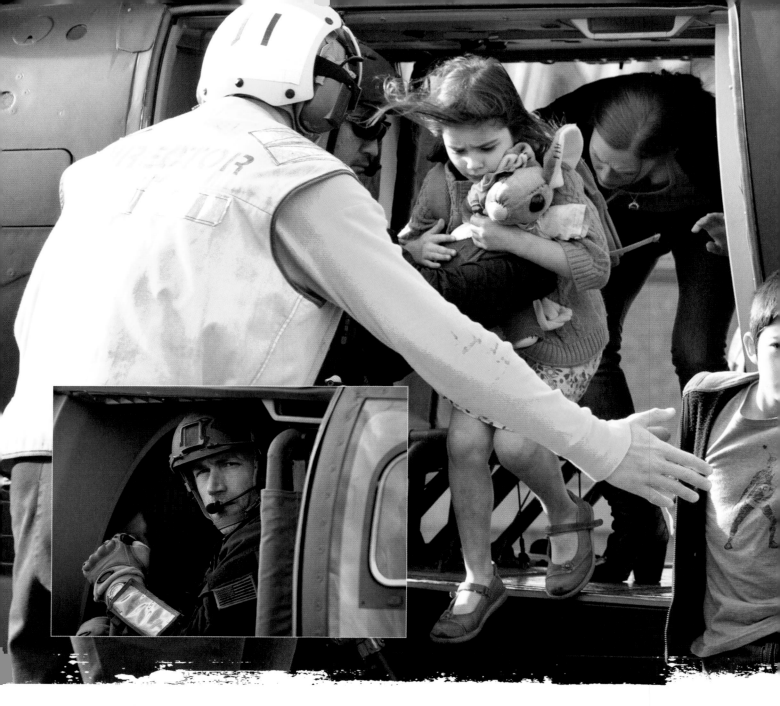

THIERRY
President is dead. 4 of 6 Joint Chiefs. VP missing.
(MORE)

THIERRY (CONT'D)
Reports of gun battles between humans in the Rayburn Building and Capitol - *your Parties are killing one another.*

Gerry scoffs at the predictability of it.

GERRY
Is this - *fleet* - on either side of that fight?

THIERRY
No. Admiral Gibson is reluctantly becoming her own nation.

GERRY
So she saved the Constitution.

Turn a corner, then step out an airtight door.

INT. MAINTENANCE BAY/BRIEFING AREA - NEXT MOMENT

Wide-open expanse. Half-assed briefing area set-up. Buzzing. Everyone unkempt, shiny with the greasy film of exhaustion. Polyglot of languages spoken. Shell-shocked Diplomats still sporting UN lapel pins nod to Thierry deferentially.

THIERRY (O.C.)
And the remnants of the UN. Closest thing to a governing body left.

Gerry - *the only person in the vicinity with the stains of actual battle* - takes in these remnants: a woman in dirty khakis and a pajama top meets his eyes, self-consciously finger-combs her hair. A man who has lost his glasses holds a document millimeters from his face. Another who looks freshly showered, nervously spinning with his wedding ring.

GERRY
We are doomed.

Thierry laughs. A 50 year-old NAVY CAPTAIN steps to a makeshift lectern, flanked by Aides peppering him with quiet intel. People come and go, pass through POV. Room crackles.

50

Gerry's eyes lock on the big screen now: a map of the World entitled <u>THE NEW KNOWN</u>. Some countries shaded gray, question marks stamped on them, signifying places with which we've lost contact, or never had it to begin with: China, North Korea, Finland, Morocco, Madagascar...

On either side of the screen are lists of numbers. On the far left we see the following numbers under the heading, WORLD:

Loss Rate, Approximate: 1,000,000/hour
Functional Extinction Estimate: 233 Days
Ammunition: 25 days
Food: 22 days
Potable water: 10 days

On the far right, numbers under the heading FLOTILLA:

Population: 9,443
Ammunition: 77 days
Food: 82 days
Desalination Capacity: 240 days

At the four corners of this screen are picture-in-picture type monitors, playing a mix of news footage and home video: Boats overcrowded with refugees sinking, throngs fleeing a smoking city, Soldiers using flamethrowers on Zs to no effect, other than to make them more *mystifying and terrifying when they still don't abate*.

And now on the main screen/map of the World, a sort of PowerPoint presentation

begins. Gerry utterly rapt as 50+ red points begin dotting the map like acne. Then those red points begin growing - *malignancies* - a timer ticking off days runs in fast forward just under the NEW KNOWN heading - *this is a projection of what is to come*. NOTE: The red never bleeds into the shaded, question-marked countries. Stops at borders. Not because they're safe, but because there's much we don't know about the World.

Malignant circles touch, meld. Within seconds the New Known world is 95% red, save scattered chunks of white: Cuba, Ireland, Iceland, Greenland, Madagascar, Israel, Antarctica.

Gerry looks at his home: New York City, RED. Then he looks at the words: "Functional

Extinction. " Squints as the implications wash over. Looks up at Thierry, like he can't fathom new reality. Thierry gentle but grim with his friend:

THIERRY
Humanity vanishes in 230 days.

Gerry immediately thinking about his children. A WARRANT OFFICER steps through frame, speaks to the Captain:

WARRANT OFFICER
Sir, cellphone videos of Helsinki. We can deem Finland a total loss.

Heads go down as the screen reflects the change: *gray to red.*

WARRANT OFFICER (CONT'D)
And Carnival Cruise Vessel "Dream" has been given permission to join. 27 knots South and closing.

Warrant Officer hands a young teenager in civvies, nose buried in a computer, a slip of paper and a can of Coke. Kid opens the Coke, chugs, then takes the slip and begins inputting. In lock step, FLOTILLA numbers on screen change.

Population: 12,001
Ammunition: 68 days
Food: 69 days
Desalination Capacity: 222 days

Map resets. Presentation starts over. More red points dot the World anew. Gerry focuses intently now on a few as they grow again: *Paris-DeGaulle - Tokyo-Narita - Atlanta-Hartsfield - Sydney-Kingsford Smith.* Tight on Gerry's face, mental gears working - then to Thierry, like he's checking his work:

GERRY
Airplanes. That how it spread? Is that why the First World – places people travel to - got hit first?

THIERRY (O.C.)
And hardest.

MAP: *Italy bleeding red,* North Korea *still unknown gray.*

GERRY
My God. *What's that leave?* Countries you couldn't travel to? Places you'd never want to go in the first place? And what in the Hell is '*it*?'

Thierry scans the room, waves over the Marathoner who we first noticed in the Van evacuating Thierry and the others.

THIERRY
This is Dr. Andrew...
(forgot his last name)

MARATHONER
Fassbach, Mr. Secretary General.

THIERRY
Please don't call me that. I'm simply the oldest guy left.
(beat to Gerry)
Andrew's a Virologist from Harvard.
(MORE)

THIERRY (CONT'D)
At the UN yesterday delivering a report when things... took a turn.

GERRY
You think it's viral?

FASSBACH
I don't see a plausible alternative - no governmental program like MKULTRA has ever worked on any scale, and things like *Ophiocordyceps* look nothing like this. So the analogy I keep coming back to is Spanish Flu: didn't exist in 1918 but by 1920 it had killed 3% of the World-

GERRY
-3% of the World died *yesterday*-

FASSBACH
-thus 'viral' is my best guess.
(beat)
But I'll grant you, if you keep looking at this from a scientific perspective, it's fascinating...

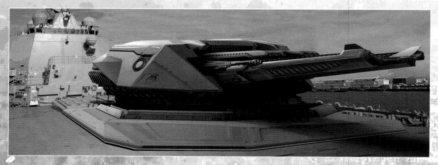

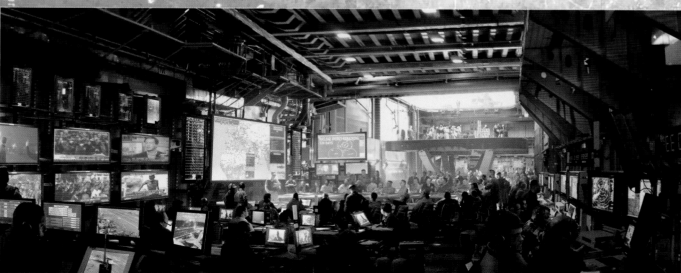

GERRY
(beat, distant)
I keep trying to look at it from the perspective of my 10 year-old who hasn't said a word since it started.

Fassbach and Thierry both look at Gerry. Thierry puts a hand on his friend's shoulder. Gerry gets his bearings back:

GERRY (CONT'D)
If it's viral, does that mean we can cure it? Vaccinate-

CAPTAIN (O.C.)
-few new items here people.

All three look now toward the lectern.

CAPTAIN (CONT'D)
China is still dark. No word or signal whatsoever now, two days and counting. Not even HAM Radio.
(beat)
Vatican has relocated to Dublin and set up shop at Trinity College.

THIERRY
(to Gerry)
-Ireland got word from Heathrow, before Heathrow fell, to burn any planes that had lost contact with their cabin.

GERRY
England saves Ireland?

THIERRY
God's ironic.

CAPTAIN
Cuba's extending territorial waters to the Florida coast North, Jamaican coast South. Confirmed Cuban Forces have landed in the Keys. Still sinking every refugee ship they come across.
(beat)
Last night we had our first baby born aboard ship-

-voice cracks. Tears up. Room goes silent as people think about their own children.

CAPTAIN (CONT'D)
Ruby Rose Sauber. She was on the early side: 5 pounds, 1 ounce.
Behind his head, the Flotilla population ticks up: *12,002.*

CAPTAIN (CONT'D)
Okay. Angel 1, updates?

THIERRY
(quietly to Gerry)
Angel 1 is a team scavenging the seaboard for jet fuel.

OFFICER #1
Lost contact. We've sent Larsen and Koles to track.

CAPTAIN
(circles something)
Everybody say a prayer. Angel 2?

OFFICER #2
Found stores of distilled water and crates of Mark-82 bombs in Norfolk-

-scattered applause-

OFFICER #2 (CONT'D)
-recommend a strike package to clear as many Zs as possible-

GERRY
(to Thierry)
-Zs?

THIERRY
Less ridiculous than *Zombie-*
OFFICER #2
-use Cutters and Trawlers to approach from Seaward.

CAPTAIN
So long as we don't use more bombs than we gain. Make it so.

Officer #2 and three other Men get up, leave.

CAPTAIN (CONT'D)
Angel 3?

OFFICER #3
NIH is overrun. CDC is burning. Air Force did Atlanta like Dresden.

Room deflates. Fassbach squints with something like pain.

CAPTAIN
(draws a line through something}
Mr. Fassbach, that leaves Korea then. *If you're game.*

Fassbach nods a nervous yes, begins packing pens and pads into a military-issue rucksack. A C-2 PILOT kneels down beside Fassbach while he packs, holding an M4 rifle.

C-2 PILOT
This is an M4. Our first stop is Charleston to commandeer the 'C-17 Extended Range' that'll take us to Asia with a refuel at Travis in Nor Cal - clear as of 2 hours ago.

This is the M4's safety-

-Gerry looks at Thierry: *explain what's happening.*

THIERRY
Earliest mention we know of the word "Zombie" was an e-mail sent from Camp Humphreys. US Army Base in South Korea-

GERRY
-when?

THIERRY
10 days ago.

GERRY
What?

THIERRY
But no contact with the base since the War started. So it's a Hail Mary, but worth the risk: if we can pinpoint where this

started, then we can begin identifying what it is and how to stop it.

Both look back at Fassbach: wide-eyed Freshman.

FASSBACH
I've never once shot a gun-

C-2 PILOT
-good, because this is a *rifle...*

Gerry looks at South Korea on the map: malignant red. North Korea: unknown gray. Watches Fassbach sling his pack.

GERRY
Who's going with him?

CAPTAIN (O.C.)
That's it for new business.

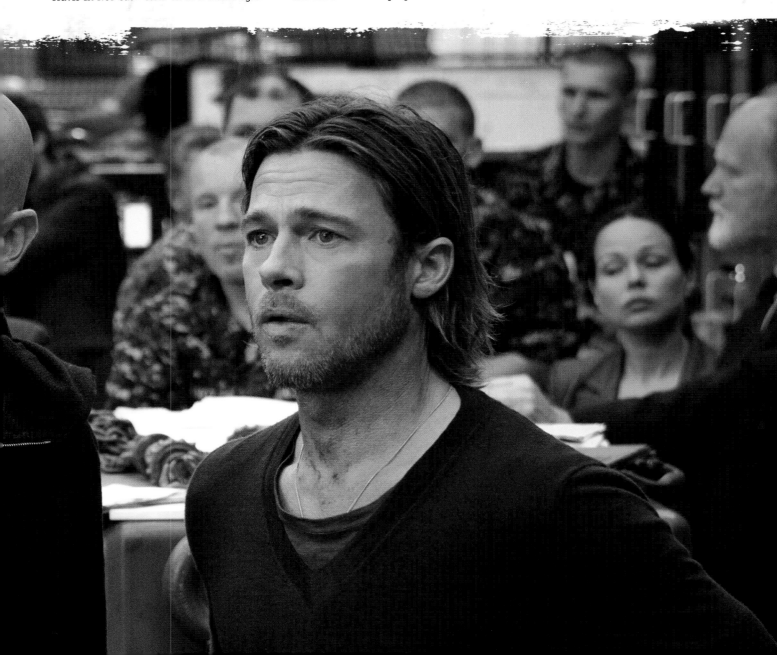

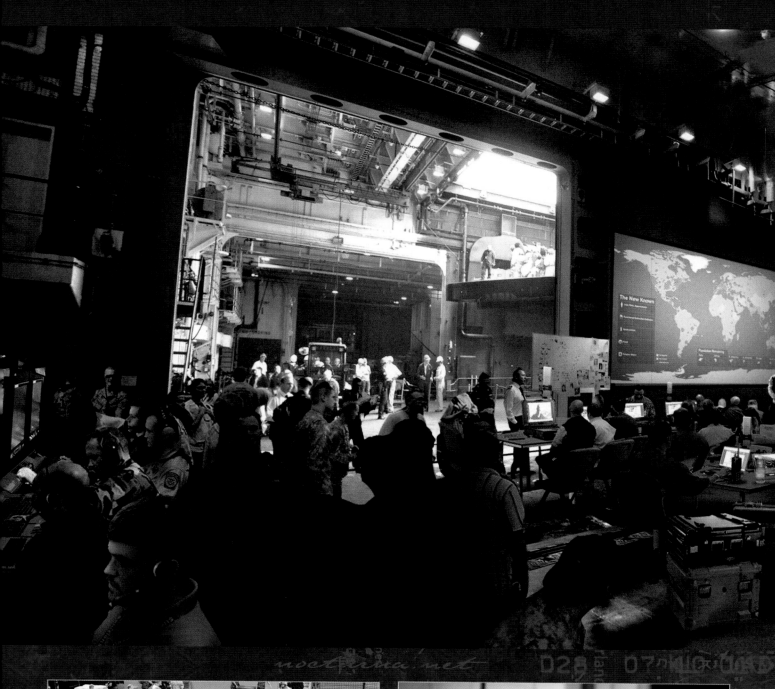

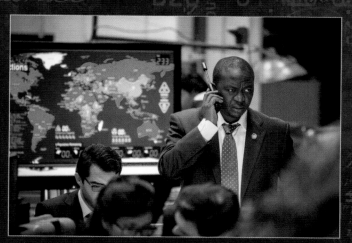

"THERE IS THE ISSUE OF US AS HUMAN BEINGS: HOW DO WE PROTECT OURSELVES?"

FANA MOKOENA, 'THIERRY UMUTONI'

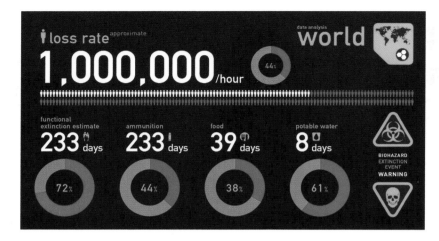

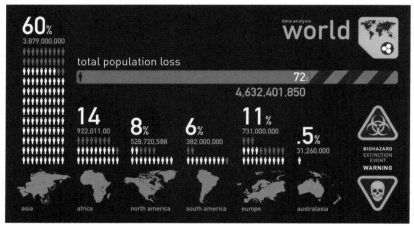

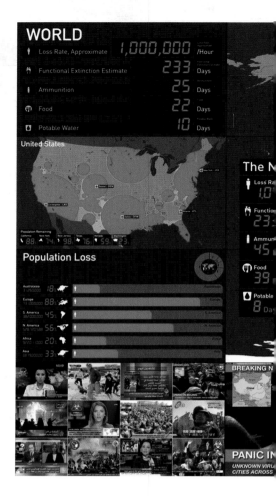

Half the room gets up. Immediate scramble for seats.

THIERRY
A couple options are being debated. A Squad of Marines-

GERRY
-that's a bad idea.

THIERRY
How so?

GERRY
To hammers everything looks like nails, and this thing could need a fine touch. And selfishly, with my family aboard I want every rifle on the boat to stay on the boat.

THIERRY
Okay. The other option is you.

Gerry caught by total surprise. Stunned stare at Thierry.

THIERRY (CONT'D)
With a smaller, more understated security detail.

Gerry can't help a small, rueful smile at his Mentor's chesslike attempt to DRAFT him. Thierry smiles back, then nods to

the Captain who steps to them: *they've already discussed the possibility of Gerry's involvement.* Captain and Gerry shake.

CAPTAIN
You were in the Congo in '93 when Ebola broke, Rwanda in '94, then Bosnia, then East Timor in '99. Not only have you been in the shit, *you were in the shit unarmed.* You know how devastated places work, you know how to talk to the type of Men who rule them. (beat, confidentially) And you and I both know Mr. Fassbach wouldn't last the night in some of the places you've slept.

GERRY
(to Thierry)
If you're giving him my resume, did you tell also tell I'm a SelfStarter 'who cares too much?'

THIERRY
No. You just did.

CAPTAIN
He did tell me the story of how you two escaped Kigali.

Gerry and Thierry's faces change at the mention of this bit of scarring, mutual history. A quiet moment.

GERRY
A long time ago. I'm now a writer of unread reports *and I'm not complaining.*

CAPTAIN
Yesterday a 'writer of unread reports' got his family plus 1 through the fall of the Northeast. Got them here, to what might be the safest place in the World. You and those around you have a habit of *not dying* in places where many are.

Gerry scanning the Captain's face. He's being put on the spot in a way he never has been before...

THIERRY
A handful of SEALs would go with you and the Doctor as a security force: plainclothes, *wise.*
Captain looks down at his watch: *places to be, people to see.*

CAPTAIN
It's one week. If you don't find something in a week, you aren't gonna find anything in Korea. Get yourself and the Doctor in and out.
(beat)
But don't pretend you're not well-suited for the job. Or that somehow your family is exempt when we talk about the *Death of Humanity.*

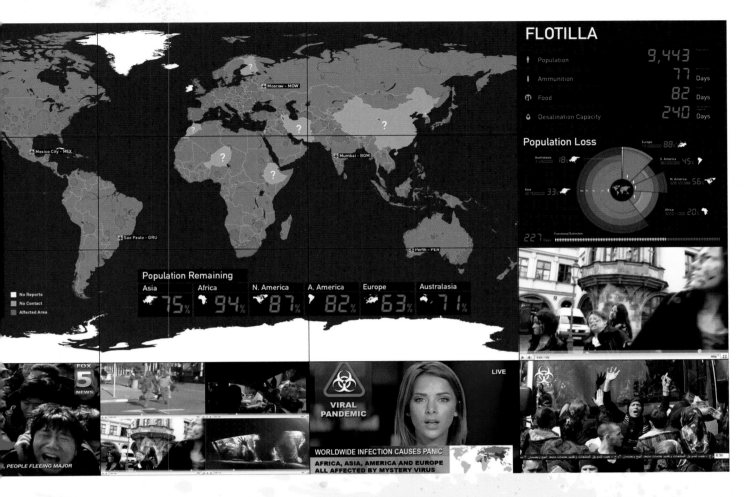

Population 9,443

Ammunition 77 Days

Food 82 Days

Desalination Capacity 240 Days

Population Loss

Europe 88%

Australasia 18%

S. America 45%

N. America 56%

Asia 33%

Africa 20%

227 Days Functional Extinction

Population Remaining

Asia 75% | Africa 94% | N. America 87% | A. America 82% | Europe 63% | Australasia 71%

No Reports
No Contact
Affected Area

FOX 5 NEWS

, PEOPLE FLEEING MAJOR

VIRAL PANDEMIC

LIVE

WORLDWIDE INFECTION CAUSES PANIC
AFRICA, ASIA, AMERICA AND EUROPE
ALL AFFECTED BY MYSTERY VIRUS

Gerry turns to look at Thierry. Thierry meets his eyes. And Gerry notices for the first time how tired his Friend looks.

INT. ARGUS - SITUATION ROOM - DAY

Two technicians looking at several maps on a set of monitors. One map is labeled:

INFECTED AREAS

It shows hot-spots blooming larger by the moment.

Another map is color relief, divided into countries, states and, in some cases, counties. One by one these areas are slowly turning black. This map is labeled:

CONTACT LOST

TECHNICIAN ONE
And how soon are they showing symptoms after contact?
(typing)
Have you recorded any instances where a person was bitten but *not* infected?

TECHNICIAN TWO
Fort Hood Tower do you read me?
(waits)
Fort Hood, come in... *Do you read?*

TECHNICIAN THREE
Attention: D.C. has gone dark. I repeat, D.C. has gone dark. The Capitol Evacuation has been suspended. All Available resources should be directed to North Boston.

TECHNICIAN ONE
The provisional government currently considers central Minnesota to be a potential safezone. But the farther you can get from densely populated areas, the better.

TECHNICIAN TWO
Confirming Cuba has *not* fallen. The Cuban army has seized Guantanamo and deliberately gone radio silent...

TECHNICIAN ONE
I'm sorry, Colonel, but we don't have the resources to evacuate you or your men... I have been ordered not to convey such requests. Sir... SIR. There is *nowhere* to evacuate you to. Sir... SIR.

Frustrated, he hangs up.

TECHNICIAN THREE
(to #2)
How the hell do we know if Russia's really gone dark? For all we know they're up there in Siberia sitting this whole thing out.

(suddenly, into headset)
Yes, I'm still here... They what? I can't hear you... I can't-

He pulls off his headset, looks grimly at Technician 2.

TECHNICIAN THREE (CONT'D)
That was the Berlin Embassy... I think... I think it just went down.

The third and most ominous screen is not a map at all. It is a series of gauges, crunching the known numbers into a dreadful what-if:

SYMPTOMATIC:

RATE OF INFECTION:

TIME TO TOTAL INFECTION:

The symptomatic number is fairly steady, flickering between 11, 12 and 13 seconds based on reports.

Like those clocks that measure tobacco deaths, the infection rate number is climbing exponentially, currently in the tens of millions.

is about to scream to keep going, a heavy door slams shut just behind them. Coleman gas lanterns HISS to life, just as what sound like dozens of Zs begin running into the just-closed door at full speed.

INT. UNKNOWN - MOMENTS LATER
The sound of men breathing heavy as the lantern light slowly begins filling the space...scrubby soldiers appear out of the dark as the light travels.

> UNKNOWN VOICE/*SPEKE*
> *Who was it-Who fell?*

> UNKNOWN VOICE #2
> Skilken.

Gerry realizes more Soldiers are above him on a walkway. *It's only at this moment he realizes he's in a Prison.*

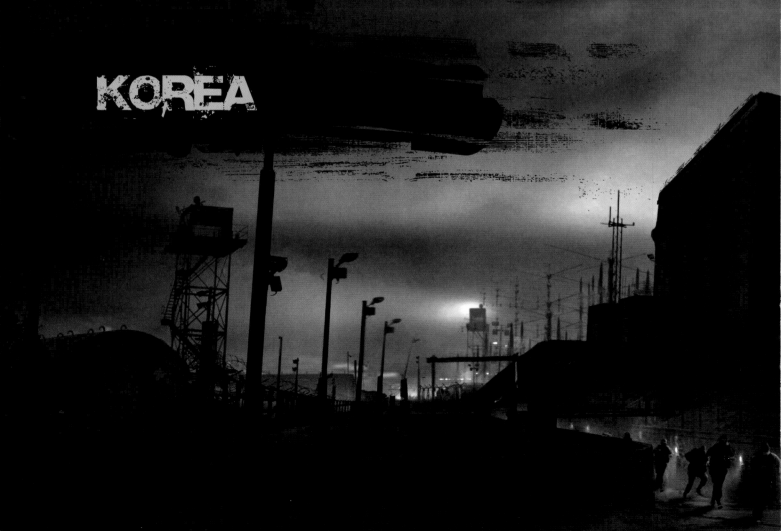

KOREA

INT. MILITARY DETENTION FACILITY -
NEXT MOMENT

Cells stand open. Two dozen soldiers surround us. All with night vision goggles, silenced rifles. Sporting BDU tunics, but then most wear jeans or cargo pants underneath. Several with days-old beards. Others wear football-style arm pads, Kevlar vests, heavy boots, scarves wound around their necks, an assortment of baseball hats and stocking caps...

The Soldier standing next to Gerry, the one who was dragging him, has Captain bars Velcroed to the center of his BDU. His nametag reads: SPEKE. When he or anybody else talks, it is in a very low voice, just north of a whisper. A curious custom in an unknown part of the World.

SPEKE
Power down goggles - police ammo.

All the men eject clips, finger out unused rounds, drop them in boxes filled with single shells, different boxes for different calibers. They then insert full clips, cock their weapons, flip the safeties on. Gerry staring at it all, adding things. Speke turns to the SEAL Commander, <u>angry</u>:

SPEKE (CONT'D)
My Boy who just died out there was 23.
23. Tell me why.

Gerry answers, matching the low volume, also bereft:

GERRY
Because the Guy out there who accidentally shot himself was the last best hope I know of.

SPEKE
What are you talking about?

GERRY
He was a Doctor. A Virologist.

SPEKE
(back to his guys)
Studied viruses.

A 40 year-old Lifer Warrior with the name tag ELLIS:

ELLIS
He don't study anything anymore.

Chuckles reverb.

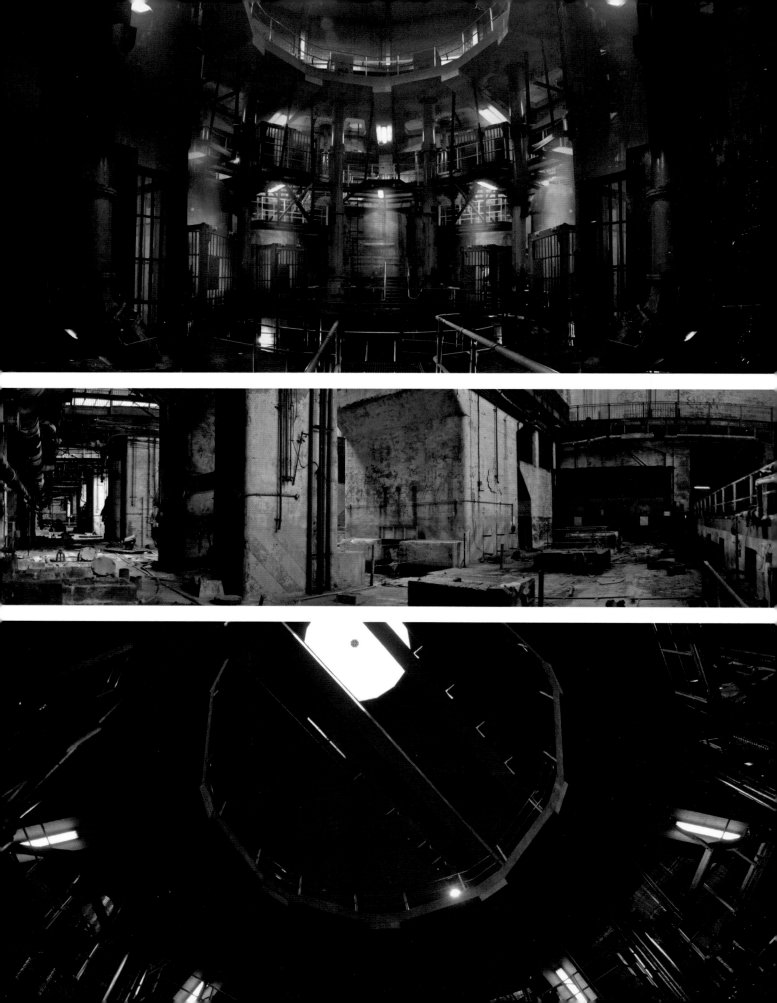

GERRY
He was looking for a way to stop this before it stops *LIFE*. At current rates of transmission or infection - *whatever the hell you want to call it* - that's less than a year away.

Silence now.

GERRY (CONT'D)
Guy had never fired a weapon but still volunteered to come here on a Hail Mary because the NIH in Bethesda and CDC in Atlanta no longer exist. *Nor do those cities.*

ELLIS **SOLDIER #5**
What about Des Moines? Houston?

And before a chorus of concern can break out:

GERRY (CONT'D)
I don't know guys - but no place back home is doing well.

After several quiet seconds.

SPEKE
Well, shit happens.

GERRY
The Doctor would've strongly agreed with you.

CO-PILOT
How do we go about re-fueling?

SPEKE
'When I say so,' and 'very carefully.'

Speke points at Gerry, the Co-Pilot, and Seal Commander now, but talks to Ellis.

SPEKE (CONT'D)
Wrap these Humps.

And just as we think we're going to be grabbed and thrown into one of the cells - or worse - Ellis and the other Soldiers who met us plane-side step to Gerry, the Co-Pilot, and the SEAL, begin outfitting them: wrapping scarves around their necks, giving them left-over Kevlar. Speke sits.

SPEKE (CONT'D)
An empty C-17...and not one of you thought to bring so much as a 12 pack? Sandwiches? Box of porn?

Co-Pilot points at Gerry:

CO-PILOT
He's the Hero. I'm just the Pilot-

SOLDIER #3 (O.C.)
-if you was a real pilot you wouldn't be flying that whale.

CO-PILOT
Only whale I ever flew was your mother.

SOLDIER #3
SHUT UP-

-chorus of berating hisses. Speke to *#3:*

SPEKE
Lincoln, stop talking shit: you're terrible at it. 'Whale?' And you didn't think he'd go right back at your Mom?

SOLDIER #4 (O.C.)
Maybe the plane is empty because they mean to fill it with us.

A pause now as everyone stares at Gerry:

GERRY
I told you why we came. I didn't know this was a prison until you hit the lights.
(quick beat)
Are the Zs drawn to noise?

Scoffs among the Soldiers.

SOLDIER #5
Oh, he's Army Intel-

SOLDIER #6
-Chairman of the Joint Chiefs.

SPEKE
Sound draws them. We call 'em Zeke.

GERRY
Less ridiculous than 'Zombie'?

SPEKE
Yeah.

ELLIS
Fought any Zeke yet?

SEAL COMMANDER
Yes.

ELLIS
Wasn't talking to you Hard Guy.

GERRY
It was a lot louder.

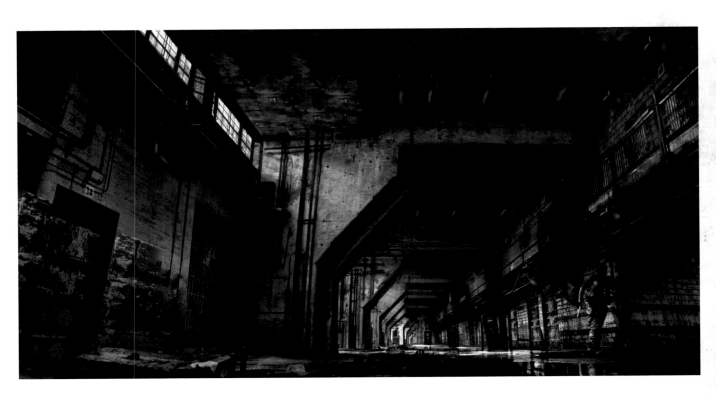

> # "YOU REALLY GET CAUGHT UP IN THIS WORLD AND THE JEOPARDY AND EXCITEMENT. "
>
> DAVID MORSE, 'BURT'

SPEKE
Where?

GERRY
Philly, Newark-

SPEKE
-bad?

GERRY
Gone.

SPEKE
If the other guy was a virologist, then who are you?

GERRY
Gerald Lane. I write reports for the UN. Worked there since I graduated college in 1990.

SOLDIER #8 (O.C.)
I was born in 1990.

GERRY
Go to Hell.

Laughter. Speke smiles for the first time. Budding respect. And in his smile we see that not very long ago, he was a handsome young man. Until the worry and grime of War aged him in fast forward.

GERRY (CONT'D)
There was a memo sent from this installation 11 days ago that had the word 'Zombie' in it. You know anything about it?

They all know something about it judging by how quiet they become. Speke stares back at Gerry.

SPEKE
It wasn't a memo. It was an e-mail. *And it's obvious nobody back home bothered to really read it.*

EXT. PRISON DAY ROOM - TIME UNKNOWN

In a remote corner of the Prison. Gerry stares at the charred aftermath of some small battle. What looks like remains burned down to charcoal, handcuffed to a cot: *cuffs melted to the frame.* Speke having trouble being here...

SPEKE
Me and mine weren't even supposed to be here. Flying from Travis to Bagram, stopped for refuel. The Warden of this place, this terrified little Colonel ordered us down here because we're Rangers - thought we might have seen something like this before: there were 15 or 16 guys in this room.
(MORE)

SPEKE (CONT'D)
Most Guards. All of 'em bitten-
(points to the cot)
-trying get HIM cuffed to that cot. He was first. *Twisting his wrists back and forth in the clasps.* You could see bone. *Wouldn't stop.*

GERRY
Is that Colonel one of the bodies?

SPEKE
Yeah.

GERRY
Are any of the Officers from this base still around?

SPEKE
AWOL, Zeke, Dead.

GERRY
But you guys stay?

SPEKE
We're all still Army. Even if some of these

fools are inmates.

Gerry impressed with Speke. Points to the cot:

GERRY
So you don't know who or what bit this guy who was buckled down?

SPEKE
No.

GERRY
Where he came from? What he did?

SPEKE
As I understand it this place was the Leavenworth of the East – guy could have been a...murderer from Uzbekistan or a thief from Okinawa. Could be from any Base in the Eastern Hemisphere.

GERRY
So we came here because we thought the Outbreak may have started here, but the origin might be anywhere on this half of the globe...

SPEKE
Sorry you had to fly here to find that out.

GERRY
How'd you guys escape this?

Ellis comes hobbling up now:

ELLIS
Expenditure of much ammunition.

GERRY
That how you tweaked your leg?

ELLIS
No. Shit's been bugging me a while.

66

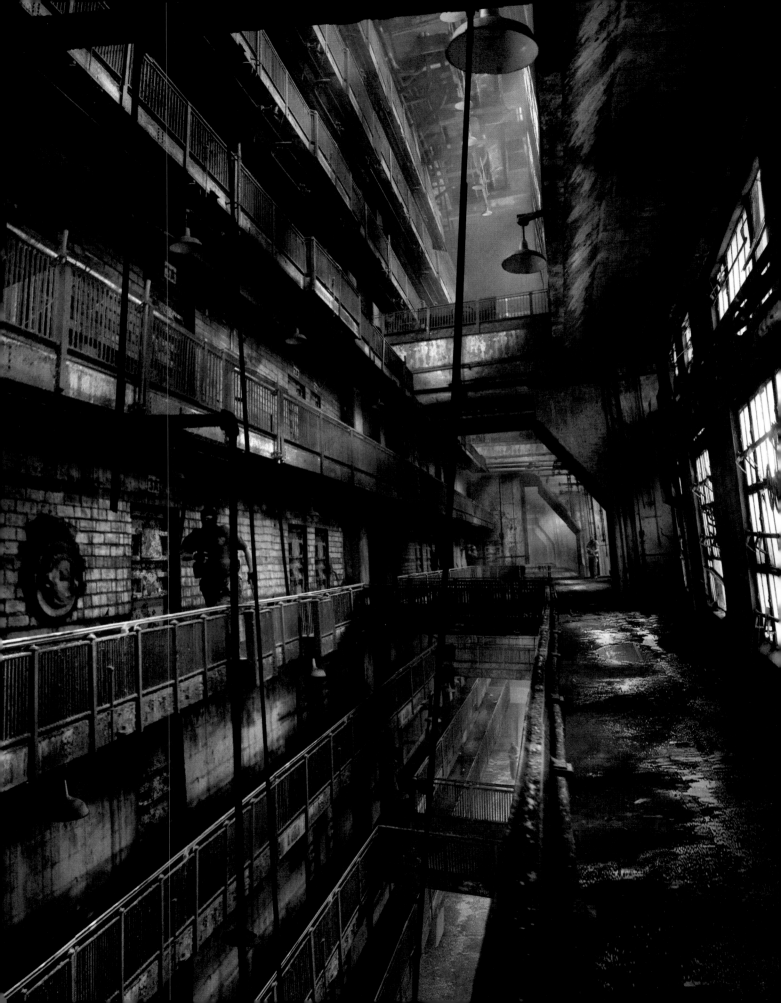

"YOU AREN'T JUST MAKING A ZOMBIE MOVIE OR A SCARY MOVIE... IT'S POLITICAL"

DAVID MORSE, 'BURT'

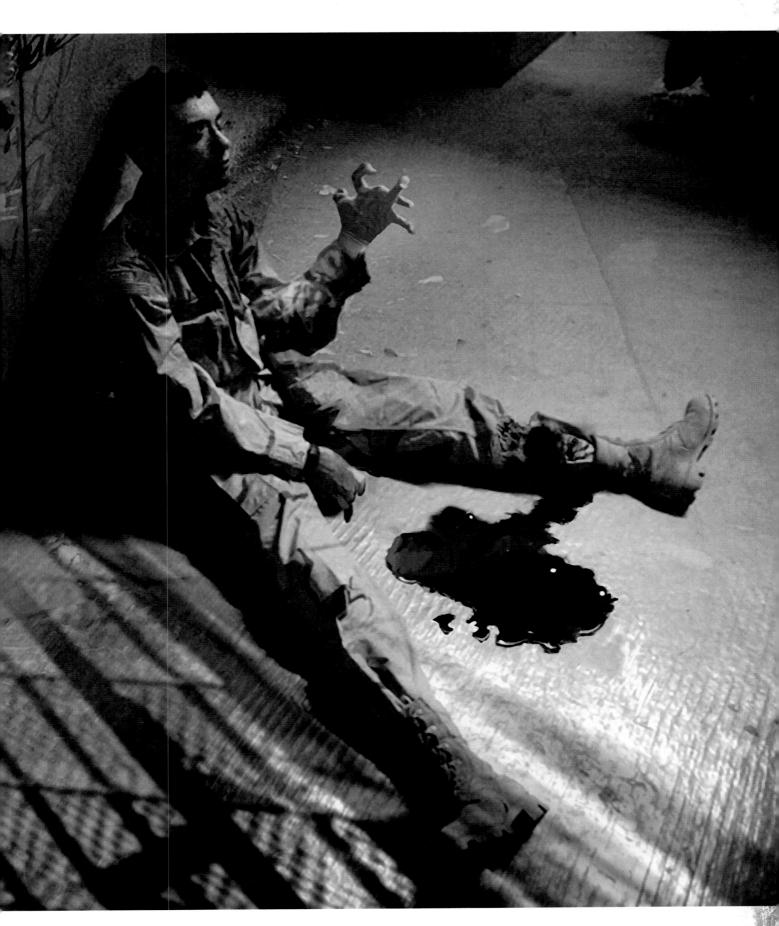

SPEKE
(about Ellis)
This Asshole stands right in the mix while 7 or 8 of those Guards turn Zeke at almost the same time. They got Oblak on his neck - I think he's how it got out of this room because he took off for thermite grenades - I mean we didn't know what it was then, what it could do...I'd have shot him...
(blames himself)
I should have shot him...
(back on Ellis)
But no, Zeke didn't have any time for Old Dirty Bastard here.

ELLIS
(motions to surroundings)
Ain't it obvious I'm charmed?

Smiles.

GERRY
People I've seen bitten go in 8 seconds - it took more time here?

ELLIS
5 or 10 minutes-

UNKNOWN VOICE (O.C.)
-tell him about "your boy" Davidson.

Speke's jaw clenches. Doesn't turn. Neither does anyone else. But Gerry. Sees this Heckler is locked in one of the nearby cells. All alone in this very lonely corner of the Planet. And he looks almost exactly like a 55 year-old BURT REYNOLDS:

BURT
STEVIE-CAPTAIN SPEKE-HELP-MY GOD ARE THEY EATING ME?

Sits in the corner of his cell. Stacks of newspapers and magazines. A hand written sheet of paper stuck to his bars:

"We will now discuss in a little more detail the Struggle for Existence." Chucky Darwin

Gerry continues to stare...

GERRY
Who are you?

ELLIS (O.C.)
Waste no time on that Asshole.

Gerry doesn't turn away though. *Burt sees he has an audience:*

BURT
Viruses get uglier as they move. SARS, HIV, Spanish Flu. But from 5 minutes down to 8 seconds? *Eek.* That actually doesn't sound viral to me at all, sports fans.

Speke turns now to look with Gerry.

SPEKE
Smoky and the Bandit is CIA. Caught

selling guns to the North.

Gerry turns back to Burt. *Burt suddenly standing at his bars, smiling, two teeth left in his mouth...*

GERRY
CIA.

BURT
Recruited out of Brown by a Rhodes Scholar.
(MORE)

BURT (CONT'D)
Most recent boss however was an avid bowler and eater of chicken fingers from Ohio State. Microcosm of the larger Entropy.
(faux polite)
And who are you?

GERRY
UN.

BURT
My God! Captain, put on some World Music! The day is saved! Did you bring palettes of empty promises? And medicine past its expiration date, half of which you've already sold out of the back of your plane?

GERRY
Why did you sell guns to the North?

BURT
Why not?

GERRY
Because the people who run that country are insane.

BURT
Give them credit for not hiding it.

GERRY
Are they stopping Zeke?

BURT
Indeed.

A moment. Doesn't know if he should believe him.

GERRY
Are they using the guns you sold them to do it?

BURT
Guns are half-measures.

GERRY
How then?

Gerry flinches suddenly. Back to Burt: just *one* tooth left in his mouth now, a pair of pliers suddenly in-hand.

BURT
Took away Zeke's exponential power.

Pulled the teeth of all 23 million of their denizens in 24 hours time.
(reverential)
(MORE)

BURT (CONT'D)
Greatest feat of social engineering in history. Rumor is Lil' Kim Jong Un had his niblets pulled on TV. Gist is so simple it's brilliant: *no teeth, no bite, no great spread.*

Gerry quiet. *Disturbed.*

GERRY
Bullshit.

BURT
Rule #1: the more insane the theory-

GERRY
-the greater the likelihood it's true. I still say bullshit.

BURT
You're right. Sorry. North Korea would never wait for Zeke to savage China or Japan or *Alaska,* then walk in after and just scoop up all the gold bullion and oil and stealth fighters and main battle tanks and nuclear missiles they could never dream-up or build themselves. *North Korea would never go to extremes.*

Gerry remains silent at that too. Burt self-satisfied.

GERRY
So they started all this then?

BURT
I don't know. But I do know they're willing to react in ways no one else will. And when you're being punished by *God,* you had better think outside the box-

GERRY
-and how do you know anything?

BURT
Our government paid me a domestic servant's wage for many years to think about "what ifs."

GERRY
And this is where all that work brought you-

BURT
-seen one dead yet? If it's not God, why do you have to burn 'em to ash to get 'em to finally stop? Why do they move like a plague? Why's Israel winning-

GERRY
-wait-what? Israel is winning?

BURT
(haughty laugh)
More books, fewer receptions Boutros-Boutros. Sealed their entire Nation days

before the Undead attacked Man. Knew first, acted first-

GERRY
-people have been building walls there for a millennia-

BURT
-but finish all those thousands of years of work a week ago. *Impeccable timing is all.*

Gerry looks down now, mind racing...

BURT (CONT'D)
Remembering other stories you heard before the War? Lee Marvin's e-mail was sent with barest encryption. And because half of America would rather watch singing shows-

GERRY
-I wouldn't mind a singing show right about now-

BURT
-we filed it as 'to be read.' But other countries, yellow and brown ones who dedicate their brightest to decoding our mail, read it ASAP.

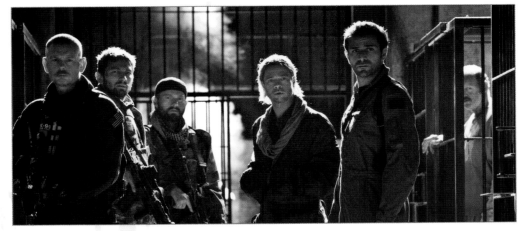

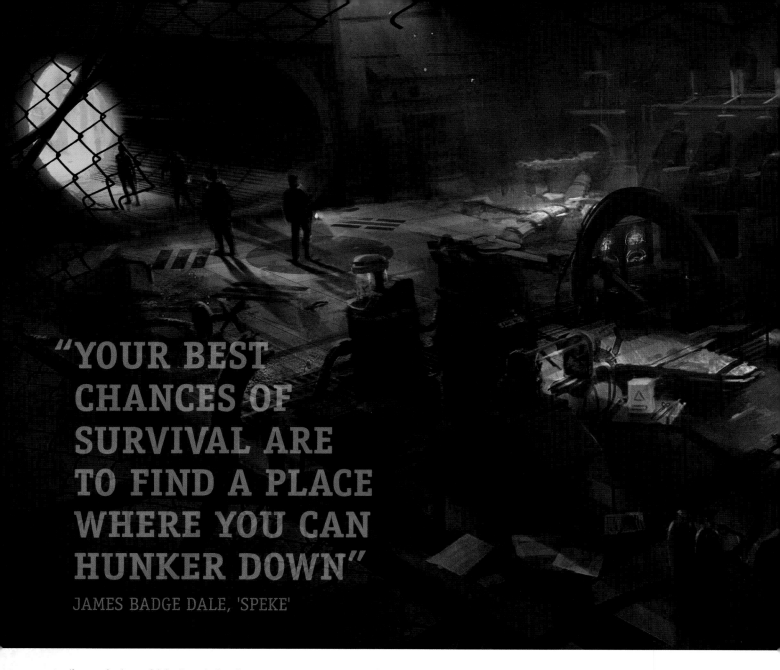

"YOUR BEST CHANCES OF SURVIVAL ARE TO FIND A PLACE WHERE YOU CAN HUNKER DOWN"

JAMES BADGE DALE, 'SPEKE'

A silence during which Gerry's head sort of tilts: *tuning to a faint, repetitive noise somewhere in the b/g.*

SPEKE (O.C.)
Wait a minute: is he right?

ELLIS
There's nothing 'right' about him-

-Gerry holds his hand up for silence just as Burt also brings a finger to his lips like a demented librarian, voice hissing, eyes alive with a detail he already knows:

BURT
Shhhhh - Sherlock's close.

Silence re-emerges as their echoes dissipate. After a second, *we can hear the noise again...a sort of SCRATCHING...*Gerry looks at Speke: *what is that?*

SPEKE
I haven't been down here since...

Gerry snaps on a flashlight, steps into the charred carnage, honing on the sound. <u>Light hits something</u>: a fraction of one of the hands on an otherwise utterly charred Z, has been untouched by the flames - the PINKY and RING FINGERS still perfect. And those two fingers - again, attached to an otherwise completely burned husk of a body - *scratch at the floor in a rhythmic, unceasing way.*

Burt, still smiling, fades back into the shadows of his cell. Co-Pilot sits to keep from buckling. Speke, Gerry, Ellis, and SEAL Commander stare. After a few seconds:

SEAL COMMANDER (O.C.)
We need to go home.

CO-PILOT
Agreed.

GERRY
Head for Hawaii? West Coast? Travis is gone by now. There is no home. *But Israel could mean answers.* If they knew far enough in advance to build walls, then they're a lot closer to the origin - the truth-

CO-PILOT
(pointing at the fingers)
-you ever seen anything like that?

GERRY
No.

SEAL COMMANDER
How do you fight that? *I fight for a living and I got nothing.* How do you *cure* that-

GERRY
-I don't know. <u>Yet</u>.

EXT. USS HARRY TRUMAN - TIME UNKNOWN

A line for the outdoor cafeteria. Connie stares.

CONNIE
Mommie, is this breakfast time?

KAREN
(beat)
I really don't know.

CONNIE
Water here tastes funny.

Sailors up front:

SAILOR #1
It's jet fuel young lady.

Connie looks up at her Mom. Worried.

KAREN
He's kidding baby.

SAILOR #2
I wish. De-Sal has trouble filtering it out.

Turns, hands Connie a *Crystal Light* packet from his pocket.

SAILOR #1
Put this in-

-without warning Rachel lunges at the Sailor, snapping like a Z. Scares us to death. Sailor flinches. Karen grabs Rachel instinctively, grips her close, as shocked as everyone else.

HALLWAY CHORUS
CONTACT! CONTACT!

Several pull sidearms. The Parajumper - from the Helicopter that pulled Karen and the family from the roof in Newark - further up in the line, sees the commotion, runs back to defend Karen and her family...

INT. PRISON - NIGHT

6 soldiers with 3 bikes, removing kickstands, stripping all extraneous parts. Each bike picked up, dropped on its tires. Soundless. Re-spray chains with WD-40.

SPEKE (O.C.)
Take this.

Gerry's POV: Speke right in front of us, his goggles on too, holding a silenced rifle with one hand, handing us something with

the other: a West Point graduation ring.

GERRY
No way-

SPEKE
-for my folks. Chicago. If they're there, Mom's pacing a hole in the floor. Better chance of you seeing 'em before me is all.

GERRY
You all could come with. Big plane.

ELLIS
Better the Devil you know...

GERRY
...than the one you don't.

Gerry pockets the ring. Shakes Speke's hand.

SPEKE
You're gonna get outta here, okay? Just pedal your ass off, and make sure Maverick there keeps the nose aimed at the setting sun-
(nods at the SEAL)
-and keep one eye on Johnny Pull-Ups at all times.

We get on one of the bikes. Co-Pilot and Seal Commander on the other two. Poised at the front door of the prison. Look up: snipers in position. Speke just in front of us, rifle ready, bare feet: *less sound*. We don't know the plan.

CO-PILOT
Remember: don't lock the Bowser's fuel line to the inlet - I need to blow it off when we're full.

SPEKE
Tell me 10 more times.
(up to his Men now)
Don't rush. Don't shoot the damn plane. If you're not a sniper don't head hunt. Just get Zeke on the ground. Remember: *spines are divine but knees work just fine*. Cut the lights. *Here we go.*

Everything goes black. Then the distinctive green light and electric whine of night vision goggles turning on. *The rest of the sequence will be seen through night vision.* Speke opens the giant, noisy door. Snipers open up immediately: tiny-bright flashes and muzzled hisses. Speke in a full sprint into the night. We race out on the bikes.

EXT. CAMP HUMPHREYS - BLACK NIGHT

With Speke, *running toward a fuel truck.* Explosions from the massive battle to the North even louder now, lighting the nearby sky for seconds at a time. Some to such a degree that the goggles whiteout, overload with light, blinding us for 1 or 2 seconds. Zs falling all around...

CUT TO:

On the bikes. Fast. Weaving between packs of Zs. And when they pass, Zs begin searching wildly for the hints of noise. The Fuel Truck driven by Speke roars by, Speke WHOOPING out the window to draw Zs to him.

INT. C-17 - MOMENTS LATER

All three soundlessly up the ramp. Get off, turn to see if they were followed - *at that very moment one of the explosions from the battle whites-out our goggles.* Unknown tense seconds as we cringe, our POV slowly fading back in.

SEAL unslings a silenced rifle. Gerry does too, fidgets with the safety, scared as he and SEAL step quickly/gingerly back to edge of the ramp to provide cover for Speke...

EXT. FUEL TRUCK - SAME MOMENT

Speke fearless. Climbing on top of the truck, clamping the fuel line in place. Jumps down to flip a switch to begin the pump - but a Z that he had run over, ground into in the undercarriage, *bites Speke's shin.* At normal volume:

SPEKE
Oh you God damn cheater.

Speke falls just as the jet engines begin their big wind-up.

INT. PRISON - NEXT MOMENT

With Ellis and the Snipers. They see Speke fall...

A CHORUS
NO-NO-GOD-NO-

ELLIS
-shoot before he turns-somebody get him before he goes-I can't do it-

EXT. C-17 -NEXT MOMENT

Just as they get to open cargo door, *they see Speke down.* And as he's getting back up, firing like mad, *he's hit with multiple muzzled hisses.* Both Gerry and the SEAL stunned, but now Zs are coming for the plane, drawn by engine noise. Both let loose bursts at the knees and legs of the nearest.

Co-Pilot comes running back to them, points to the bowser:

CO-PILOT
IT'S NOT PUMPING!

SEAL Commander turns to Gerry without a hesitation:

SEAL COMMANDER
Israel better payoff...

And SEAL sprints into the fray, toward the Bowser...

INT. USS HARRY TRUMAN SLEEPING QUARTERS - TIME UNKNOWN

Karen stands in front of her children, holding Rachel especially tight. Parajumper standing nearby. Thierry in a heated conversation with two Marines:

MARINE #1
Her daughter is a Quisling.

Karen looks at Thierry - what is he talking about? Thierry puts his hand on Karen's shoulder.

THIERRY
Humans mimicking Zs. A way to cope. And it's happening enough that there's a name for it-

KAREN
(trying to stay calm)
-it's okay. She's fine. She's just seen things in the last few days - she just needs some *time* to process-

MARINE #1
-ma'am, there's a clean hold in the Brig for just this. For her safety.

-Karen quickly scrawls the word ALIVE across a pink stocking cap with a magic marker. A mother's ingenuity.

KAREN
She'll wear this everywhere-

MARINE #1
(apologetic)
it won't do.

THIERRY
Gentlemen, I take responsibility for this family as if they were my own.

MARINE #1
-all due respect-

THIERRY
-which is code for 'no respect'-

MARINE #1
-teams we've sent out come back with bad news or don't come back at all.
(beat)
People are tense. If her girl snaps at the wrong time-

KAREN
-please don't separate my family...

ESTABLISHING (GETTING A BREATH AFTER KOREA)
The Antonov flies through the air as NIGHT GIVES WAY TO DAWN.

INT. COCKPIT - ANTONOV - FLYING - DAWN

ON GERRY. Back in the air, safe. He removes his headset, digs out the SatPhone – Turns it ON.

ONE BATTERY BAR. Gerry turns to the Pilot -

GERRY
You wouldn't happen to have a charger for this?

The Pilot just stares. Nope. Gerry shakes his head - BOOP - Brings up the DISPLAY - "Home."

PILOT
What do you hope to find in Israel?

GERRY
Some answers.

PILOT
The answers were supposed to be in Korea.

GERRY
Well now they're in Israel.

PILOT
Who with?

GERRY
I have someone in mind. I just hope he's still there.

INT. ARGUS - NIGHT

ON Karen. Her eyes wide open as the girls sleep on the bunks next to her. Her SatPhone buzzes. She grabs it, sits up, answers:

KAREN (INTO SATPHONE)
... Gerry?

INT. COCKPIT/ARGUS - INTERCUT

Gerry can't help but SMILE when he hears her voice.

(Note: What follows is the difference between how they sound and how they act- each putting on a face for the other.)

GERRY
... Hey, baby.

KAREN
Jesus... Thank God - I tried to call you.

GERRY
Yeah, I know. Uh... Bad timing.

KAREN
Are you okay?

GERRY
Oh sure... A little tired from all the running around.

KAREN
That's the spirit.

GERRY
So listen... Korea didn't work out.

Karen clenches a fist to her mouth, stifles her frustration, catches her breath.

KAREN
So what's next?

GERRY
Israel.

She sags, regroups.

KAREN
Try to get some sleep on the way.

GERRY
How are the girls?

Karen looks over, sees them SLEEPING -

KAREN
Getting lots of attention. A ship-full of parents who don't even know where their own kids are.
(lowering her voice)
I think Rachel understands how bad this really is.
(beat)
Is anything else still out there?

ON GERRY. Looking out the cockpit window, dark sky turning orange. And in the far distance:

TWO MUSHROOM CLOUDS

A moment later, the phone hisses and the signal drops completely, along with the instruments on the plane. Our heart skips a beat, then the plane recovers from the effects of the distant radioactive blast.

Gerry looks at the phone in his hand as it reboots. The single word on the screen:

HOME

INT. USS HARRY TRUMAN SLEEPING QUARTERS - NEXT MOMENT

Karen's Sat-Phone on the floor, ringing. But no chance of it being heard: *the scene has devolved into small-scale chaos while*

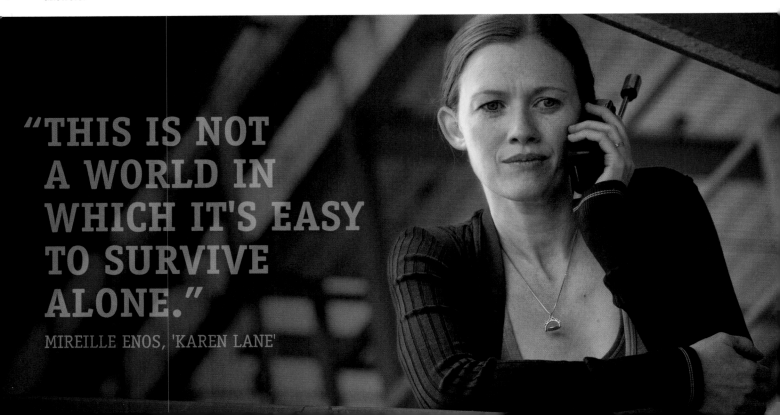

"THIS IS NOT A WORLD IN WHICH IT'S EASY TO SURVIVE ALONE."

MIREILLE ENOS, 'KAREN LANE'

we *were away*. The Marines are trying to grab Rachel, whisk her away. Thierry tries to protect Karen - a man of peace reacting to violence. In the melee, Thierry is thrown to the ground, *hard. And then he begins clutching his chest.*

MARINE #1
MEDIC! MEDIC!

Parajumper puts himself between the other Marines and Rachel.

PARAJUMPER
BACK UP!

INT. C-17 COCKPIT - SAME MOMENT

Phone just keeps ringing. Gerry finally hangs up. Powers it down to save the battery. Then can only sit back. Engines

deafen...

INT. C-130 - ISRAEL – DAY

As Gerry unbuckles his seat-belt:

GERRY
(to pilot)
Stay with the plane and be ready to go. I'll be back before dark.

We stay with the Pilot as Gerry moves out. The Pilot watches him go. Are we sure we trust this guy?

EXT. ROAD - DAY

Overhead shot of a military vehicle flying down a narrow street that feels like a trail through a canyon: high man-made walls on the left and right. Camera pulls up until

we see an entire city spreading out before us...

In white font: Jerusalem

EXT. JURGEN WARMBRUMM'S COMPOUND - DAY

Establishing. Wrought iron gates that soldiers pull open to allow the two vehicles up a narrow alley/driveway.

INT. STAIRCASE/HALLWAY - MOMENTS LATER

Gerry following SEGEN upstairs, eyes peeled, taking in a flurry of activity: soldiers in full regalia and civilians in disheveled professional dress rush past on the stairs. All is loud and rushed and bustling.

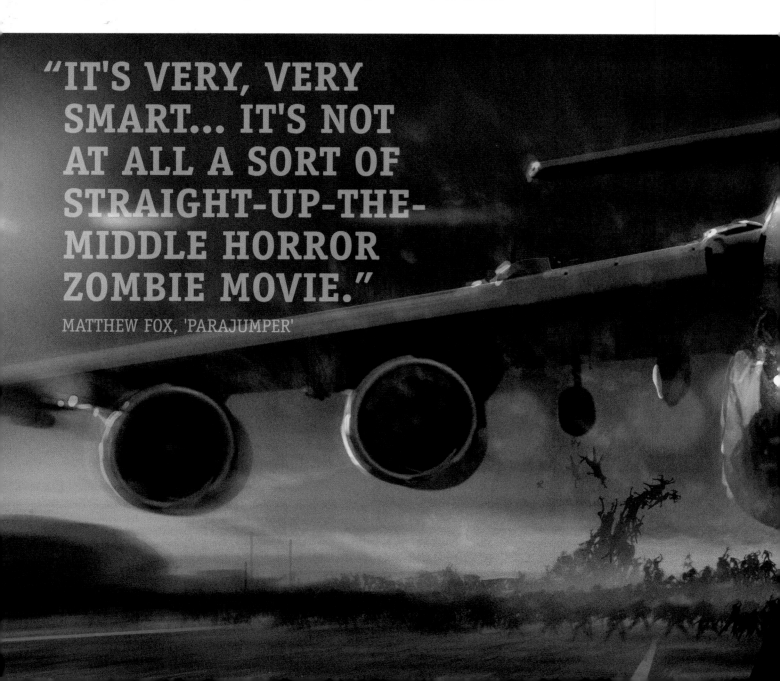

"IT'S VERY, VERY SMART... IT'S NOT AT ALL A SORT OF STRAIGHT-UP-THE-MIDDLE HORROR ZOMBIE MOVIE."

MATTHEW FOX, 'PARAJUMPER'

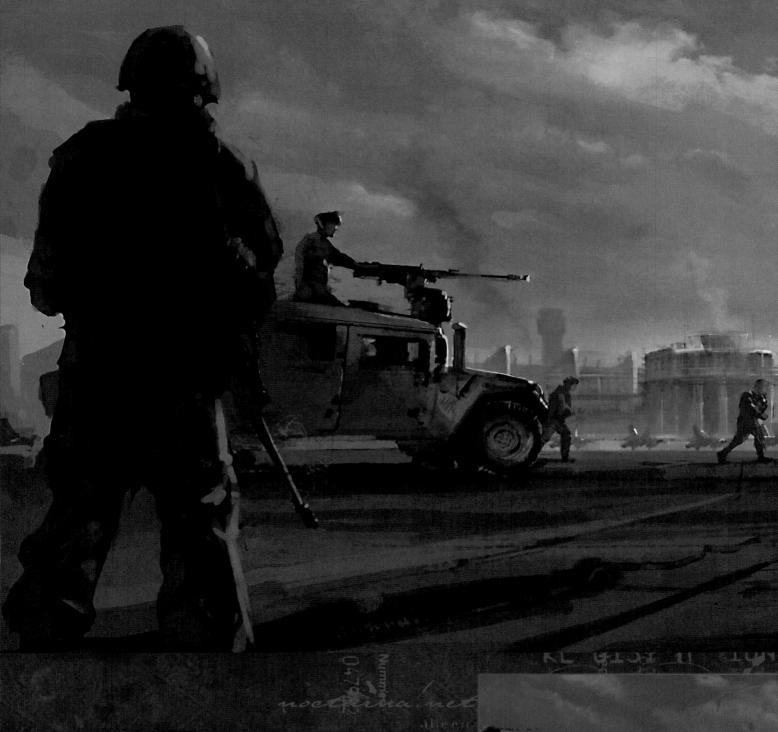

JERUSALEM

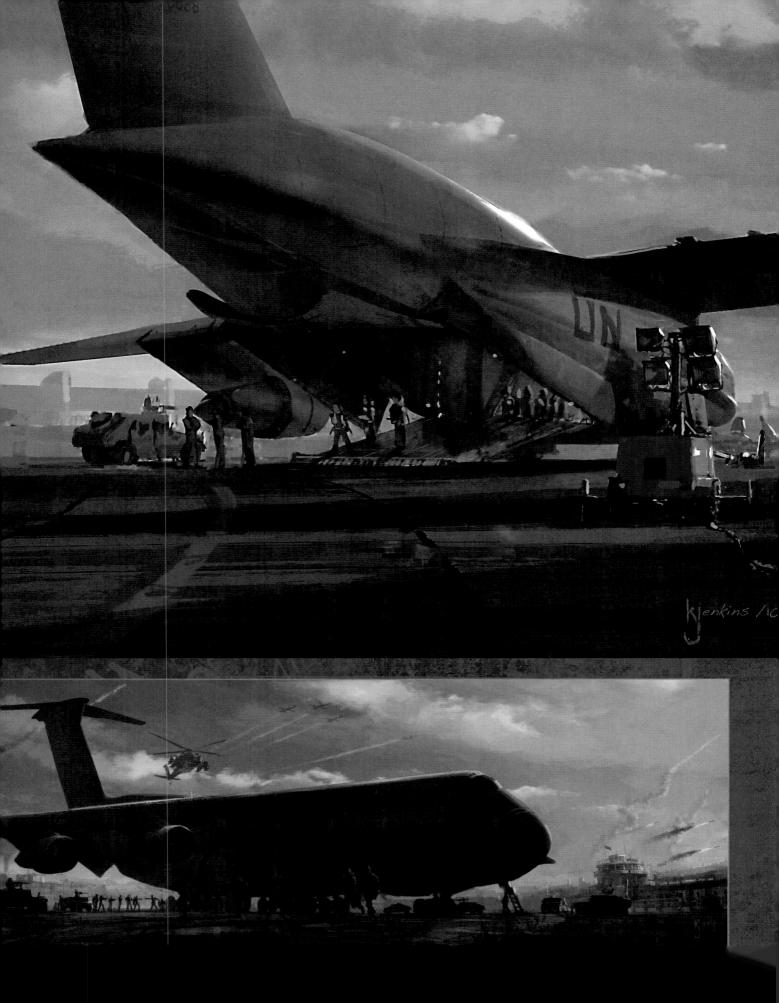

kjenkins /10

INT. WARMBRUMM'S OFFICE - MOMENTS LATER

Quiet. Gerry standing in the middle of an office watching as JURGEN WARMBRUMM fastidiously makes coffee. Mid-conversation:

JURGEN
The problem with most people is that they don't believe something can happen until it already has. That's not stupidity or weakness, that's just human nature.
(looks up)
Sugar?

GERRY
Black.

JURGEN
Good trade-craft.

GERRY
How did you know?

Hands a cup to Gerry, who can't help but stare at the steam:

JURGEN
(smiles)
Gerald Lane. You wrote the self-defeating Jeremiad about your employer, the UN,

back in 2000 that caused a few small ripples? Sidelined your career?

Gerry just nods 'yes.'

JURGEN (CONT 'D)
Thought you'd have parlayed those ripples into a self-righteous book that oversimplified things.

GERRY
No nose for profit. How'd you know?

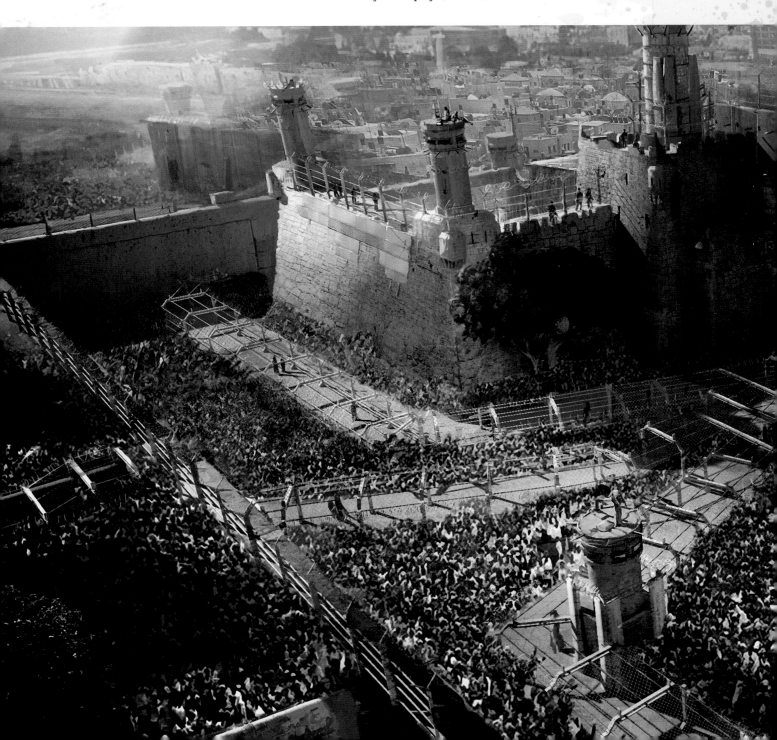

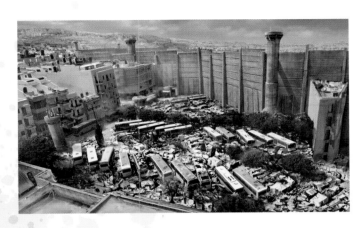
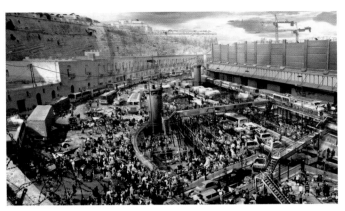

"IN ISRAEL, THE ZS [HAVE] AN ADDED TWITCHY-NESS AND MALFUNCTION TO THEIR MOVEMENT."

ANDREW R. JONES, ANIMATION CONSULTANT

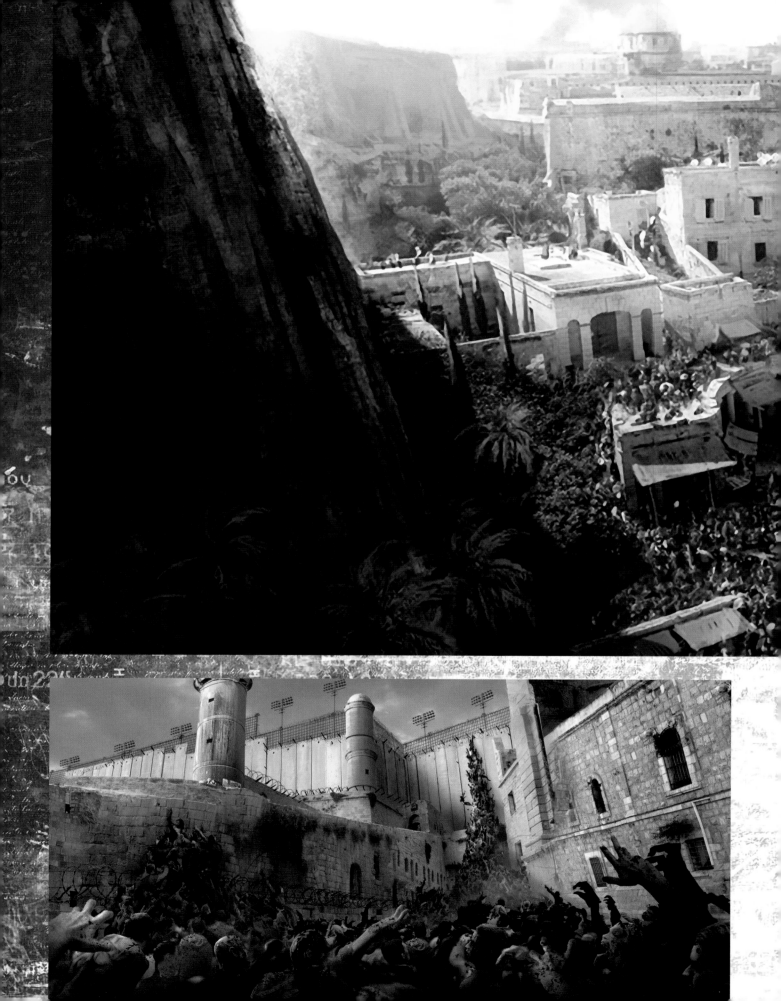

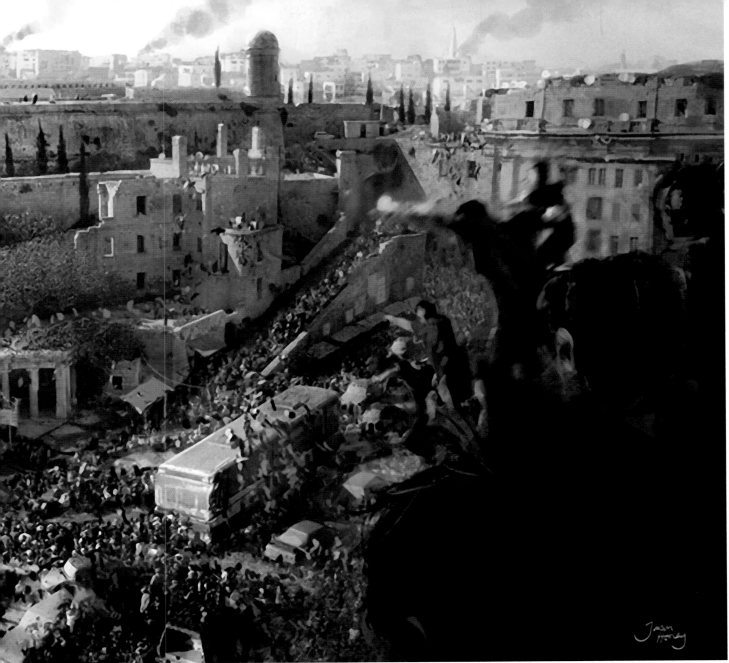

🔘 *This spread: Artwork showing the siege of Jerusalem.*

JURGEN
(beat)
We intercepted a communique from a Chinese General to a North Korean General. It was a warning to the North Korean that the Chinese were fighting the Jiang-Shi. Guess the translation?

GERRY
Zombies

JURGEN
Technically 'Undead.'

Jurgen sips. Gerry waits for more...

JURGEN (CONT 'D)
End of story.

GERRY
(beat)
Jurgen Warmbrumm. High ranking officer with the Mossad. Described to me once as 'sober, efficient, but not terribly imaginative.'

JURGEN
When did you meet my ex-wife?

GERRY
And yet you build a Wall to enclose your entire country because you read the Chinese word for 'Zombie' in a letter?

JURGEN
When put that way, I'd be skeptical as well. Were I not a Jew.

INT. MILITARY VEHICLE – DAY

Jurgen driving. Gerry in the passenger seat. Segen in a vehicle behind.

JURGEN
In the '30s Jews refused to believe they were being concentrated into Camps. In 1972 we couldn't fathom we'd be massacred at an Olympics. In the months before October, 1973 we saw footage of Arab troop movements but unanimously agreed they didn't pose a threat. A month later, the Arab attack almost drives us into the Sea. So we made a change.
(beat)
The 10th Man. If nine of us look at the same information and come to the same exact conclusion, it is the responsibility of the 10th man to disagree. No matter how

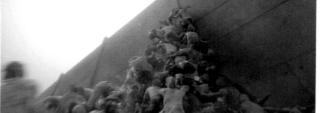

improbable it may seem, the tenth man has to start digging on the assumption the other 9 are wrong.

GERRY
And you were the l0th Man.

JURGEN
Precisely.

Coming to a heavily armed/fortified military barricade blocking the road. Vehicle stopping. Gerry and Warmbrumm get out. Segen trailing.

EXT. STREET - DAY

JURGEN
Since everyone assumed this talk of 'Zombies' was cover for something else, I began my investigation on the assumption that when the

Chinese said 'Zombies,' they literally meant 'Zombies'.

GERRY
Then did this start in China?

They enter family home and walk through to kitchen.

Family eating dinner.

JURGEN
That's a narrative many people would believe.
(MORE)

JURGEN (CONT 'D)
But then most people decide in advance what it is they're going to believe.
(to the family)
Shalom, shalom.
(back to Gerry)

You have a family?

GERRY
And I left them on a flight deck in the middle of the Atlantic.
(ducking through door)
So I want to know what you think. Did this start in China?

INT. DOG HOUSE/HALLWAY - NEXT MOMENT

JURGEN
I don't know where it started.
(beat)
But you know the first communique emanated from there. You know China went dark as this was happening. And there is reason to believe Chinese Forces are moving on their neighbors.

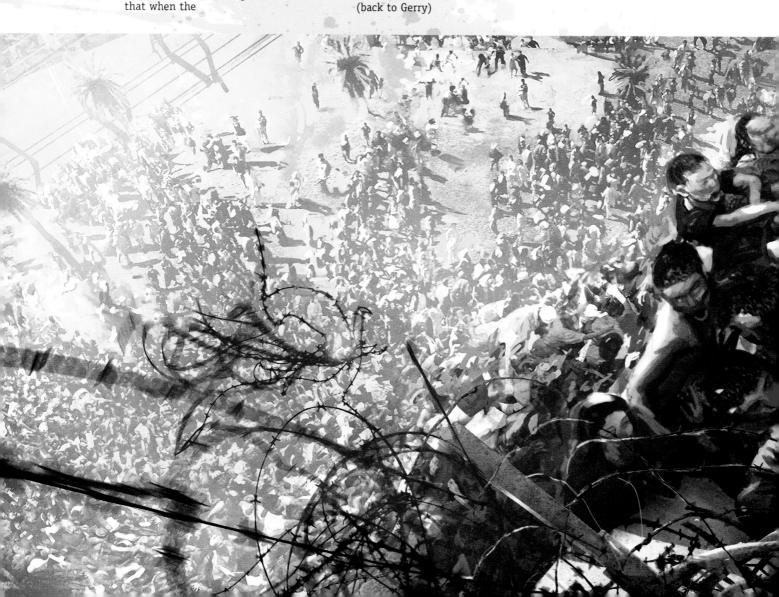

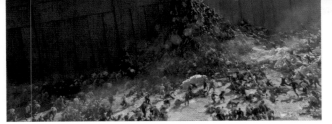
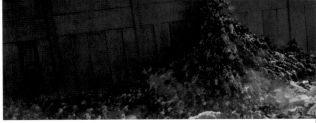

EXT. BUILDING/COURTYARD - MOMENTS LATER

> **GERRY**
> China's attacking their neighbors?

> **JURGEN**
> Everything is a guess at this point.

Gerry spins...adding things up...then:

> **GERRY**
> (brass tacks)
> Wait. If China is able to attack its neighbors, it follows they must have figured this thing out. Yes?

Jurgen just sort of shakes his head, stays quiet: sees that Gerry is unyielding. A dog with a bone.

> **GERRY (CONT'D)**
> When did you intercept the Chinese Communique?

> **JURGEN**
> (beat)
> 3 months ago.

Gerry blanches at that: 3 months? 90+ days?

INT. HALLWAY - NEXT MOMENT

> **JURGEN**
> And, yes, we did share it with all of our allies.

EXT. BALCONY - BRIGHT DAY

Stepping out into bright sunshine. Eyes adjust. *Overlooking BUS LAND now:* a Transportation Depot filled with all manner of buses disgorging steady streams of the recently saved - many crying with joy, kissing the ground before happily getting in-line in front of large tents with both Red Crosses and Red Crescents painted on: *medical checkpoints*. The rumble of Military Jets and Helicopters: low, loud. Gerry's eyes wide now with amazement, maybe even envy...

> **JURGEN**
> These are the Jerusalem Salvation Gates: 2 of 10 portals through the Security Perimeter, into fortified Israel.

And we see from where these buses keep coming: side-by-side archways cut into the ENHANCED SECURITY WALL (ESW), leading into BUS LAND. The ESW looms like a uniform butte, 100 feet high, stretching across frame. Nothing less magnificent than a new Great Wall to fend off new hordes. Gerry still astounded at the scope

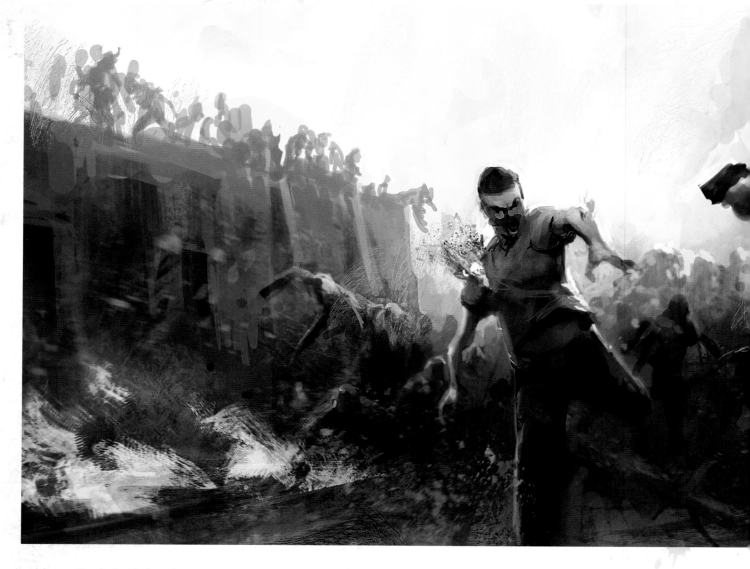

and *humanity* of what he's seeing.

GERRY
You're letting people in. Palestinians and Arabs...

JURGEN
Every human being we get behind the Wall is one fewer Mekaver to fight.

EXT. MOBILE COMMAND POST - NEXT MOMENT

Walking through BUSLAND now. Come to the middle. IDF Generals and Civilian Officials behind sand-bagged machine guns, just in front of three large, old PA speakers set atop 10-foot stands. Two Generals monitor camera feeds from the other side of the wall.

JURGEN
In a War where your Allies fall first, it's in one's self-interest to begin courting new friends.

GERRY
I hope it works. I truly do.

Off to our left, a GROUP of young men suddenly, steadfastly, *not* getting into the Medical lines. Two of the Generals turn. An IDF Platoon approaches this GROUP refusing to get in line.

Gerry and Jurgen focus on this inchoate protest now. The IDF Platoon has attracted even more local attention: the Group refusing to get in-line triples from 10 to 30 in a blink. Palestinian Authority (PA) Units step in now too as the Crowd begins chanting something garbled. *This is a Tinder Box.*

Chanting doubles in volume as 30 people become 60. Soldiers manning the machine guns swing barrels toward the scene. Chatter squawks from every walkie-talkie. Two different Generals disengage the safeties on their sidearms. Jurgen puts his hand on his stomach: ulcer.

Two teenage girls in Hijabs hustle toward the Command Post, *fearless*. Everyone in the Post instantly edgy. The girls stop, scanning for something, one *grabs a MICROPHONE from a table*. One of the Civilian Officials nearby flinches at her move - the girl in the Hijab sort of gently touches his arm: *it's okay*, then flips on the mic, hands it to the other as General #2 aims his gun up, ready to fire a warning shot when the Girl holding the mic starts *SINGING*... no sound though...

Everybody in the Command Post stares a moment. General #2 puts his gun away, *flips on the power to the Speakers...*

SPEAKERS come alive *with the Girl's youthful voice*...people turn to spot from where this voice is coming, and what it means...and very slowly others begin joining in...small smiles between Gerry and Jurgen. Then Gerry back at it:

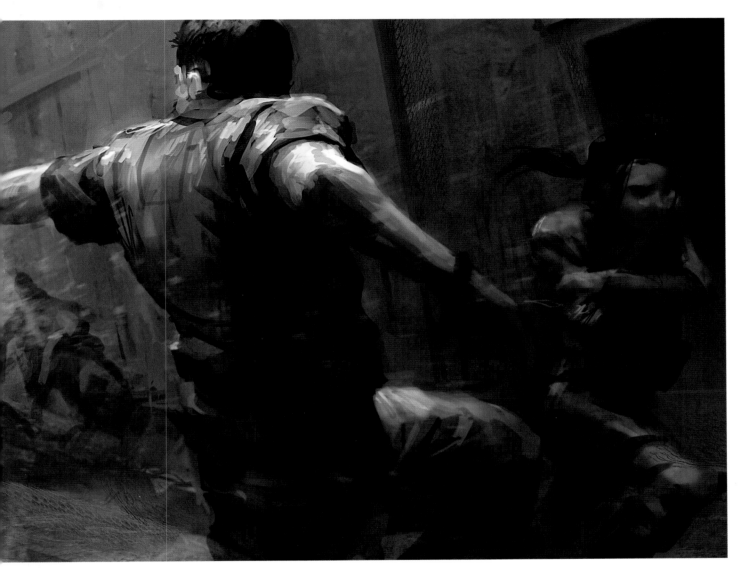

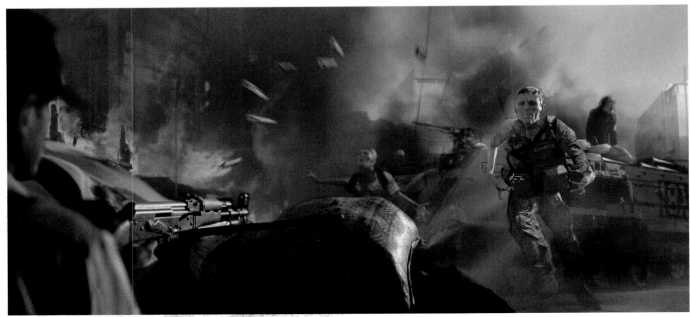

GERRY (CONT'D)
If I could get into China, where would I
go? You know any names I-

JURGEN
-China is a *black hole, Mr. Lane.*
If it's overrun you're in trouble – if it's
not overrun, you're in bigger trouble:
the entire place went dark to cover
something.
(beat)
Go home to your family.

Gerry pauses a second...

GERRY
If I can get there, I have to go. Because it's
too late for me to build a Wall...

Jurgen can't help but be impressed with
the Man's pursuit of a goal that seems at
best futile, at worst deadly. Sees the raw
materials of another 10th Man: *someone
who keeps digging no matter how unlikely
it may seem.*

And now hundreds are singing the peace
song *"Od Yavo Shalom Aleinu."*

IDF and PA platoons smiling, dumbfounded,
some still stonefaced, scanning to make
sure this isn't a trick. General #1 cries.
General #2 keeps patting #1's back.
Warmbrumm: a disbelieving smile. Gerry
too. Glorious, silver-lined moment.

Gerry walks towards the singing. Jurgen
follows him, even joins the song. Gerry
turns to him, still smiling - *just behind his
turned head something PLUMMETS through
frame,* lands on the roof of a Bus near
the base of the ESW with an enormous,
abbreviated crash...

Most of the revelers don't even hear it.
But those in the vicinity, Gerry and the
Command Post among them, get QUIETER
as they turn, scan, trying to identify what
the hell that sound was. Gerry and Jurgen's
smiles fade now as their eyes go to the
Wall, then travel to the ESW's crest, *just as
two more figures -Zs- bomb through frame,
hit that same bus.*

Many more revelers hear this double impact.
Celebratory volume drops noticeably.
The little girl on the Mic though remains
heedless, still singing, still beautiful, *but
now it sounds like* a dirge. *5 more Zs drop
now,* hammer that same bus: roof totally
pancaked now.

One of the Helicopters hovering just above,
and on the other side of the wall - the Z side
- OPENS FIRE. The whole world FLINCHES,
the Singing dies, then the whole world
begins moving backwards - not panicked
yet, but getting away.

We see a video feed from that very same
Chopper: what looks like a PYRAMID of Zs

forming *up* the wall - how a fungus climbs
a vertical face - at astonishing speed.

EXT. THE OTHER SIDE OF THE WALL -
SAME MOMENT

The 100-foot ESW stretching to either
horizon. Thousands of Zs arrayed against
the Wall, but at a point just opposite BUS
LAND, *this PYRAMID forms.* Zs converging
now from all points, like some primal
signal has spread instantaneously.

That same Helicopter shoots again: *into the
mid-point of the PYRAMID as it climbs faster
than we thought possible.* Zs above this line
of fire plummet back down as the Pyramid's
structure fails - reminds us of Skyscrapers
falling.

And as it crumbles, graffiti art of a Girl
jumping for a balloon just out of her grasp
suddenly reveals itself - *but not for long as
the Z Pyramid rebuilds itself right before our
eyes,* even faster now, converging on this
one point.

EXT. BUS LAND CELEBRATION - SAME
MOMENT

More Zs fall. People can see the inevitable,
start running to the buses. And a steady
stream of Zs begins dropping from the top
of the ESW - the first ones over now offering
a macabre cushion to those falling after.
Zero-sum, animal intelligence at work -
we're dealing with a different species.

A dozen Zs from the most recent batch
STAND UP now. The sounds of machine
guns and pistols come alive. Masses who
can't get on buses sprint toward the Old
City now, gathering numbers of Zs on their
heels. And as everything is failing, *Gerry
again sees something he can't explain about
the Zs, something that feels like deja vu:* this
first phalanx of relatively mobile Zs run/
limp right past an 80+ year old Palestinian
Man to get at a cluster of college-age kids.

The old man just scans all around him,
wide-eyed terrified, jostled by the Undead,
but not attacked. But respite is temporary.
Seconds later, *but only after the Zs have
attacked all the younger victims,* do they
seem to notice him. And when they do,
there isn't nearly as much interest as
only a few Zs compete for the bite, albeit
viciously.

GERRY
THEY HIT THE YOUNG FIRST...

The Command Post fleeing toward the Old
City now too. Segen, the IDF platoons, as
well as the PA troops follow, backpedaling
as they try to stanch the Z advance.

GERRY (CONT'D)
(to Jurgen)
DROP BOMBS OUTSIDE THE WALLS UNDERLINED BEHIND

THE Zs - DRAW THEM OFF!

Warmbrumm stunned though, not hearing
anything as his project and hopes fall to
pieces before his eyes, and with it most
likely his country. He turns to Gerry,
staring blankly...

GERRY (CONT'D)
JURGEN ! THE MEKAVER OPERATE ON
NOISE, BOMBS DROPPED BEHIND MIGHT
RELIEVE PRESSURE-

-General #1 hears Gerry, begins speaking
into a handheld. Jurgen sort of snaps to
now, grabs Segen, nods to Gerry:

JURGEN
Take him West - New Gate or Jaffa Gate -
they'll be the last to fall. *Your life for his.*
(to the other Generals)
NOTIFY THE MATKAL-

-A vehicle pulls up, Warmbrumm jumps
right in-

JURGEN (CONT'D)
-TELL THEM TO AUTHORIZE THE CLOSING
OF THE CITY OR WE LOSE THE COUNTRY-

-Vehicle roars off as the sound of bombs
dropping from jet aircraft fill the air.

EXT. OLD CITY GATE – DAY

Gerry following Segen, an IDF platoon, and
masses of others now fleeing for their lives
into the Old City, through narrow gates
that create a sort of crushing funnel effect.
Segen barks at the IDF Platoon in Hebrew,
taking command of them, as we sprint to
not get caught in the crush.

EXT. THE OLD CITY - DAY

And just get through. Running now with
this Platoon into a deserted, ancient, side
street, more fencing overtop. Segen leading
the way. Expert. In addition to their assault
rifles and standard kit, several of these IDF
Soldiers have shotguns across their backs,
machetes strapped to hips.

And now the Zs, *PROPAGATING faster than
we can move through the City,* begin raining
down in 1s and 2s onto that fencing from
the tops of the nearby ancient walls and
buildings. Just ahead several Zs actually
hit, *then break right through the fencing.*
Segen barks in Hebrew:

SEGEN
KEEP MOVING!
(points at Gerry)
HE STAYS IN THE MIDDLE OF US.

Platoon engages this pack of Zs: a mix of
what used to be Hasidic Jews and young
Palestinians in green surplus army jackets,
attacking us shoulder-shoulder now.

CLOSE ON: A tiny pile of empty vodka bottles.

CLOSE ON: Gerry unspooling a strip of gauze from a medical kit.

CLOSE ON: Segen's wounded arm, tightly wound with a field dressing. Gerry ties it off. He presses her forearm to her chest. She nods, catching her breath.

GERRY
Name's Gerry, by the way.

SEGEN
Segen.
(re: her arm) Are you a doctor?

He shakes his head.

SEGEN (CONT'D)
How did you know?
(off Gerry's look)
Cutting it off. How did you know it would work?

GERRY
I didn't.

Segen nods, utters something in Hebrew.

GERRY (CONT'D)
What?

SEGEN
"Your life for his." The last thing Jurgen said to me... Funny, no?
(re: arm)
Now I'm just a liability.

PUSH IN ON Gerry, struck by a thought. He blinks. PROCESSING.

FLASH - SPEKE AHD ELLIS IN KOREA JAIL CELL

GERRY
That how you tweaked your leg?

ELLIS
No. Shit's been bugging me a while.

SPEKE
(about Ellis)
This Asshole stands right in the mix... But no, Zeke didn't have any time for Old Dirty Bastard here.

ELLIS
Ain't it obvious I'm charmed?

FLASH – THE STREETS OF JERUSALEM

The THIN BOY COWERS as a horde of Zs runs for him...

FLASH - FASSBACH ON THE ANTONOV

FASSBACH
... *Sometimes the thing you thought was the most brutal aspect of the virus turns out to*

be the chink in its Armor.

THEN PARTS LIKE THE RED SEA.

BACK ON GERRY – IN THE EXIT ROW – REAL TIME

Gerry digs into his jacket, pulls out the SatPhone, powers it up.

FLIGHT ATTENDANT
(by rote)
Sir, I'll have to ask you to-

Gerry's icy glare silences her. He dials HOME, puts the SatPhone to his ear. As it rings, he notices Segen looking at him, fascinated. Curious.

INT. COMMAND ROOM - ARGUS - RIGHT

THIERRY in the midst of a heated conversation with some MILITARY TYPES. Karen anxiously looks on with the girls among a SMALL CLUTCH OF CIVILIANS - the topic of discussion:

THIERRY
I don't care what our limitations are - we are responsible for the lives of everyone on this ship - whether they are civilians or not-

CHIRPCHIRP. Karen realizes the noise is coming from her pocket, she scrambles to answer.

KAREN (INTO PHONE)
Gerry? Are you okay?

Thierry abruptly stops talking, turns to Karen.

INT. PLANE - FLYING - DAY - INTERCUT

GERRY
Baby, listen. I only have a few minutes. I need Thierry.

KAREN
He's right here. I love you.

GERRY
I love you, too. I'm sorry. You gotta hand over the phone.

As hard as it is to do, she does it. Thierry puts the phone to his ear:

THIERRY
Where the hell have you been, my friend?

GERRY
No time to talk. Battery low... I need some intel on the quick-

THIERRY
-Karen said you were going to Israel?

GERRY
(growing frustrated)

Israel's been overrun. I'm on the one of the last planes out. We need safe passage. A place to land.

THIERRY
Just tell me what flight you're on. We'll get you down.

GERRY
Not good enough. You need to talk to Fassbach's people. Find me a medical research facility... One that makes vaccines. Then put us down as close to it as possible.

THIERRY
I don't understand-

BLEEP. Gerry looks at the phone: BATTERY LOW.

GERRY
No time to explain. Do whatever you have to. Make it happen.

THIERRY
Okay, okay.

GERRY
Tell Karen and the kids I love 'em.

THIERRY
Gerry...

GERRY
Yeah.

THIERRY
I still don't know where you are.

Shit. He almost forgot. LOUD BANGING TAKES US TO:

INT. COCKPIT - DAY

The Co-Pilot opens the door to find Gerry offering his SatPhone.

CO-PILOT
What the hell?

GERRY
You're gonna want to take this.

EXT. SKIES ABOVE MIDDLE EAST - DUSK

The airliner cruises westward toward the sun.

INT. AIRLINER - FIRST CLASS - DUSK

Gerry paces anxiously. The Co-Pilot emerges from the cockpit, a little stunned. He hands Gerry the phone.

CO-PILOT
Your battery is dead.

Gerry looks at the phone, his lifeline severed. But then:

CO-PILOT (CONT'D)
Wales just radioed... They said we're cleared to land at Cardiff.

Gerry sighs, partially relieved. The Co-Pilot offers a slip of paper. Gerry takes it, reads.

CO-PILOT (CONT'D)
They also said there's a W.H.O. research facility about twenty miles from the airport. They can't be sure it's still operational. Best they could do.

Gerry pockets the slip of paper.

CO-PILOT (CONT'D)
What is this all about? Who the hell are you people, anyway?

Gerry looks at Segen, back at the Co-Pilot.

GERRY
I'm afraid we're all there is.

He looks at the phone again, sags a little, stuffs it in his pocket. Shit.

INT. ARGUS - DAY

Karen watches over the sleeping girls, clutching the now useless SatPhone in her hand, staring at the word on the screen:

GERRY

She fights back the tears for as long as she can.

EXT. AIRLINER - NIGHT

Later. As the airliner begins to descend through the clouds, backlit by a full moon...

EXT. AIRLINER – FIRST CLASS - NIGHT

CLOSE ON GERRY: sleeping soundly against the bulkhead, Segen resting against him, out cold.

Drift through the cabin, passengers sleeping, exhausted.

REVEAL:

The Flight Attendant emerges from behind a partition curtain at the back of First Class, coming up the aisle from the galley, carrying two bottles of water. She knocks on the cockpit door and enters as:

CLOSE ON: That SMALL DOG, sitting in his SLEEPING OWNER'S lap. The dog is awake, hopping down, padding along the aisle towards the galley as we:

INT. AIRLINER - COCKPIT - NIGHT

The flight attendant hands the waters to the Pilot and Co-Pilot. We catch a glimpse through the windshield as we emerge from the clouds, seeing moonlit forest below - distant ground lights.

CO-PILOT
[We're starting our descent. Wake the passengers for landing.]

INT. AIRLINER - GALLEY ELEVATOR - NIGHT

A curtain separates business from coach. Just past it, we see a galley elevator. The little dog nudges past the curtain, stops... sniffs... stares up at:

THE ELEVATOR DOOR. PUSH IN SLOWLY on the small, opaque windows. Meanwhile:

PUSH IN SLOWLY ON the dog as it takes a step back, growls...

INT. AIRLINER - FIRST CLASS - NIGHT

FLIGHT ATTENDANT's P.O.V. of the dog as she approaches down the aisle, curious.

INT. AIRLINER - GALLEY - NIGHT

The Flight Attendant rounds the corner, wondering what the little dog is growling at. She parts the curtain, sees the elevator door. She opens it.

REVEAL: Dark and empty. She closes the door. The dog is backing up, still growling. She bends down to pick the animal up. The dog turns and runs up to aisle.

The Flight Attendant sighs. Behind her, we see light through the opaque elevator window now. She turns, steps into coach, pulls the curtain closed behind her when:

Thump... She focuses on the elevator door.

Thump... She opens the door and:
A ZOMBIE LUNGES OUT OF THE DARKNESS.

INT. AIRLINES - BUSINESS CLASS - RIGHT SIDE - NIGHT

CLOSE ON: Gerry and Segen, stirring from a restless sleep to the sound of a commotion in coach. Shouts becomes screams. Gerry is suddenly up with a start. He heads toward the commotion as passengers all around him stir.

INT. AIRLINER - COACH - NIGHT

Gerry emerges through the curtain separating the front of the plane from the back, witnessing an unholy sight: Several Zs - the Flight Attendant among them, are laying into the passengers.

A Z is strapped into a seat in the foreground, snapping at Gerry, only the seat-belt holding it back. Meanwhile:

A wave of Zs is growing exponentially away from Gerry, drawn to the screams of the people trapped in back.

INT. AIRLINER - BUSINESS CLASS - RIGHT SIDE - NIGHT

Gerry turns, looks back at the First Class Passengers as they stir, realize something is wrong, start to make noise. SEVERAL PASSENGERS see Gerry standing there, a stricken look on his face, a finger to his lips.

A WOMAN cries out. HER HUSBAND claps a hand over her mouth. In a moment of wordless fight-or-flight camaraderie, the people in first class realize they are on flying in a deathtrap and have just a few seconds to come up with a plan. Gerry looks around, trying to think.

He lunges for an overhead bin, pulling out whatever luggage is in there. He stacks bags in the aisle. Everyone else gets the idea immediately.

They quickly, quietly get up, wake anyone still sleeping.

INT. AIRLINER - BUSINESS CLASS - LEFT SIDE - NIGHT

Passengers toward the front of the plane grab the heavy food carts from the galley, rolling them down the aisle.

Passengers start building barricades in the right and left aisles that lead to the back of the plane.

They move with increasing speed, stifling panic as the screams in the back of the plane intensify.

INT. AIRLINER - BUSINESS CLASS - RIGHT SIDE - NIGHT

Gerry is putting a last bag in place when:

WHUMP. Something hits the other side of the barricade hard. Gerry steps back, sees a second medical kit in rear-most right-side overhead. He grabs the oxygen tank, ready to use it as a bludgeon.

The Passengers behind him fall into three layers:

Fighting Passengers (ready to confront Zs), Cowering Passengers (confused, frozen with fear), Panicking Passengers (moving toward front of the plane, starting to lose it.)

Among the Fighting Passengers backing up Gerry we see the Man who gave up his seat and the Man who silenced his wife (Male Passenger 1 and Male Passenger 2).

The cabin lights come on, startling everyone.

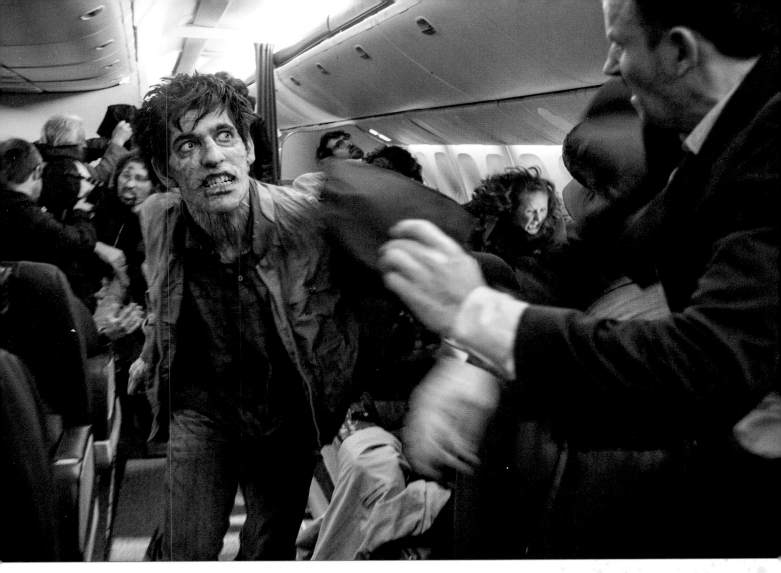

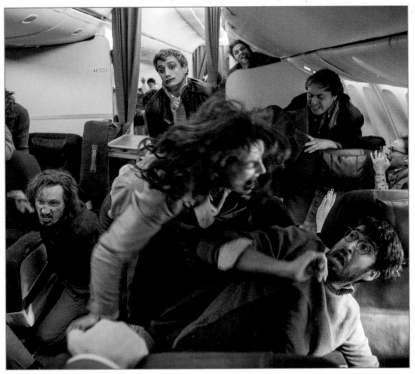

PILOT (ON SPEAKER)
[Flight attendants prepare for cross-check and arrival.]

BOOM. The top portion of left side luggage barricade collapses. Zs try to lunge through the gap. Passengers club them with whatever is on hand.

BOOM. The top portion of the right side barrier collapses. A Z scrambles over the barrier, into business. Gerry clubs it as more Zs scramble through the gap. Passengers move forward to fight them.

INT. AIRLINER – COCKPIT - NIGHT

The Pilot and Co-Pilot hear the chaos over the engines now. The Co-Pilot unbuckles, gets up, looks through the peep-hole.

CO-PILOT'S P.O.V. A fish-eye view of pure carnage in first class. A Z suddenly appears right in front of us, slamming into the door.

The Co-Pilot looks to the Pilot in horror. The Pilot looks ahead to:

PILOT'S P.O.V. Distant ground light coming closer. But not fast enough for his liking...

INT. AIRLINER - FIRST CLASS - NIGHT

The situation is rapidly shifting beyond any sort of control. The majority of Fighting Passengers are drawn to the right side to control the bigger breach.

LEFT SIDE: The Fighting Passengers here have a smaller breach to control - Zs choking the gap until they themselves are a snapping, writhing barricade.

A Z bites Male Passenger 2. He turns as:
RIGHT SIDE: The Zs are slowly driving Gerry and the fighting passengers back. Zs are able to spread to the left side of the plane.

BOTH SIDES: cowering passengers must now choose: Fight or Panic. Most, not all, choose the fight.

Zs attack Gerry and the other Fighting passengers from the left.

CRACK-CRACK. GUNFIRE. THE Z GOES DOWN – REVEAL:

Segen with her pistol, kneeling by the front-most seat. Against all instinct, Gerry moves toward her as she fires directly toward him, killing Zs as they rush up behind him.

Suddenly her gun is empty. She and Gerry press their backs against the bulkhead, in front of the front-most seats. The Zs have overpowered the last of the passengers. Segen pulls out the grenade. Leave the decision to Gerry. No choice. He takes the grenade, pulls the pin, tosses the grenade over the seats. It lands in the third row, right side.

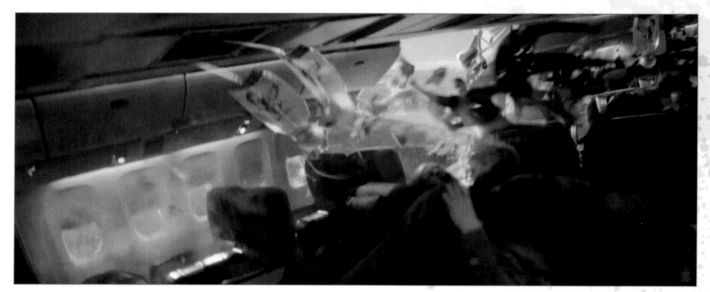

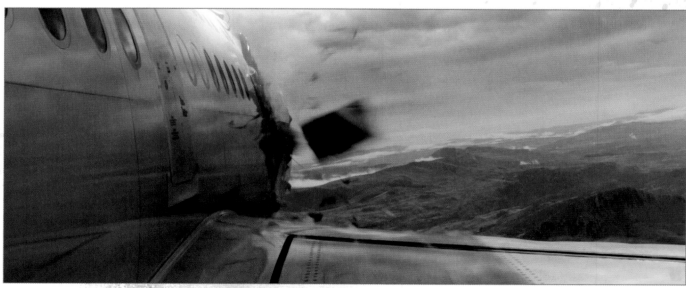

"I HAVE TREMENDOUS RESPECT FOR WHAT'S COME BEFORE, BUT AS A FILMMAKER, YOU ALWAYS WANT TO PUSH BOUNDARIES AND CREATE SOMETHING NEW AND INTERESTING."

MARC FORSTER, DIRECTOR

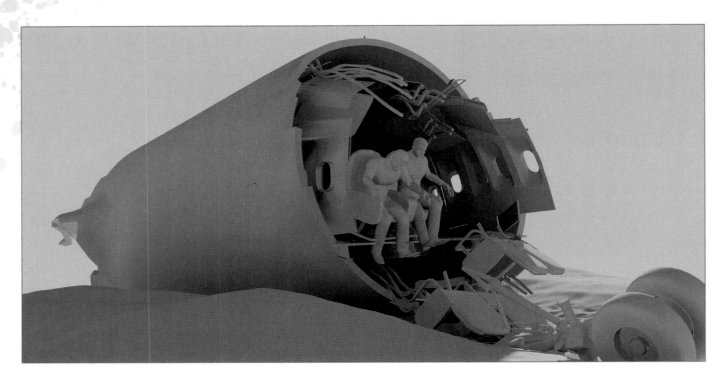

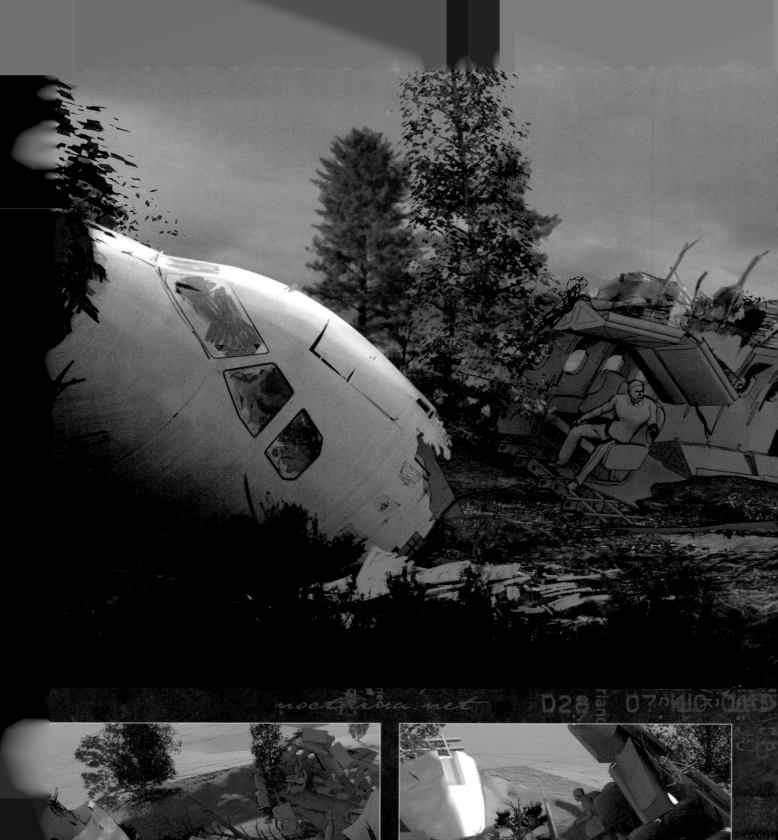

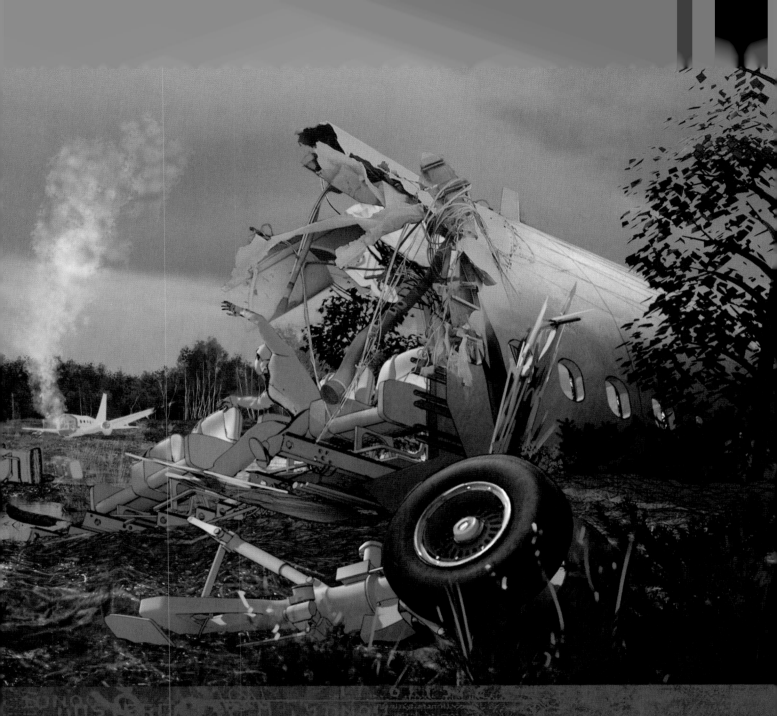

"WORLD WAR Z IS A LARGE SCALE WAR FILM"

MARC FORSTER, DIRECTOR

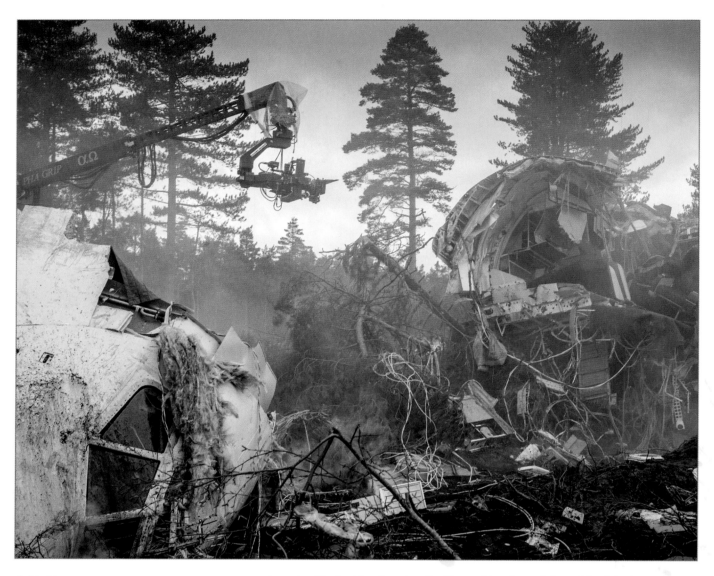

right side.

An earsplitting explosion, strangely denuded by airplane insulation, rocks the cabin. A cloud of smoke and debris is instantaneously sucked out through a breach in the fuselage along with every Z on that side of the plane.

EXT. AIRLINER - NIGHT

Debris and Zs scatter in the jet-stream like leaves, much of it sucked into the engine.

INT. AIRLINER - COCKPIT - NIGHT

An outboard explosion. Alarms, flashing lights. The Plane banks hard to one side. The Pilot struggles to bring it back.

PILOT
[HYDRAULIC FAILURE]

INT. AIRLINER - FIRST CLASS - NIGHT

Gerry and Segen scramble into the front-most seats. He buckles her in. Buckles himself. Gerry looks left and sees:

PASSENGER 1, still alive, buckling himself into one of the front-most center seats.

Gerry, Segen and Passenger 1 slide low into their seats and pray.

A new sound. A sporadic rumbling - growing louder. Faster. Gerry looks back. ANGLE ON:

The hole in the side of the plane - the tops of trees streaking past. Zs are approaching from the back of the plane, sucked out as they try to pass the breach.
Gerry looks to Segen and lies:

GERRY
WE'RE GONNA MAKE IT. WE'RE GONNA BE OKAY.

She looks up at him and nods, deciding to believe him despite herself. And then:

Hands grab him from behind. A Z is on him. Gerry fights with all he has, strapped into the seat as the snapping, savage thing tries to bite him.

(Suggest Passenger 1 is fighting off Zs as well.)

Segen offers what help she can with one hand, but it's not much.

CLOSE ON: The Z, tireless, jaws snapping.

CLOSE ON: Gerry, looking at the hole in the plane, seeing the trees. He just has to hold on a little longer...

The thundering sound of the plane hitting the trees crescendos. The Z opens its mouth wide. Segen screams. And the world goes

BLACK

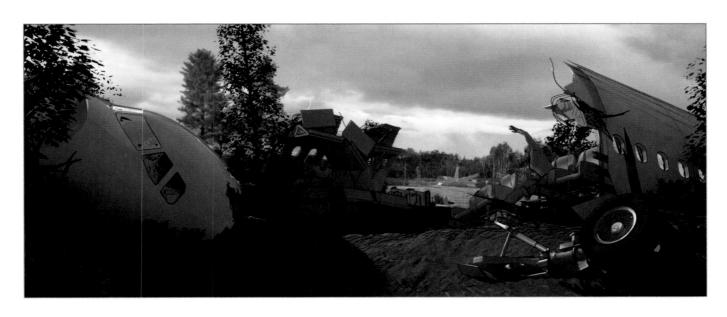

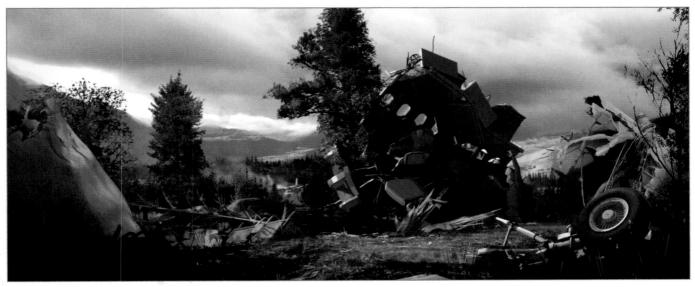

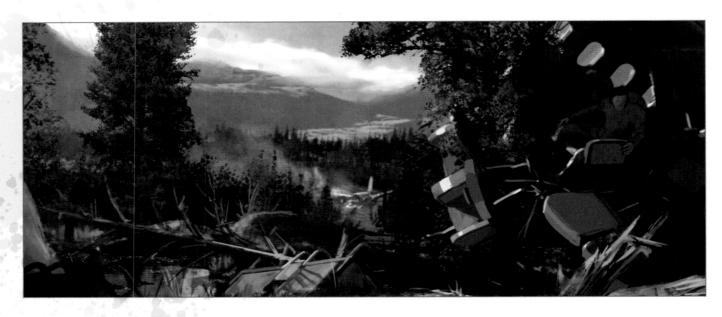

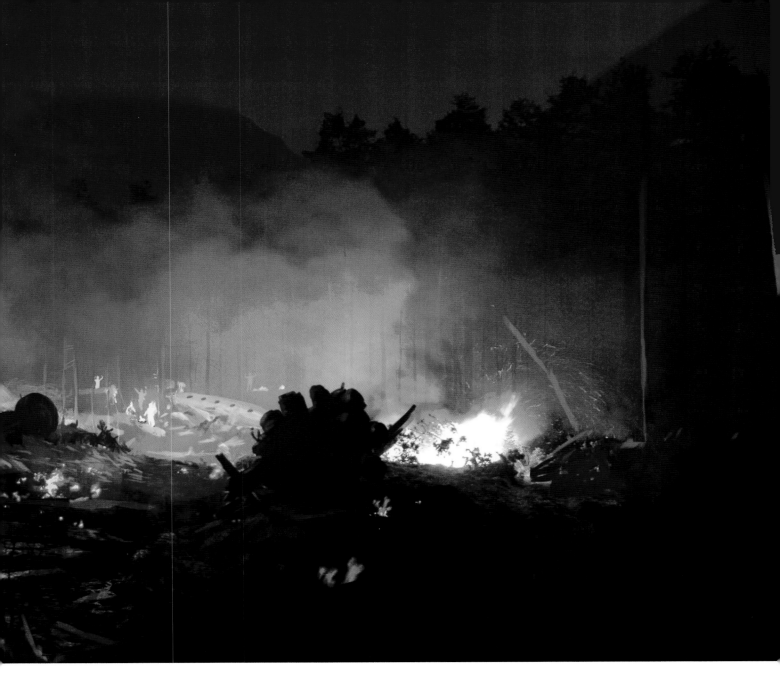

INT. CRASHED PLANE/EXT. WOODS - DAWN

FADE UP SLOWLY ON

Gerry, eyes closed. They flutter open. He looks around and finds himself still in the plane, strapped in his seat. Segen is gone from the seat beside him. He is aware of a strange, repetitive noise. He looks left and sees:

A chunk of the wrecked plane - a Z still strapped into its seat, thrashing rhythmically. REVEAL:

Gerry too is in a chunk of the plane. His face bears a few scratches - otherwise miraculously unhurt. He goes to move, gasps from pain.

REVEAL: A piece of aluminum jutting from the soft flesh in Gerry's left side. He tries to pull it out but just touching it brings intense pain.

Gerry looks up at the night sky - a canopy of trees above him. He is alone, hurt, miles from God knows where. He struggles to pull the phone from his pocket, powers it up. It immediately shuts off. He tries again, no use. Pain, exhaustion and despair creep up on Gerry. This is the end.

The sound of feet shuffling in the undergrowth behind him, coming closer.

Gerry tenses, undoes his seat-belt, tries to move, sucks up the pain. Then:

SEGEN
What are you doing? Are you crazy? You'll kill yourself.

REVEAL: Segen, banged up but very much alive, approaches with a handful of items including ones she learned to use not long ago:

Little vodka bottles.

SEGEN (CONT'D)
Show me what to do.

WALES

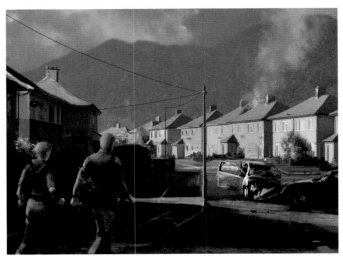

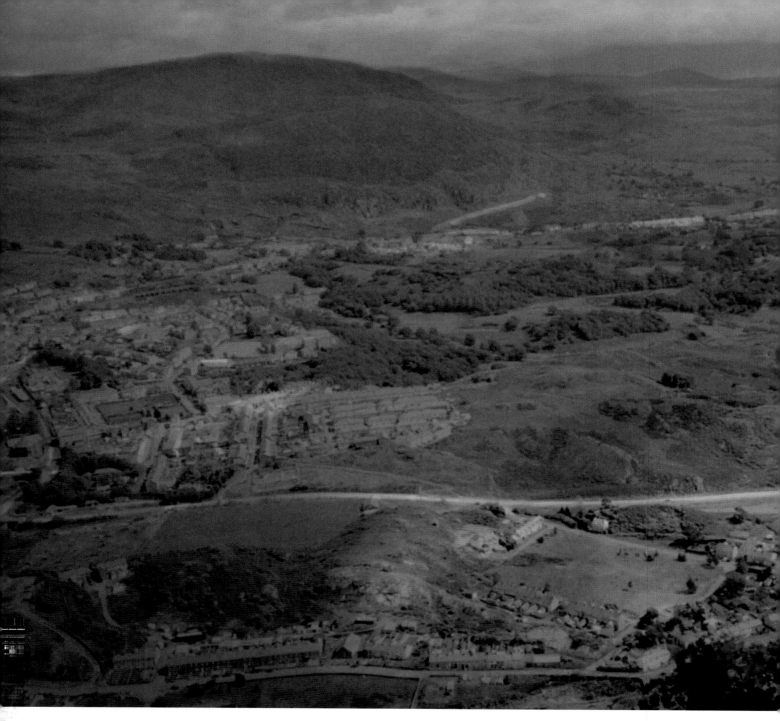

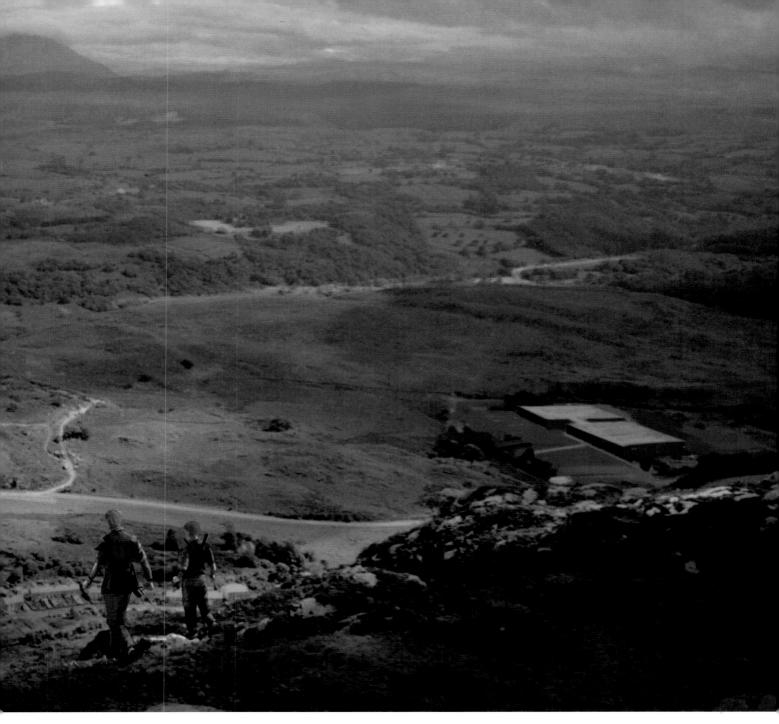

"APOCALYPTIC IN ITS SCALE AND LOSS OF HUMAN LIFE. IT'S A GREAT SCRIPT."

MATTHEW FOX, 'PARAJUMPER'

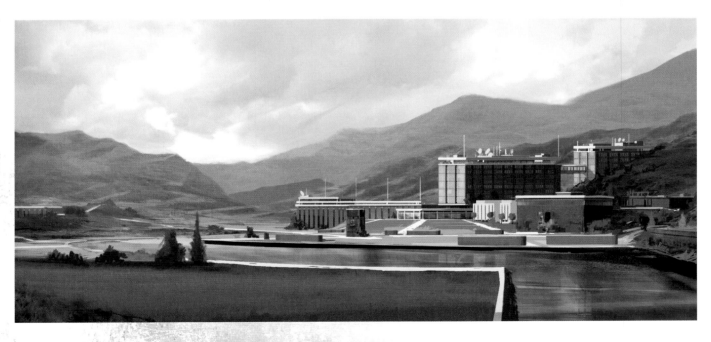

EXT. FOREST - DAY

Gerry and Segen support one another, walking slowly, still in shock. Behind them, the forest floor is surprisingly free of debris except for shattered tree branches and a few bodies. However:

CRANE UP SLOWLY, through the dense canopy, above the treetops TO REVEAL:

The plane has cut a wide swath through the forest just beyond. Trees are plowed flat and the unmistakable shape of the plane's tail section juts from a plume of smoke.

EXT. WELSH COUNTRYSIDE - DAY

Gerry and Segen walk along a county road past a sign reading:

CARDIFF - 22km

EXT. W.H.O. FACILITY - DAY

The RESEARCH FACILITY looms large in the center of a wide, otherwise empty field. It is a stark, monolithic office complex, seemingly deserted. Then:

> **VOICE (ON LOUDSPEAKER)**
> STOP WHERE YOU ARE.

Gerry and Segen halt, look around.

> **VOICE (CONT'D)**
> TURN AROUND AND WALK AWAY.

> **SEGEN**
> Gerry-

He looks at her, she directs his eyes to A LONE SNIPER, aiming at them. They are in the wide open - nowhere to run even if they wanted to.

> **VOICE**
> I REPEAT. TURN AROUND AND WALK AWAY.

> **GERRY**
> Get on your knees.

> **SEGEN**
> What?

> **GERRY**
> Do it.

> **VOICE**
> THIS IS YOUR FINAL WARNING.

They step away from each other and kneel. Gerry puts his hands behind his head, holds his breath.
LONG PAUSE.

The front door of the facility opens. TWO

MEN emerge and walk quickly toward them. As they do:

SEGEN
Are you sure you know what you're doing?

GERRY
They're scientists, not soldiers.

SEGEN
You hope.

GERRY
...Yes.

The FIRST MAN, still walking fast, raises a pistol, aiming directly at Gerry.

SEGEN
GERRY-

CRACK

CLOSE ON: Gerry's face, wincing. PULL BACK TO REVEAL:

A large dart in his chest. A tranquilizer.

GERRY'S P.O.V. As he topples over onto his side, the world fading as the SECOND MAN fires at Segen.
BLACK

INT. CONFERENCE ROOM/MAKESHIFT ER – DAY

Gerry lying in the very same place we found him at the beginning.

CLOSE ON the Brit. Javier. We're back.

BRIT
You know what this place is.

GERRY
Of course I do. That's why I'm here.

BRIT
Then you understand how that must look to us.

Gerry addresses Javier in Italian.

GERRY
[My name is Gerry Lane. Former specialist with the U.N. They told me where to find you. I need to-]

Javier reaches into his coat pocket and produces Gerry's SatPhone. Gerry freezes, suddenly tense.

JAVIER
This is important to you.

GERRY
How long have I been out'?

BRIT
Two days.

Javier powers up the phone. This seems to surprise Gerry. He leans forward ever so slightly. The display shows a string of numbers and one SINGLE WORD:

JAVIER
Where exactly... is "Home?"

Gerry thinks. Can he trust these men? He has no choice.

GERRY
My wife. She's on the USS Argus. If you let me call her, she'll put you through to a UN Envoy who can verify who I am..

Javier studies him, looks at the Brit. After a beat, Javier presses dial, puts the phone on speaker, lays it on the table.

It rings. And rings. And rings. The longer it rings, the more skeptical Javier and the Brit become. And the more Gerry's concern grows. Finally:

INT. ARGUS - COMMAND ROOM - INTERCUT

VOICE (ON PHONE)
Thierry Umutoni.

GERRY
(curious)
Thierry, it's me.

Long pause.

THIERRY (ON PHONE)
My God... Gerry... Oh my God. Where are you?

OF OUR TOP PEOPLE BECAME
WALKING CANNIBALISTIC DEAD,
CH WAS NOT GOOD NEWS."

PALDT, "THE BRIT"

go dark, others crackle with static. On the rest we can see B-Wing belongs to the Zs. It's hard to get a sense of how many - but almost every live monitor has at least a few. Some wander slowly in the halls, others just stand there. Inert. Waiting.

> GERRY
> ... Jesus. How many are there?

> KELLY
> There were thirty people working in B-wing.

> GERRY
> I've haven't seen them move like that.

> BRIT
> They're dormant...waiting for stimulus...

The Brit points to one screen in particular and A GLASS ENCLOSED LAB there.

> BRIT (CONT'D)
> Vault 1-3-9. Where your samples would be...

He points to one of the monitors showing:

> BRIT (CONT'D)
> That is the sky-bridge connecting B-wing to the main building here... And that...

He turns and points to a set of heavy fire doors on the far side of the room. They have been heavily barricaded with steel shelving stacked with cinder-blocks and anything else of real weight.

> BRIT (CONT'D)
> ...is the only thing standing between us and the sky-bridge.

All eyes turn to Gerry. The Brit asks the question:

> BRIT (CONT'D)
> So. What do you propose, Mr. Lane?

Off Gerry's look we GO TO:

INT. DOORWAY TO CORRIDOR BY OBSERVATION ROOM - NIGHT

QUICK CUTS as The WHO staff dismantle the barricade in front of the door to the sky-bridge. Meanwhile:

Gerry prepares for silent running - removing his belt, jacket, objects from his pockets. He wraps his shoes in cloth. The Brit wraps his forearms, biceps and calves in a thick layer of duct tape. When he is finished, Javier holds up a baseball bat and a fire-axe.

> JAVIER
> Each has it's merits...

Before he can choose, A HAND reaches past him and takes the bat. He turns to find Segen, also taped up, shoes padded.

> GERRY
> Where do you think you're going?

> SEGEN
> You forget I have orders. Take the axe.

CLOSE ON Javier, considering. He picks up a roll of tape and starts to wrap his own arms.

> KELLY
> You're not serious.

JAVIER
B-Wing's a maze. They'll never make it
back alone.

KELLY
(re: Gerry)
You don't even know if his theory is
correct?

JAVIER
I know I'm not asking one of you to take
him in there.

The Brit offers a pistol. Gerry considers it.

BRIT
Last resort.

GERRY
The whole object here is to be as quiet as
possible.

BRIT
It's not for the Zs. It's for you.

Gerry shakes his head. No deal. Segen tucks
the bat under her bad arm, takes the pistol,
shoves it in her belt.

JAVIER
Try not to kill one.
(off Gerry's look)
It only makes the rest of them more...
aggressive.

SEGEN
Open the door.

INT. SKYBRIDGE - NIGHT

The door opens. Gerry, Segen and Javier
enter the skybridge corridor. It's quiet. Too
quiet.

JAVIER
If anything comes down this hall before
we do, you seal these doors for good.
Understood?

The Brit looks to Gerry, then back to Javier.
He nods.

GERRY
Sure you wanna to do this.

JAVIER
Of course I don't... Let's go

BRIT
Good luck.

He closes the door with a decidedly final
click and the sound of two bolts sliding into
place. Javier looks to Gerry and gestures
down the skybridge as if to say "after you."

The group walks down the long, narrow corridor. They reach the door at the far end. Gerry opens it a crack to A STRANGE SCRAPING SOUND. REVEAL:

INT. B-WING - CAFETERIA - NIGHT

A soda machine stands half-opened beside a hand-cart loaded with cans. More cans are scattered on the floor in front of the door (hence the scraping noise).

Gerry, Segen and Javier enter the cafeteria to find the husk of the old world - flickering fluorescent lights, rotting food. A single chair knocked over by a blood stain on the floor hints that someone died in the middle of their meal.

As he steps through the door, Javier accidentally kicks a single can of soda. Gerry and Segen freeze as it rolls across the cafeteria.

It bangs into the base of a counter on the far side of the room and comes to a rest. After a beat, everyone resumes breathing.

INT. B-WING – CORRIDOR 1 – NIGHT

One by one, Gerry, Segen and Javier emerge into B-WING.

Fluorescent lights flicker, affording us hints of the horror that occurred here: Claw marks on the walls, blood stains on the floors, broken glass, overturned medical equipment - offices once barricaded, then breached.

All we hear is the sound of the air system quietly exhaling. The silence makes our ears ring.

Gerry looks to Javier: *"Which way?"* Javier gestures down corridor 1. Gerry nods: *"Follow me."*

INT. OBSERVATION ROOM - CONTINUOUS

Brit, Kelly, and Ryan watch the group on one monitor, simultaneously watching Zs on all of the others.

INT. B-WING CORRIDOR - GLASS LAB - NIGHT

(Note: The following is intercut as needed with the observation room P.O.V. Brit, Kelly, and Ryan are on the edge of their seats for the whole thing.)

The solid wall transitions to a glass-enclosed lab. The walls are glass from about waist-high to the ceiling - able to conceal a crawling person. But the two sets of double doors are floor-to-ceiling glass.

Gerry stops at the edge of the glass lab and peers in. Three Zs linger in the lab, drifting. They rotate at varying speeds like undead security cameras.

Gerry looks back at Segen and Javier, a finger to his lips. He gestures with his hand for them to get down, ready to crawl. Segen goes first.

Keeping a lookout, Gerry times the movement of the Zs in the lab carefully. He taps Segen when she can crawl past the glass doors unseen. But she has to be fast unless one of the Zs turns in time to catch a glimpse of her. Hard to do with one hand.

She stops between the two sets of glass doors, looking back to Gerry for the signal. He waits, times the Z's movements until they are all looking away. He nods. She moves. Once past the glass lab, she stands up and presses her back to the solid wall. Safe.

Next is Javier. He crawls, just skirting past the glass doors as:

A Z turns quickly - sensing something. Gerry recoils, pressing his back to the wall. Javier stops, crouching, pressed to the wall, trapped between the two sets of glass doors.

The Z wanders right up to the glass, looking out. It is standing right above Javier on the other side of the glass. We hold our breath. From this angle it cannot see Gerry or Segen. They stand on either side of the glass lab, looking at each other - backs pressed to the wall, holding their breath.

Finally, the Z turns and walks away. Gerry dares to peer into the lab, seeing the Z's back to him. He nods and Javier quickly crawls past the second set of glass doors.

It's Gerry's turn. Segen is the look-out for him now. She holds up a hand. Then signals: "Go."

ANGLE ON: A Z turns quickly, unexpected. Segen quickly holds up a hand to Gerry: "Stop."

They repeat the same motion. It's safe, then it isn't. The Zs are slightly agitated, moving faster, more randomly. Gerry grows frustrated. Finally:

He peers into the lab, times it himself. He runs - not bothering to crawl.

INT. GLASS LAB - LOOKING OUT

Gerry flies past the window a mere instant before all three Zs are facing in his direction. They just miss seeing him.

INT. B-WING CORRIDOR - GLASS LAB - NIGHT

Segen looks at Gerry sternly. "Don't ever do that again."

Gerry shrugs. They move on.

INT. B-WING - GLASS CORRIDOR - NIGHT

A long corridor with a glass enclosed center.

Javier indicates to Gerry that this is the way to go. Before they can get very far:

A Z emerges at the far end of the corridor profile. Gerry and the others freeze - totally exposed.

They quickly back up and around the corner to:

INT. B-WING - STAIRWELL DOOR - NIGHT

Javier opens the door as slowly as he can but:

CREE-

They all freeze. The hinge is louder than a chain-saw.

INT. B-WING - VARIOUS

Follow the sound of the halted creaking noises as it echoes down the halls. Zs that are moving suddenly stop. Zs that are motionless suddenly look up.

They wait for more stimulus while:

INT. OBSERVATION ROOM - CONTINUOUS

Brit, Kelly, and Ryan hold their breath, watching a gradual shift in the Zs behavior. They are slowly waking out of their semi-stupor.

INT. B-WING - STAIRWELL - NIGHT

Gerry and Co wait for the Zs. None come. But the door is open now. Gerry motions for Javier to close it.

CR-

Javier freezes. The slightest motion either way and the door will make a racket. They have a tiger by the tail. Gerry puts a hand on the edge of the door, motions for Javier to step back.

Gerry psyches himself up, coils his arms, counts in his head "1-2-3." He shoves the door open as fast as he can, as wide as he dares, stopping its motion just as quickly. The loud creak is cranked up to an instantaneous high-pitched squeal. There is just enough room for Segen and Javier to squeeze past him.

Once they are in the stairwell, Gerry rests the end of the axe-handle at the corner where the floor and the door-jamb meet. Then he wedges the head of the axe under the doorhandle. He lets the weight of the door rest on the axe, holding it in place.

The door won't close when they leave it. But now Gerry is unarmed. He turns to head down the stairs and finds Segen offering: Bat? Gun? He motions for her to keep both. They head down the stairs.

INT. STAIRWELL EXIT - NIGHT

Gerry opens the stairwell door and peers into the hallway. Just a few feet away he can see a corner and an arrow-sign reading:

LABS 101-150

Unfortunately there is a Z wandering the hallway as well. The Stairwell door is between the Z and the corner. They will have to run for it and hope not to be seen.

Gerry opens the door wide, keeping one eye on the Z's back.

Segen and Javier round the corner, moving quickly. Too quickly. Because:

INT. B-WING - CORRIDOR 1 - NIGHT

Their feet are wrapped in cloth for silence sake. Javier gets too far ahead of himself, starts slipping, tries to recover. In doing so, he drops his crowbar. It lands like a gong.

INT. B-WING - VARIOUS - NIGHT

Zs react to the sound, not moving, but getting a sense of direction...

INT. OBSERVATION ROOM - CONTINUOUS

BRIT
Jesus Christ.

Because he sees:

INT. B-WING - CORRIDOR 1 - NIGHT

CLOSE ON: An unarmed Gerry, just emerging from the stairwell, the corner in front of him, the Z behind him. He turns as:

The Z attacks. Gerry ducks, hits the Z low. It flies over him, scrambling across the floor.

It gets to its feet, turns back on Gerry and:

BANG. The Z drops. REVEAL Segen standing behind it, pistol in hand.

INT. B-WING - VARIOUS - NIGHT

Zs fully reacting now, following the sound. Converging...

INT. CORRIDOR 1 - NIGHT

Gerry rounds the corner just as Segen shoves Javier to run. He has the bat. Gerry scoops up Javier's crowbar without stopping.

They run down the long, narrow corridor as Zs come around the corner at the far end, moving fast.

INT. OBSERVATION ROOM - NIGHT

From this vantage we can see the group running, Z converging.

BRIT
They're done for.

INT. CORRIDOR 1 - NIGHT

Gerry, Segen and Javier rounding a small curve, arriving at:

INT. CROSSROADS - CONTINUOUS

Two stairwells - one left, one right.

GERRY
Which way is the vault?

JAVIER
(pointing left)
That way.

GERRY
(to Segen)
Take him... GO.

Segen and Javier run up the left stairwell. Gerry walks back to the curve, showing himself to the charging Zs. He waits as long as he dares, then:

He turns and runs up the right stairwell, making sure the Zs see him. They all run after Gerry, ensuring Segen and Javier are safe.

INT. CORRIDOR 2 - NIGHT

Gerry runs as fast as he can, skidding to a halt when he sees a maze-like series of three air-tight doors. He weaves through them - no time to pull the doors closed behind him.

A lone Z manages to get through the first door before it closes on the others. This same Z manages to weave through each successive door, hot on Gerry's tail.

Meanwhile, Zs slamming into the outermost door.

INT. LAB - NIGHT

The Z charges into a semi-lit room, searching when:

WHAM

A crowbar slams it upside the head. Gerry on the attack. The Z hits the floor hard, recovers, attacks.

But Gerry is through fucking around. He is standing his ground this time.

INT. B-WING - VAULT CORRIDOR - NIGHT

A long, narrow corridor flanked by glass enclosures on one side. Up ahead, VAULT 139.

Segen and Javier are almost there. Unfortunately:

Zs are coming toward them from the far end of the corridor. The vault is between them and the approaching Zs.

Javier grabs Segen, pulls her back. She resists.

SEGEN
WE CAN MAKE IT.

JAVIER
WE CAN'T.

They turn the other way and run.

INT. OBSERVATION ROOM - CONTINUOUS

Intercut the following action from this vantage - Ryan and Brit watching helplessly as Javier and Segen run for their lives.

INT. CROSSROADS - NIGHT

Segen and Javier run back down the left stairwell.

INT. CORRIDOR 1 – NIGHT

They run back down corridor 1 with Zombies closing in.

INT. STAIRWELL EXIT - NIGHT

They just make it into the stairwell, slamming the door behind them. Zs smash into the steel door.

INT. STAIRWELL - NIGHT

CLOSE ON: The axe left by Gerry. Javier grabs it as he rushes through the door. He and Segen run past.

We linger on the door, left to close on its own...

Slowly...

CREEEEEEEEEEAK

INT. GLASS LAB CORRIDOR - NIGHT

Segen and Javier run past the glass-lab and:

SMASH. Zs explode through the glass just behind them. They collapse against the far wall, find their feet and give chase.

INT. LAB - NIGHT

Gerry and the Z continue their battle. It manages to get a hold of his arm in its teeth, biting down hard. Gerry screams, spins, using the Z's weight against it. The Z breaks free, tearing the tape off in its teeth, staggering back. Gerry goes after it, swinging the crowbar with both hands.

He backs the Z into a corner, behind a desk, and finishes it off.

He stands back, staggers, inspects himself for bleeding wounds. All good. He keeps moving.

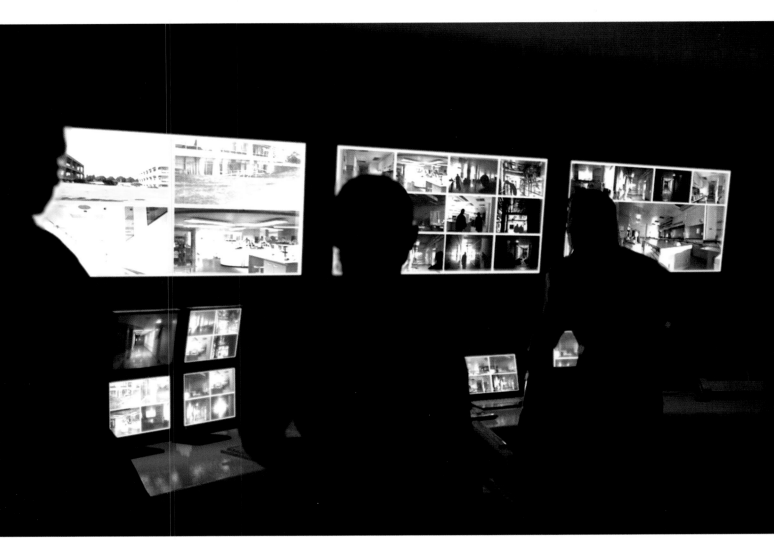

"IT'S INCREDIBLY THRILLING, AND TERRIFYING"

RUTH NEGGA, DR. KELLY

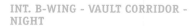

INT. GLASS PASSAGE - NIGHT

Javier and Segen run down the long, box hallway. Several Zs appear on the other end of the hall, blocking their way. No choice: Segen drops the bat, draws the pistol. Javier raises the axe.

Segen fires repeatedly. The gun runs out with one Z left. She has no defense.

SMUNCH

Javier kills it with one blow of the bat. They enjoy just a half-second of victory before they hear the sound of charging Zs behind them.

They run.

INT. OBSERVATION ROOM - NIGHT

BRIT
Where's Gerry?

RYAN
I don't see him.

KELLY
Look.

She points, see Javier and Segen running.

KELLY (CONT'D)
They're headed for the skybridge.

Kelly and Ryan look at Brit who doesn't move.

KELLY (CONT'D)
Do we open it or not?

RYAN
You heard what Javier said.

Brit turns abruptly and walks to the skybridge doors, throwing the bolts as:

RYAN (CONT'D)
We can't.

Brit shoots him a "fuck-off" scowl and throws the door open.

INT. B-WING - VAULT CORRIDOR - NIGHT

A long, narrow corridor flanked by glass enclosures on one side. He stops, looks around, realizes.
He backs up and takes it in:

VAULT 139.

He practically tripped over it.

INT. B-WING - OUTER VAULT - NIGHT

Gerry enters the glass outer lab and approaches the inner vault. Inside he can see the stainless steel containers containing live cultures.

All that stands between him and those containers is a combination keypad.

A PHONE RINGS LOUDLY, startling him. Gerry turns and spots a phone on a nearby counter. He lunges for it, waiting to see if the sound has attracted unwanted attention. Finally, he puts it to his ear.

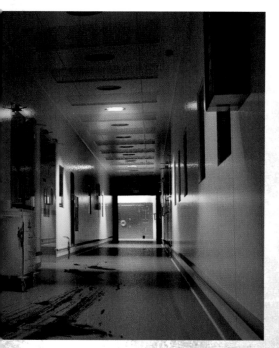

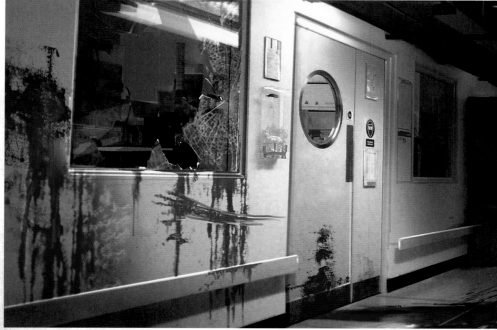

INT. OBSERVATION ROOM - NIGHT

Kelly on the other end of the phone.

KELLY (ON PHONE)
9-5-6-9-6-4.

INT. B-WING - OUTER VAULT - NIGHT

Gerry looks at the pad. She repeats.

KELLY
9-5-6-9-6-4.

Gerry hangs up, walks to the pad. Punches in the code.

SHHHHHHHHHHH. The Vault opens. Gerry steps in. The vault door closes behind him.

INT. SKYBRIDGE - DOORWAY

Brit stands by the open door, Ryan waiting anxiously behind him. Then:

Segen and Javier burst through the doors at the far end, running like hell. A beat later.

Zs come chasing after.

BRIT
COME ON, RUN.

Milk it for all its worth. Segen and Javier, getting closer to the door, Zs getting closer to them.

Segen and Javier fly through the open door. Brit and Ryan slam it shut as:

WHAM. Zs pile into the door.

INT. OBSERVATION ROOM - CONTINUOUS

Segen, Kelly, Ryan and Javier push the door shut with all they've got.
Brit manages to throw the top bolt, then the bottom. They take turns holding the door and dragging large objects into a growing barricade.

The door is sealed. Then, Javier looks to Kelly at the monitors.

JAVIER
What happened to Gerry?

Before Kelly can answer...

INT. B-WING - VAULT 139 - NIGHT

His breath steaming from the frosty air, Gerry carefully collects numerous virus samples in delicate glass vials. When he has everything he thinks he needs, he turns to leave. And freezes.

REVEAL: A Z standing on the other side of the glass. It twitches, staring, bangs its head lazily on the glass.

INT. OBSERVATION ROOM - NIGHT

The others enter the room in time to discover Gerry's encounter on the monitor.

INT. B-WING - VAULT 139 - NIGHT

Gerry considers his options, considers the button that will open the vault door, considers the heap of pathogens in his folded arms.

He thinks a beat, puts all of the stuff down on the counter. He fumbles for a needle,

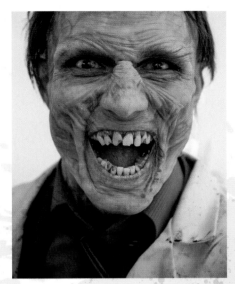

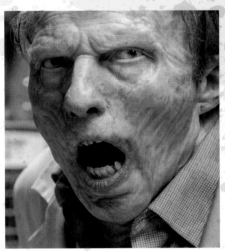

finding one that might not be meant for injecting human subjects. He stares at vials labeled SARS, MENINGITIS etc.

Which one?

Finally, Gerry closes his eyes and simply picks a virus at random.

He looks again at the Z outside. He looks outside the booth to the phone, then up at the security camera:

INT. OBSERVATION ROOM - NIGHT

On the monitor they see Gerry in his predicament, looking up at them for help. But there is nothing they can do.

BRIT
Jesus, he's going to inject himself.

KELLY
With what, though? We don't know which one will work.

JAVIER
We don't know if *any* of them will work.

RYAN
I can tell you this much. If he uses anything he took from that left incubator he's dead anyway.

On the monitor, Gerry rolls up his sleeve.

Segen leans in, showing fear for the first time.

INT. B-WING - VAULT 139 - NIGHT

CLOSE ON The needle clattering to the floor.

CLOSE ON Gerry's face, unable to believe what he's done. He turns, looks for a place to sit. He slumps down in the corner, rubs his face with no small sense of disbelief. And waits.

INT. OBSERVATION ROOM - NIGHT

Javier paces. The Brit sips coffee. Kelly stares at the monitors - specifically the one showing the biometric vault and several Zs buzzing around it.

SEGEN
How long does he have to wait?

JAVIER
Until he's infected? Not long. But that's not the question we're really asking, is it?

INT. B-WING - VAULT 139 - LATER

Gerry stands up, collects the vials he came for and stands in front of the vault door. He stares at the Zombie outside, then the button to open the door. He takes a deep breath...

And hits the button.

THE DOOR OPENS AND GERRY IS FACE-TO-FACE WITH A Z.

The Z's reaction is surreal. It flinches, but looks through Gerry, then around him. Gerry slowly sidesteps, squeezing out of the vault between the Z and the edge of the door.

The Z wanders into the vault, searching. The door closes automatically behind it, sealing it in. Sealing Gerry out.

CLOSE ON Gerry, not even daring to look back. He walks slowly, calmly toward the door and the corridor beyond.

CLOSE ON the Z in the vault behind him turns, looks at Gerry leaving, or rather in Gerry's general direction, almost like it senses something but cannot guess what...

INT. OBSERVATION ROOM - NIGHT

The group watching Gerry walk through the facility, finally reaching the cafeteria.

CLOSE ON: The monitor that shows the skybridge. One monitor looks at the doors that would let Gerry back in to their side of things.

The way is blocked by Zs.

KELLY
What do we do?

JAVIER
There's nothing we can do.

INT. SKYBRIDGE BETWEEN WINGS - WHO FACILITY - NIGHT

A wall of Zs between Gerry and home.

INT. CAFETERIA - NIGHT

Gerry approaches the half-open soda machine. He reaches in, takes out a soda resting precariously inside. He opens it, takes a sip...

Then pushes the soda machine wide open.

CLOSE ON: Soda cans spilling onto the floor, making a terrible racket.

INT. SKYBRIDGE BETWEEN WINGS – WHO FACILITY - NIGHT

Zs reacting to the sound O.S. They go after it.

Gerry steps apprehensively into the corridor as Zs rush toward him. He walks as calmly as he possibly can. The Zombies stream past him as if he were invisible.

He walks on, toward the door at the far end of the hallway. A long walk indeed. And finally.

The sound of one bolt, then another. The door opens.

Segen holds the door for him. Waiting with a smile.

INT. OBSERVATION ROOM - CORRIDOR - MORNING

A needle jabs in Gerry's arm. PULL BACK TO REVEAL Kelly giving the injection.

The barricade has been put back in place. The skybridge has been sealed off.

EXT. WELSH COUNTRYSIDE - DAY

Gerry and Segen walk along the same road that brought them to the lab. They pass a sign reading:

CARDIFF BAY – 12km

EXT. REFUGEE CAMP - DAY

HELICAM SHOT, cruising low over rugged countryside.

REVEAL: A Refugee camp below - a remote clutch of buildings surrounded by barbed wire and guard towers. A satellite dish implies a link to the outside world.

REVEAL: It sits in the bowl of a coastal inlet - a cove safe from rough seas and a rougher world.

REVEAL: A dock on the beach below. A large boat is moored in the cove. A smaller boat cruises toward the dock.

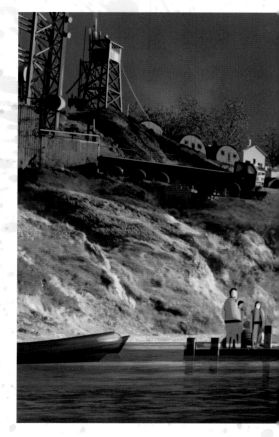

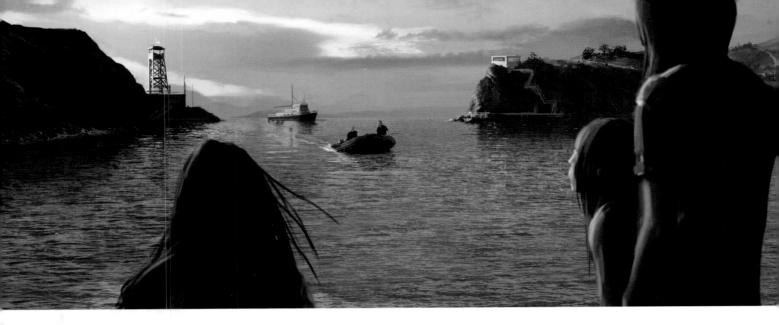

CLOSE ON: A hand in wake-water, pulled along by a moving boat. REVEAL:

Gerry in a small zodiac launch, Segen beside him. His skin is wind-burned. Segen is tan, her hair longer.

EXT. DOCK - DAY

The zodiac cruises up to the dock. Gerry doesn't wait to tie off, stepping out of the launch and walking up the dock. He smiles at something O.S. REVEAL:

Karen and the girls running down the dock toward him.

The girls reach him first, grabbing him around the waist. He hugs them tightly, looking up at:

Karen walking toward him, relieved to see him.

She stops a few paces shy. They take each other in.

Then they embrace. They don't move quickly, they don't hold on desperately. The moment is one of relief. A moment to be savored.

WIDE ANGLE of Gerry and his family on the dock, silhouetted by the shimmering sea.

BLACK

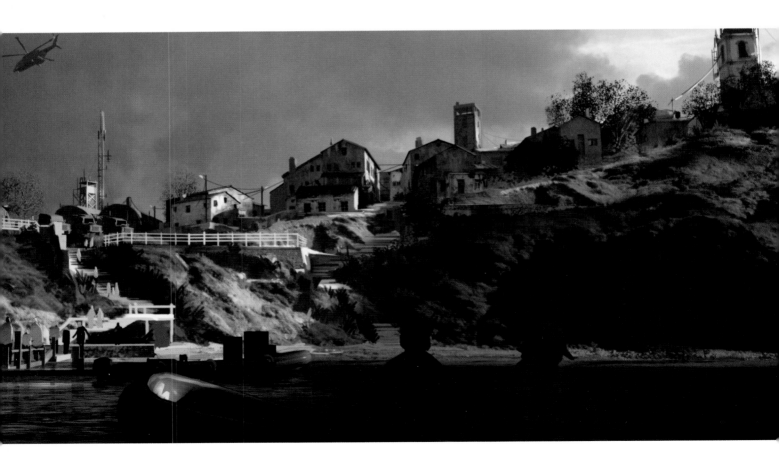

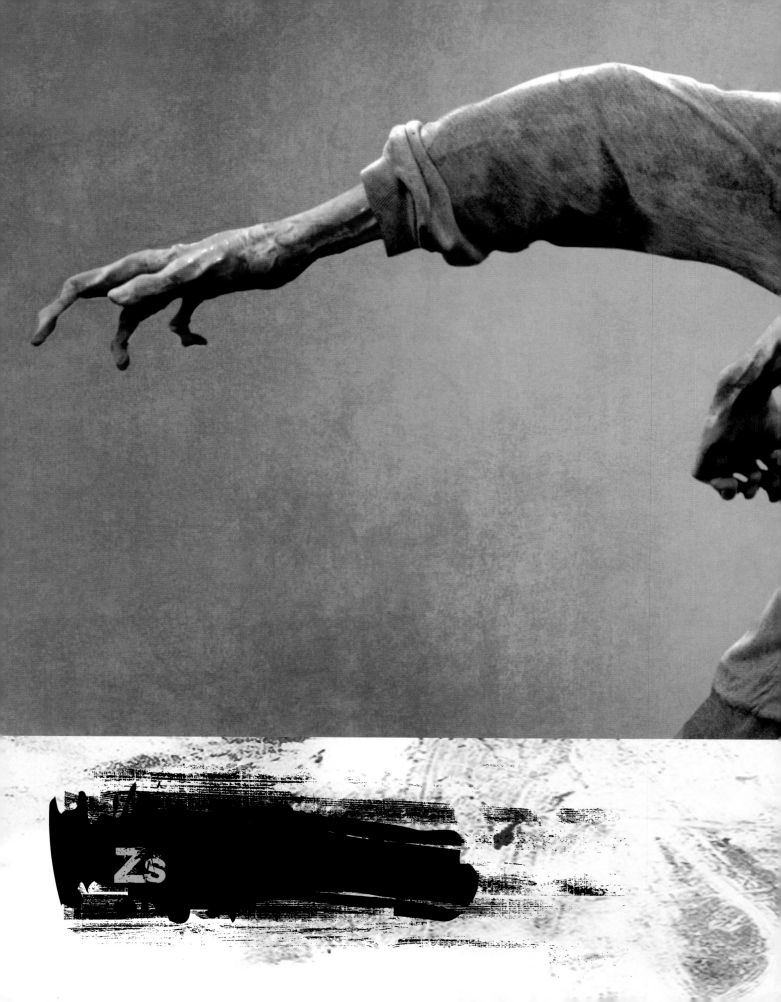

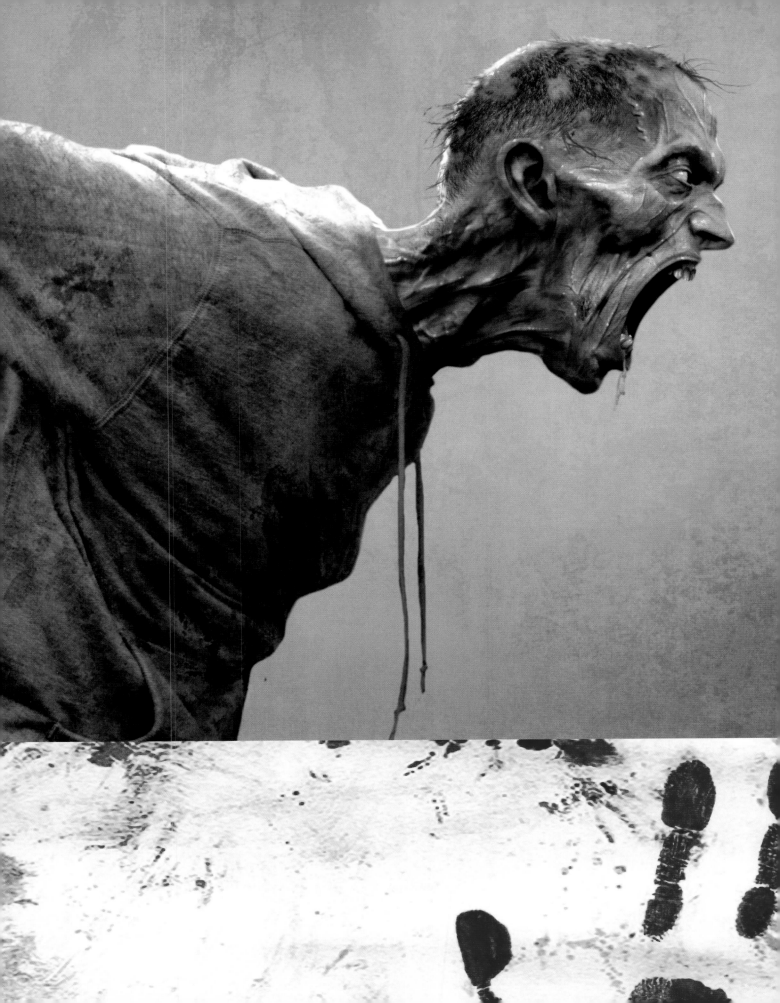

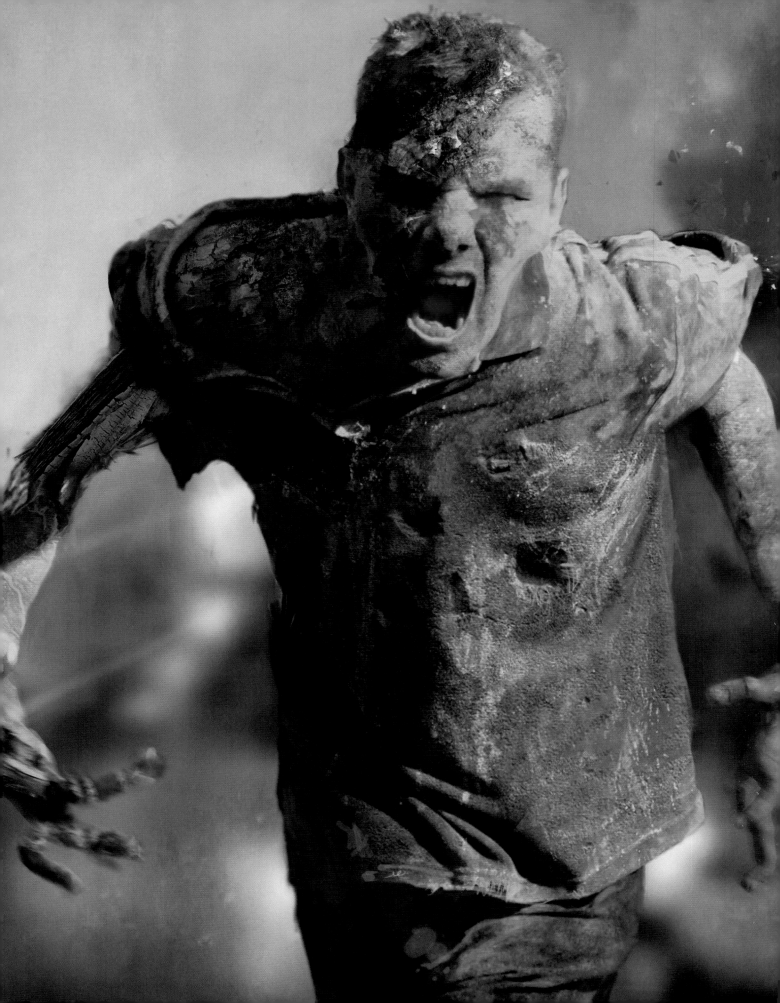

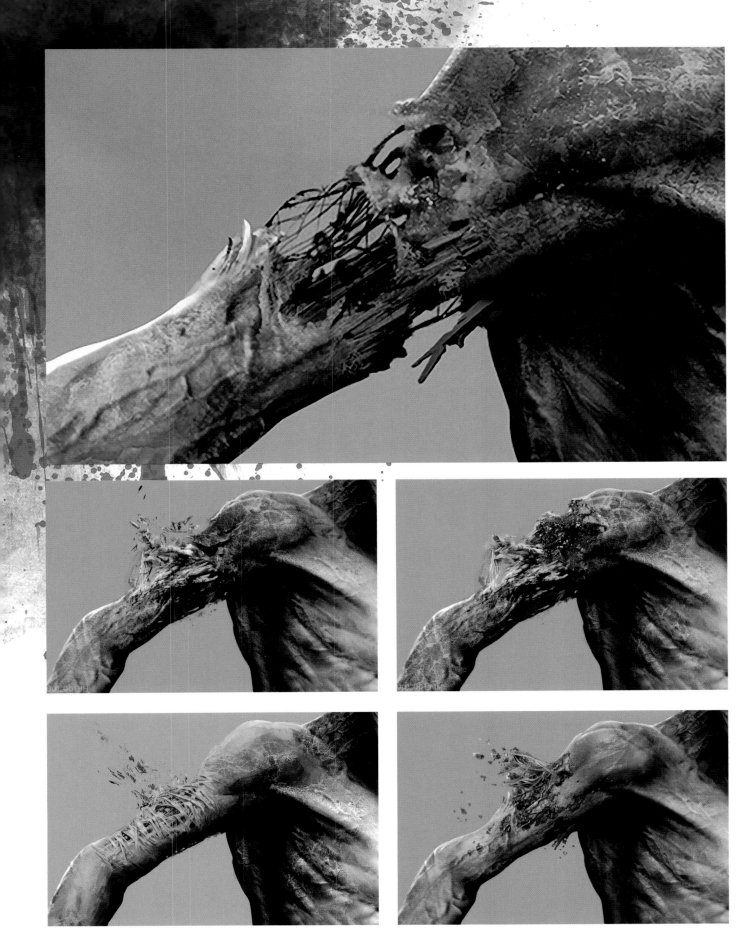

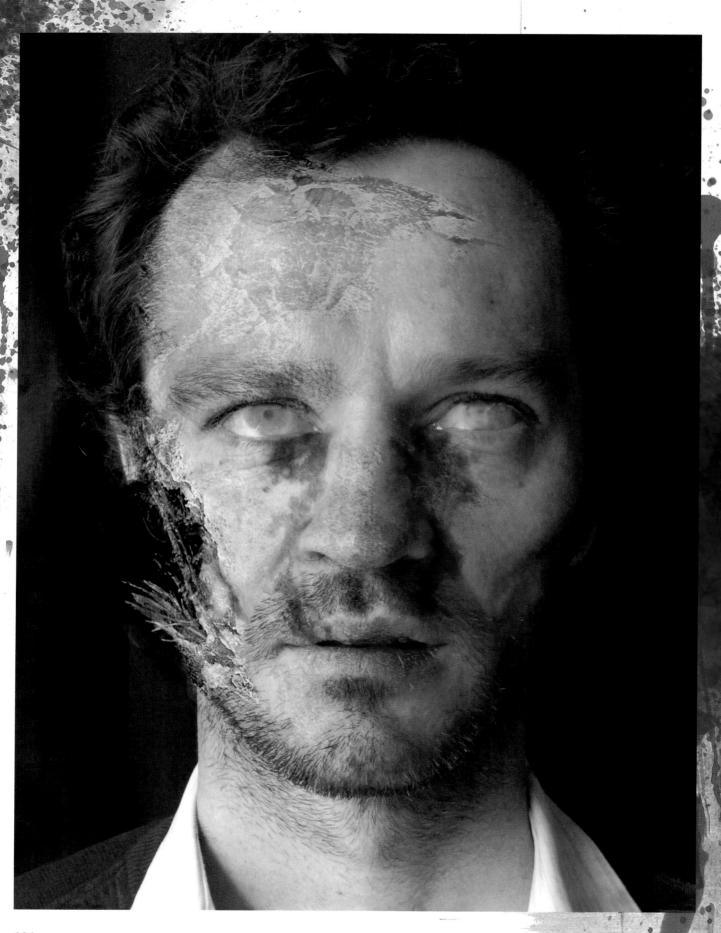

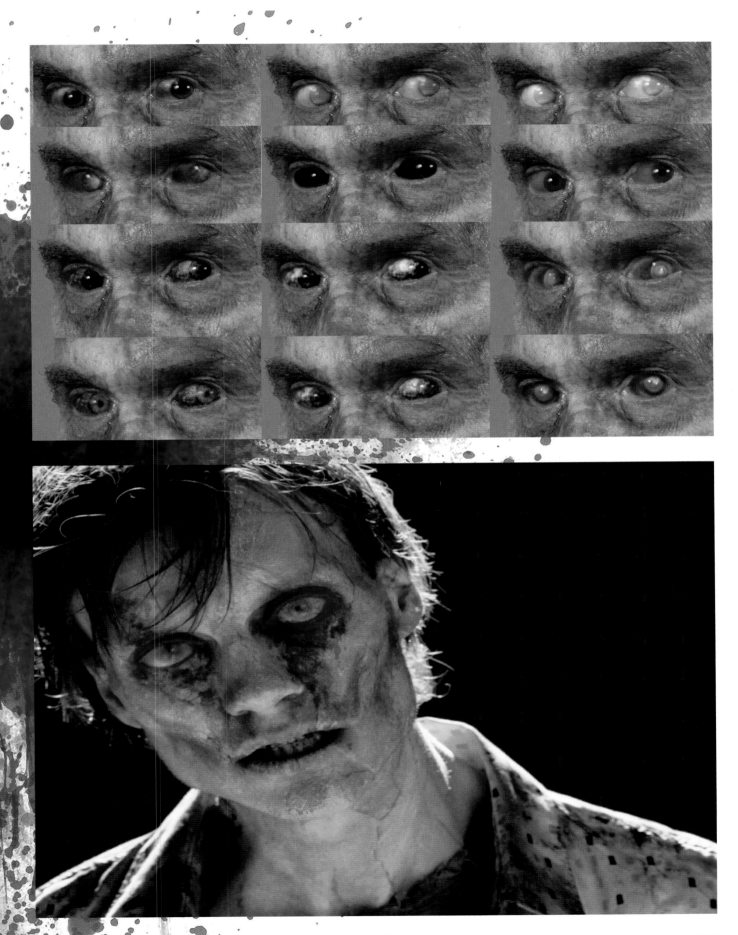

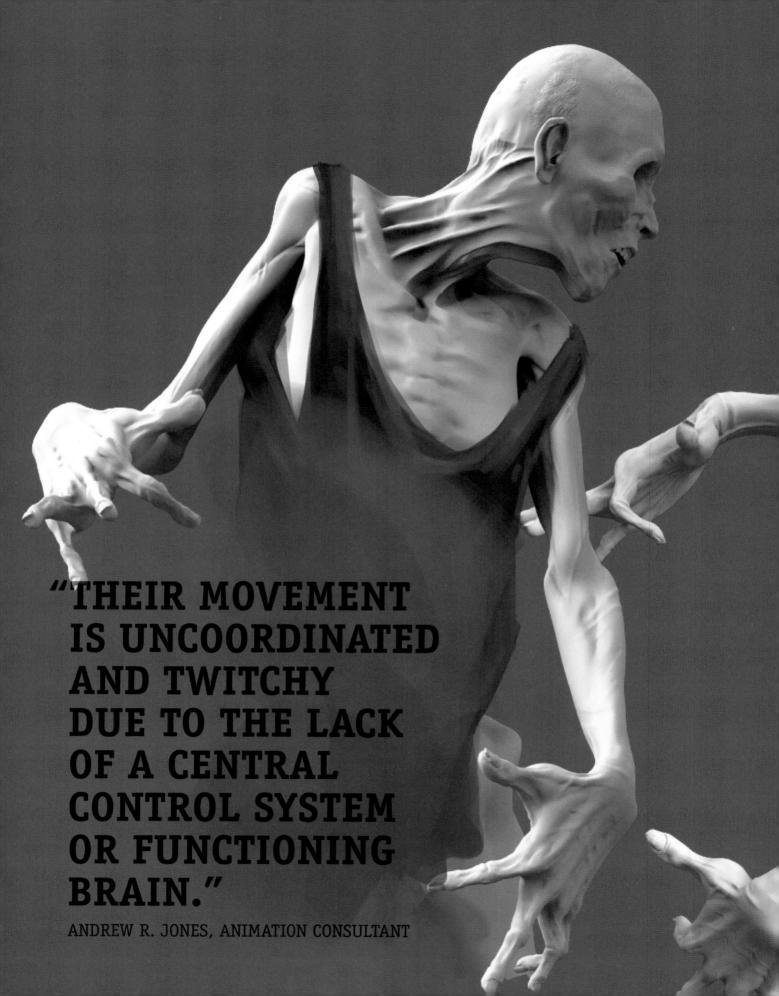

"THEIR MOVEMENT IS UNCOORDINATED AND TWITCHY DUE TO THE LACK OF A CENTRAL CONTROL SYSTEM OR FUNCTIONING BRAIN."

ANDREW R. JONES, ANIMATION CONSULTANT

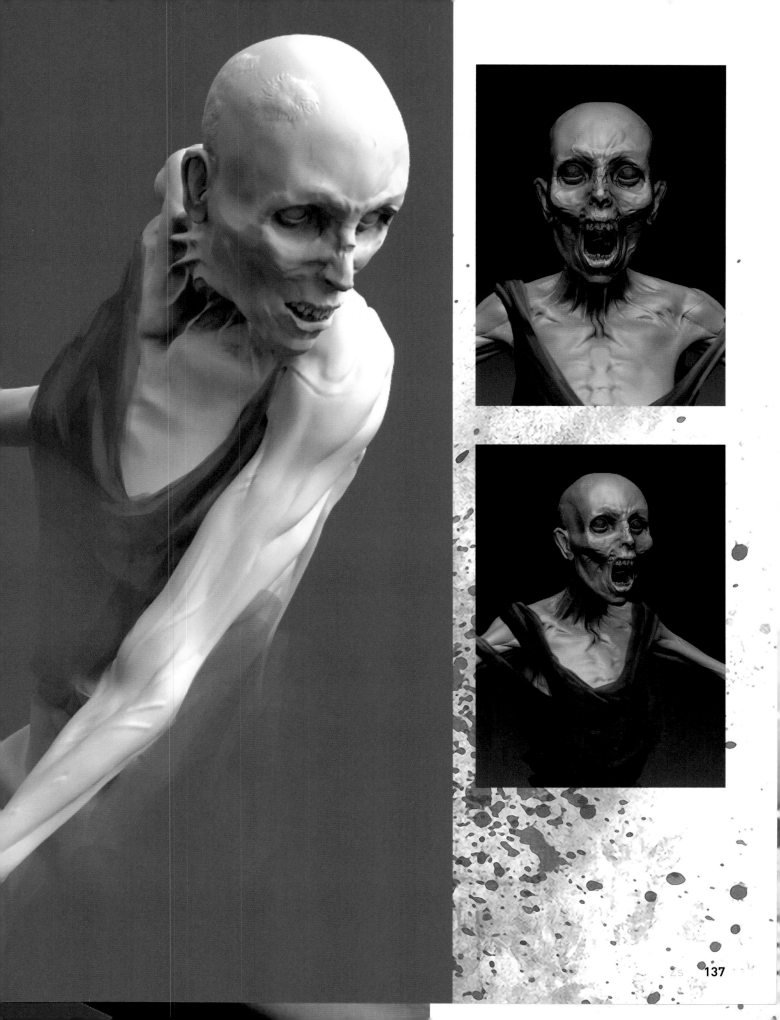

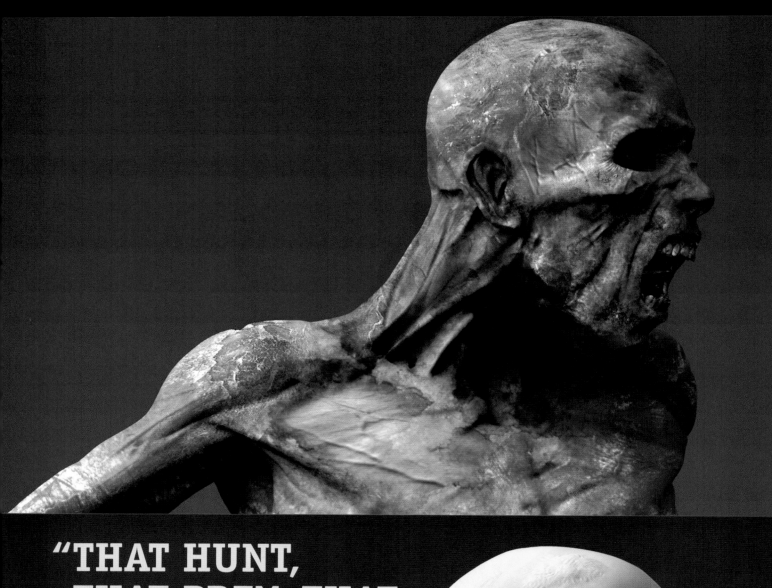

"THAT HUNT, THAT PREY, THAT FOCUS, THAT STRENGTH TO BITE. NOTHING ELSE MATTERS."

ALEX REYNOLDS,
ZOMBIE MOVEMENT DIRECTOR

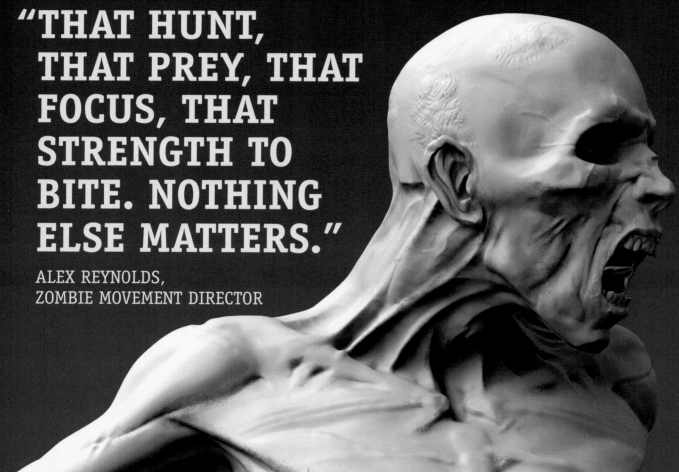

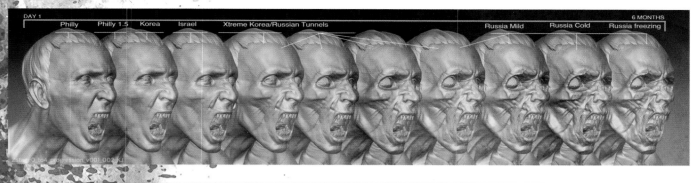

| DAY 1 | | | | | | | | | 6 MONTHS |
| Philly | Philly 1.5 | Korea | Israel | Xtreme Korea/Russian Tunnels | | | Russia Mild | Russia Cold | Russia freezing |

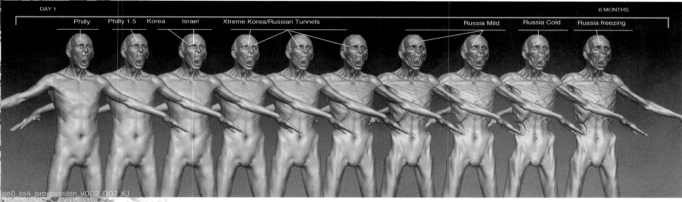

| DAY 1 | | | | | | | | | 6 MONTHS |
| Philly | Philly 1.5 | Korea | Israel | Xtreme Korea/Russian Tunnels | | | Russia Mild | Russia Cold | Russia freezing |

"THE SKIN THINS AND TIGHTENS AROUND THE BONE." ANDREW R. JONES, ANIMATION CONSULTANT

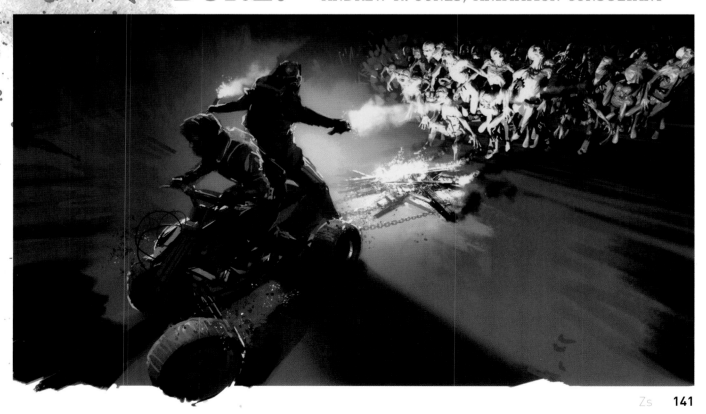

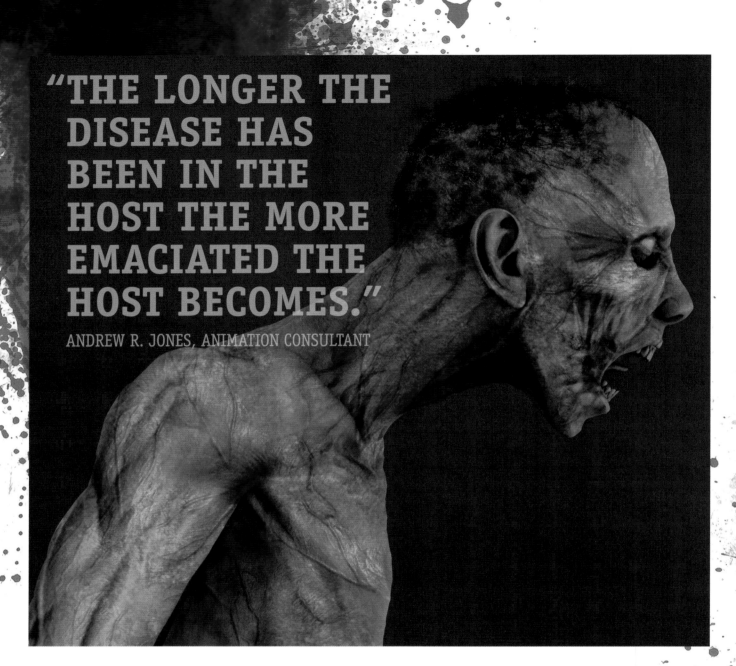

"THE LONGER THE DISEASE HAS BEEN IN THE HOST THE MORE EMACIATED THE HOST BECOMES."

ANDREW R. JONES, ANIMATION CONSULTANT

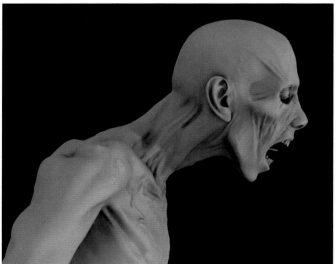

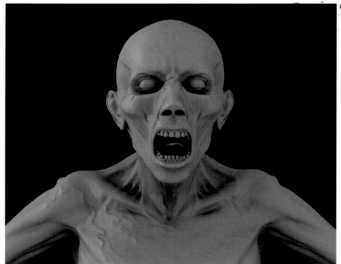

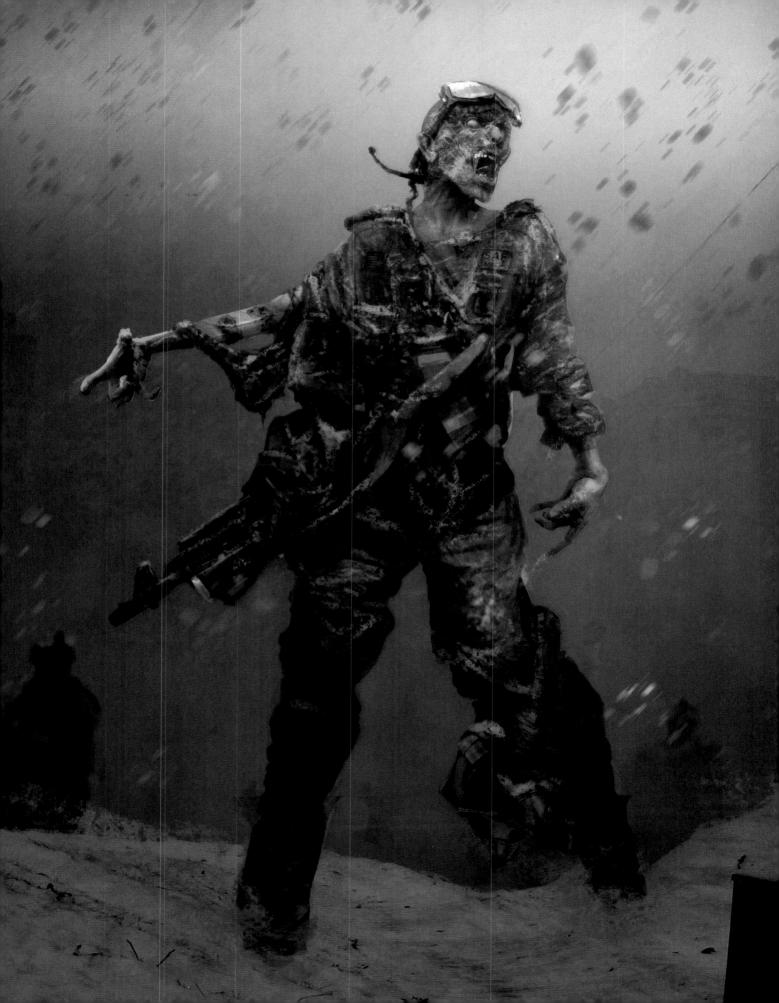

"IF YOU LOOK AT EVERY ZOMBIE WE HAVE, EVERY ONE OF THEM HAS A SPECIFIC DESIGN TO IT."

MAYES RUBEO, COSTUME DESIGNER

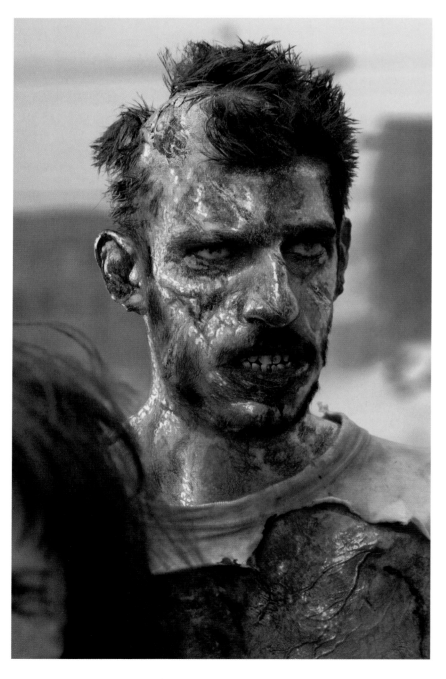

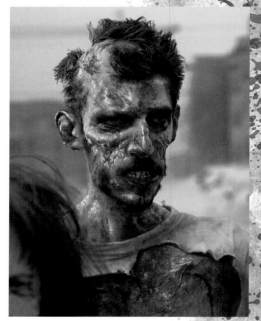

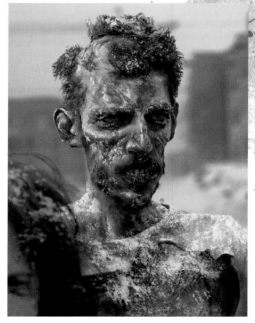

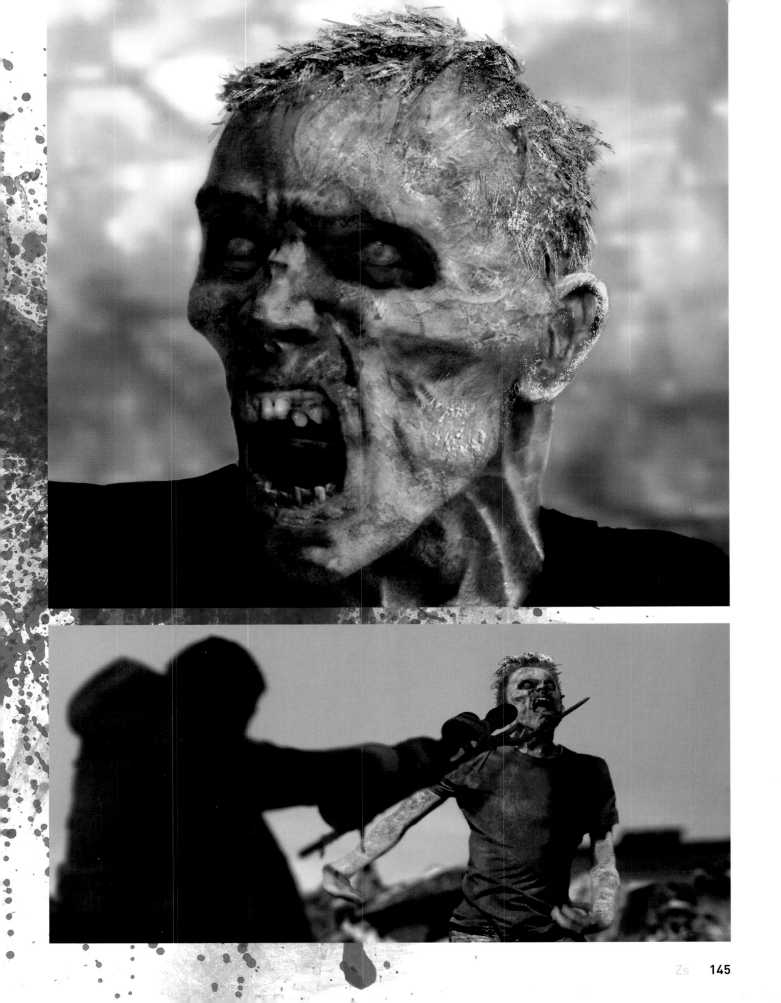

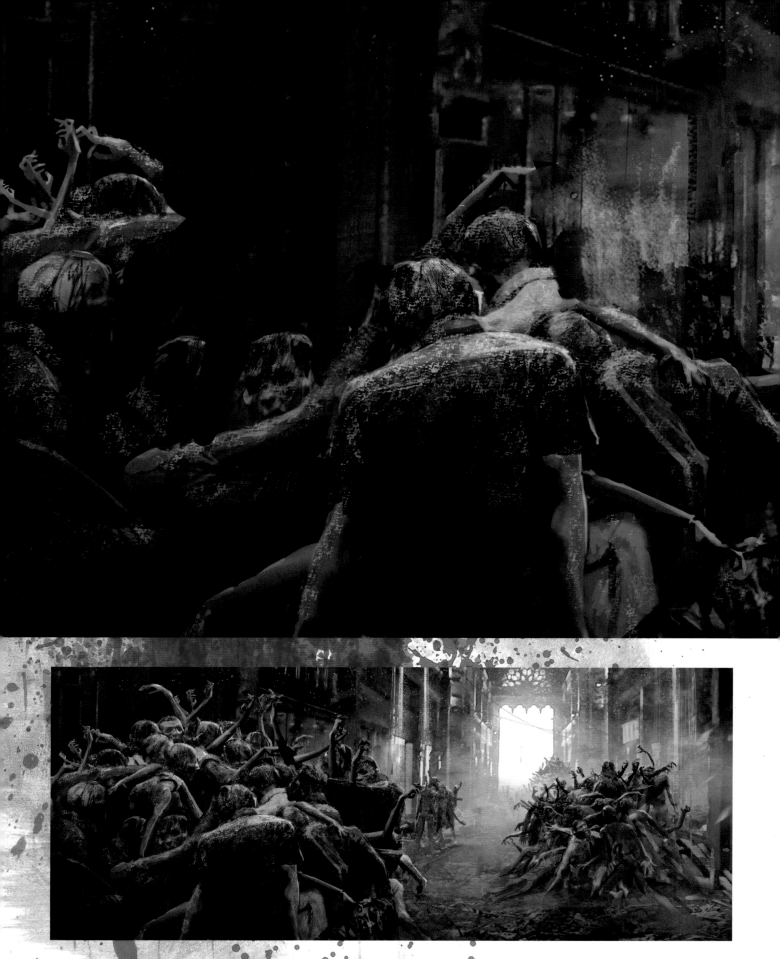

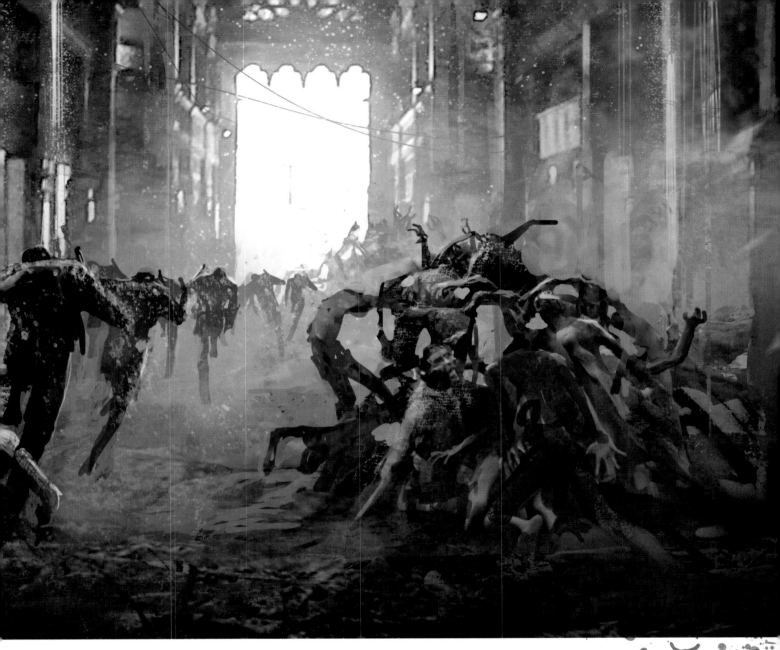

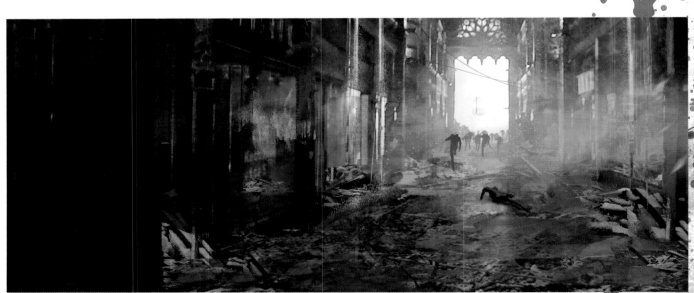

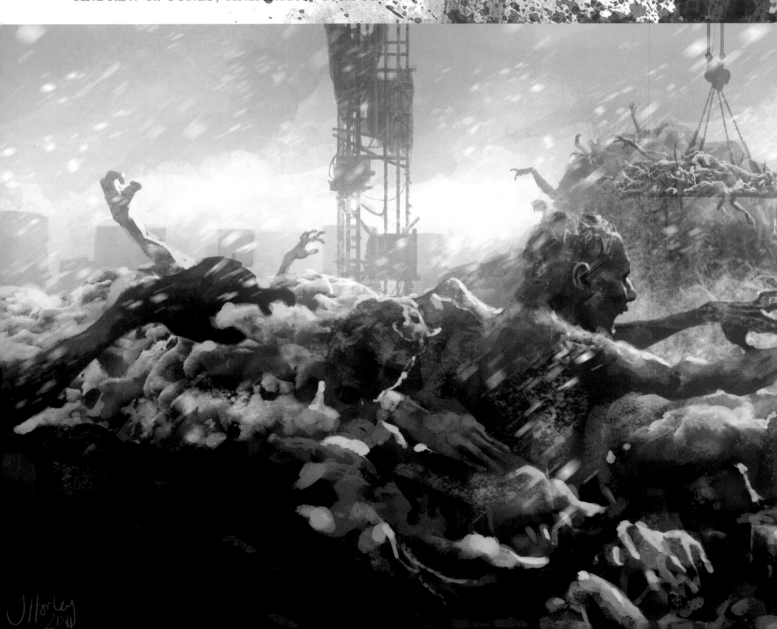

"THE ZOMBIES IN WWZ ARE A DISEASED HUMAN RACE. THE DISEASE STOPS THE HEART AND THEN RE-ANIMATES EVERY CELL OF THE HOST."

ANDREW R. JONES, ANIMATION CONSULTANT

"THEIR MAKE-UP, HAIR, CLOTHING AND DESICCATED LOOK ARE PRODUCTS OF HOW WE INTERPRET THEIR BEHAVIOR. LIGHTING, COLOR AND CONTRAST – EVEN CLOTHING COLOR – IS DELICATE AND CRITICAL."

SCOTT FARRAR, VISUAL EFFECTS SUPERVISOR

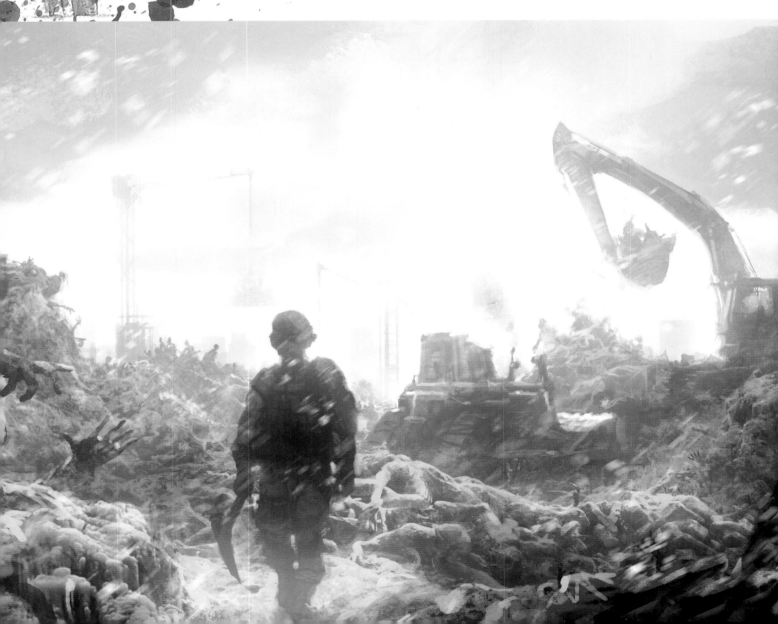

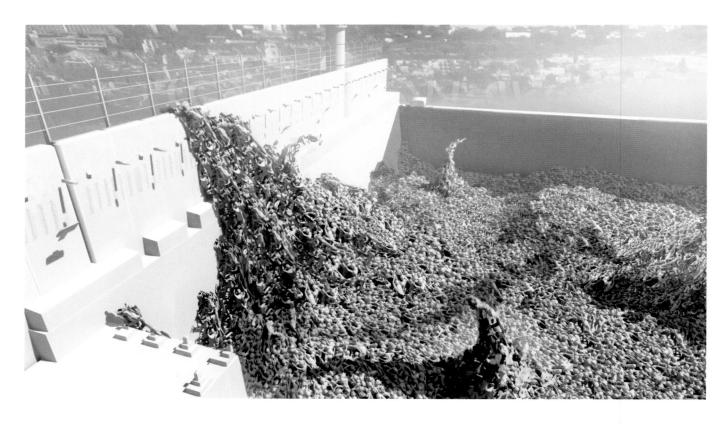

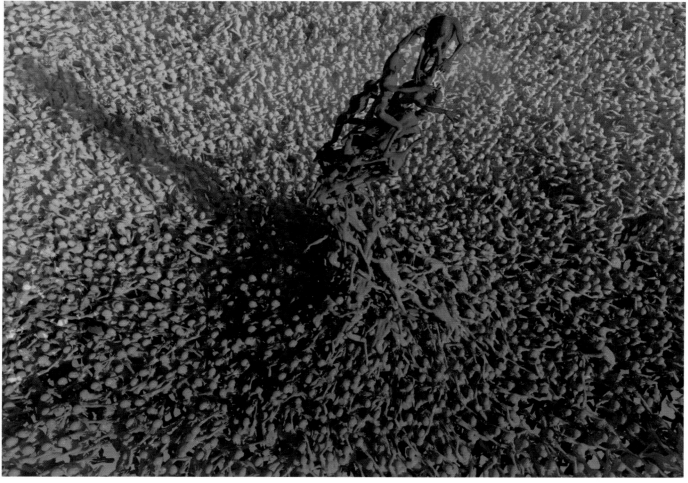

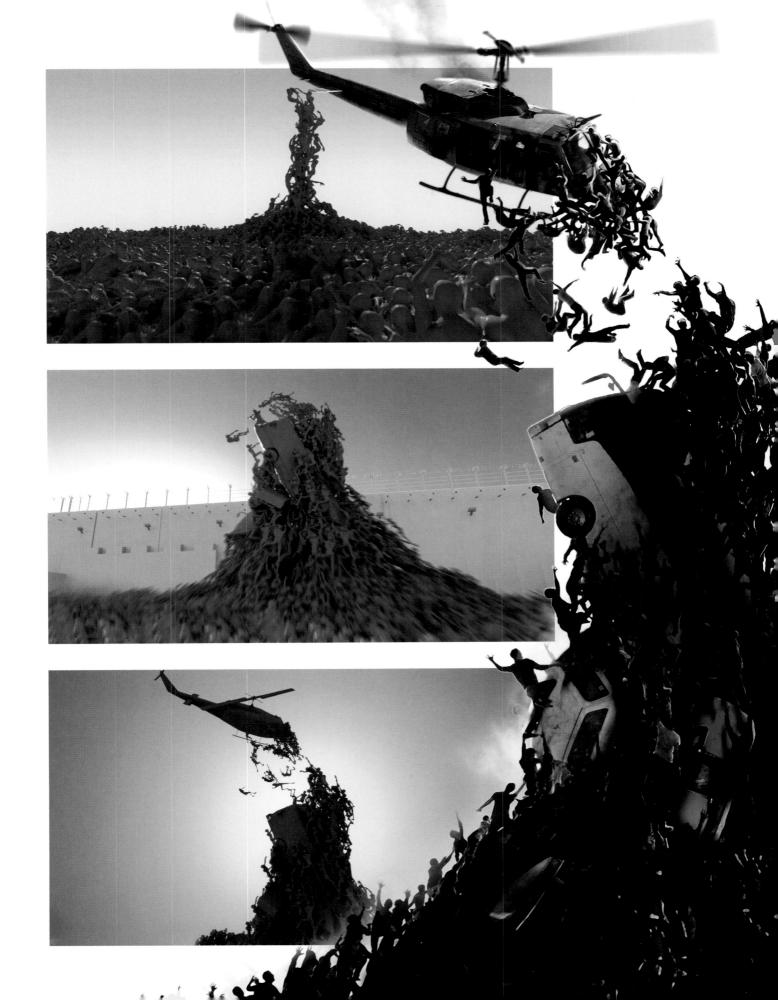

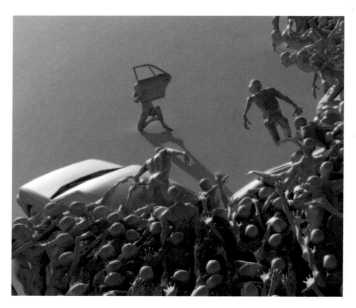

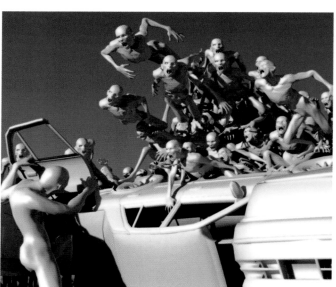

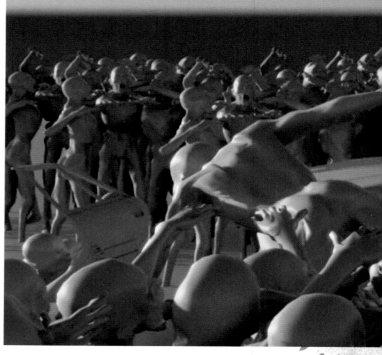

"WE'RE REALLY BRINGING LARGE SCALE TO THE ZOMBIES."

SIMON CRANE, 2ND UNIT DIRECTOR

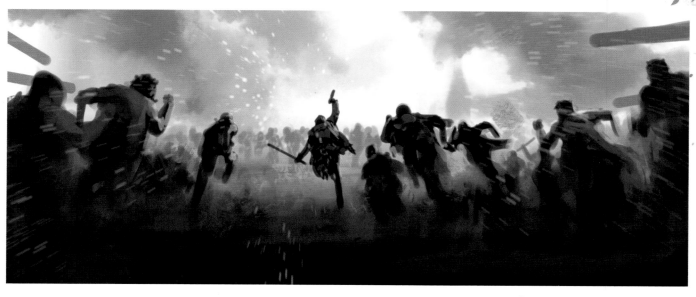

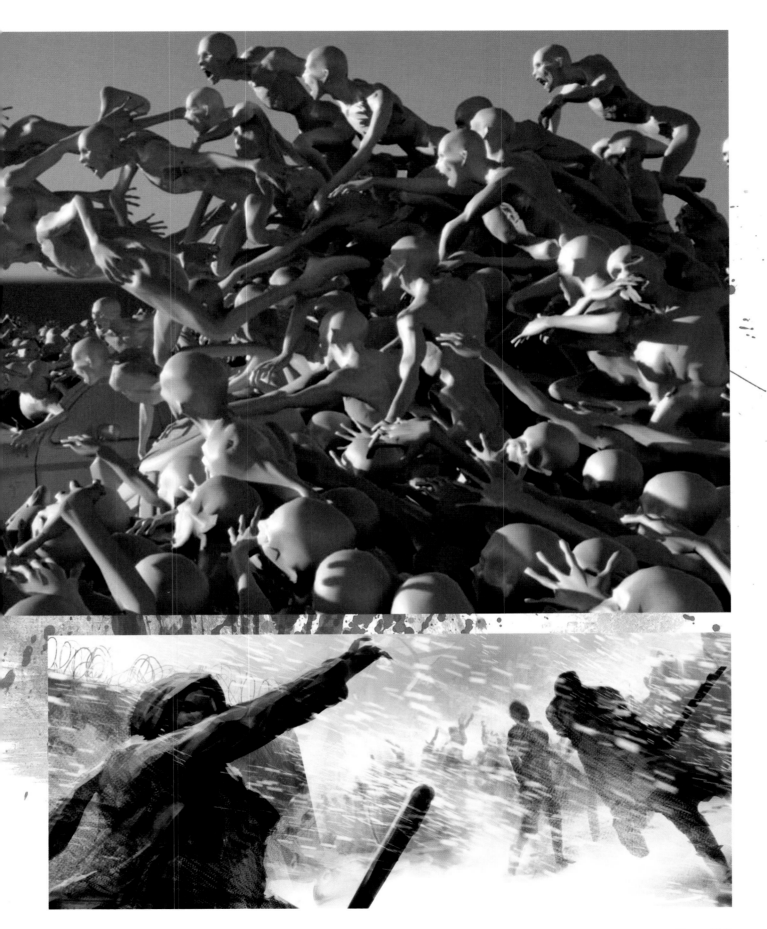

TOOLS

There's two sides to this film. There's all the firearms that we're doing which are normal traditional kind of modern day firearms. And then we've got the zombie killing weapons. Very early on in the film they realize that bullets don't really kill zombies. So weapons aren't used. They begin to lose them and we start to go over to weapons to decapitate the zombies. Or cut them up or cut their legs off. Once you cut the zombie's legs off he's gonna hit the ground and then you can dispose of him.

The lobo itself, we've kind of come up with a design – our own design. It has to be a weapon that hasn't got any serrated edges on it. It can't stick and stay into whatever you hit. It has to be smooth and clean so you can remove it. It has to be able to be fought on three or four different angles. It can't be a long weapon, but it has to be something you can run with. Because a lot of ways in fighting the zombies you'll do an attack and then you need to retreat.

We've come up with hammers. Large hammers with spikes on them. I started to play with a golf club with a spike on it... that was a great weapon.

I'm staring at things going, "That would make a great zombie weapon," you know, as we wander through the sports department.

SIMON ATHERTON, WEAPONS MASTER

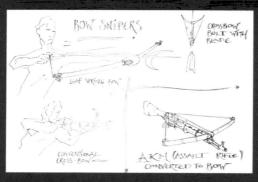

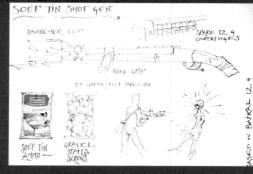

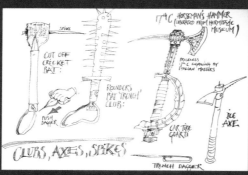

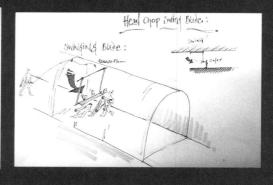

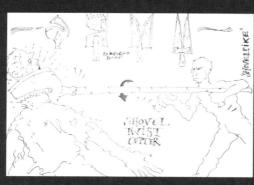

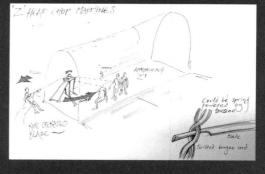

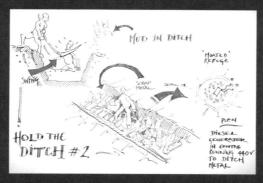

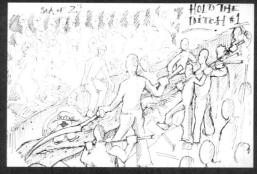

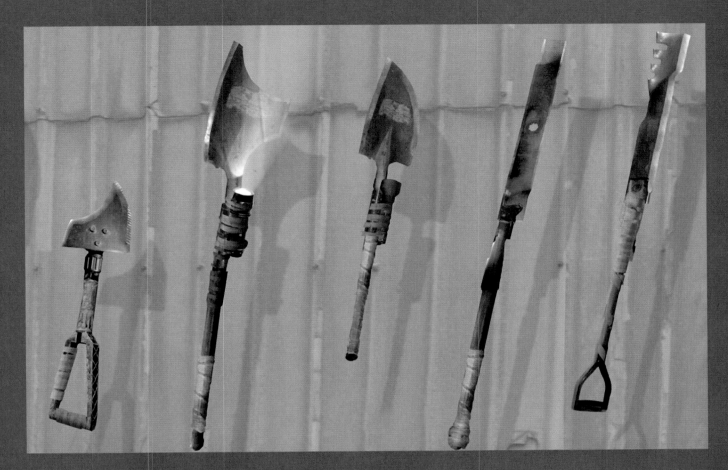

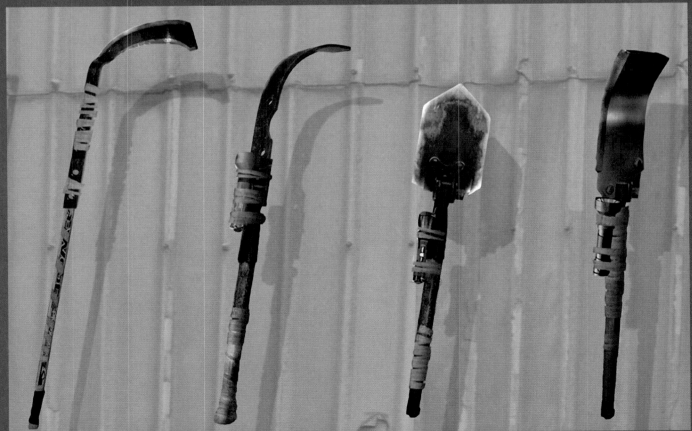

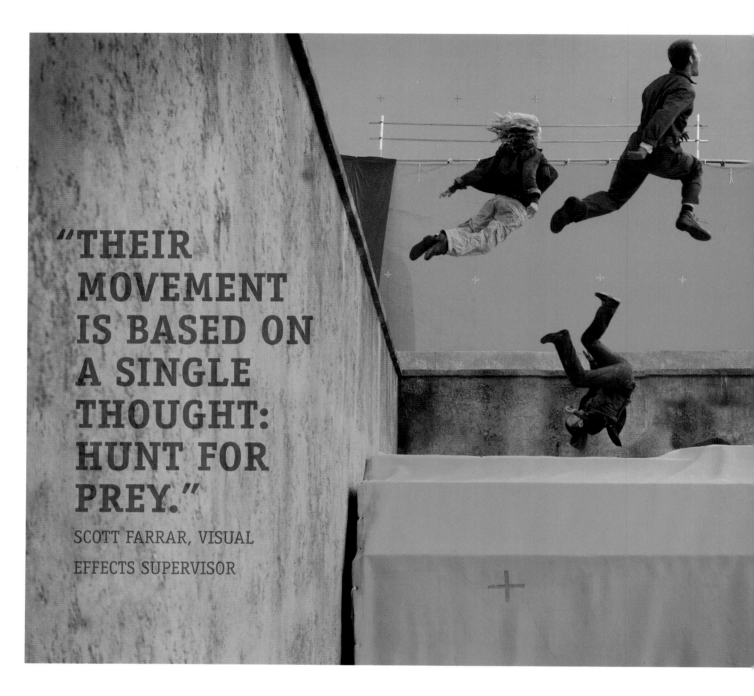

"THEIR MOVEMENT IS BASED ON A SINGLE THOUGHT: HUNT FOR PREY."

SCOTT FARRAR, VISUAL EFFECTS SUPERVISOR

SHOOTING GREENSCREEN

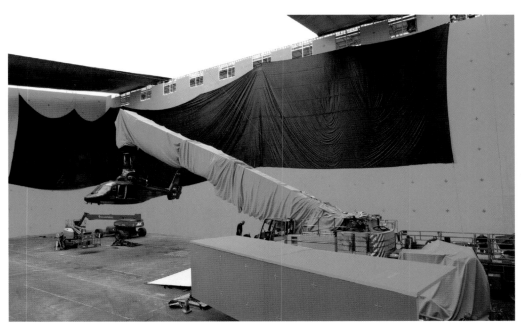

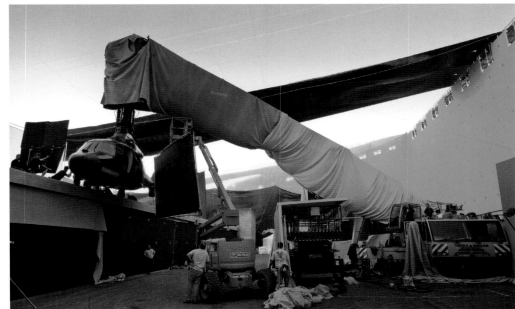

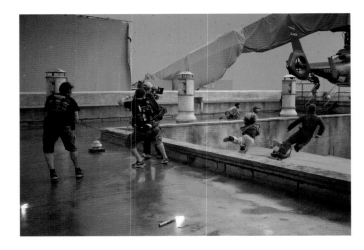

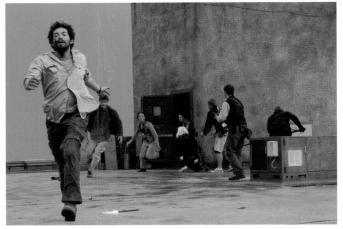

"THEY HAVE NO THOUGHT OR CARE FOR THEMSELVES"

SCOTT FARRAR, VISUAL EFFECTS SUPERVISOR

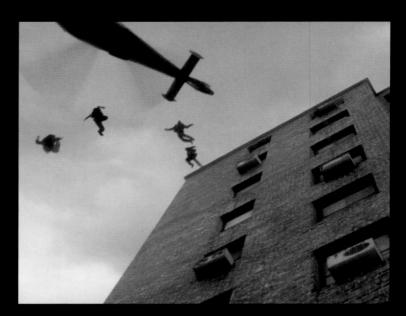

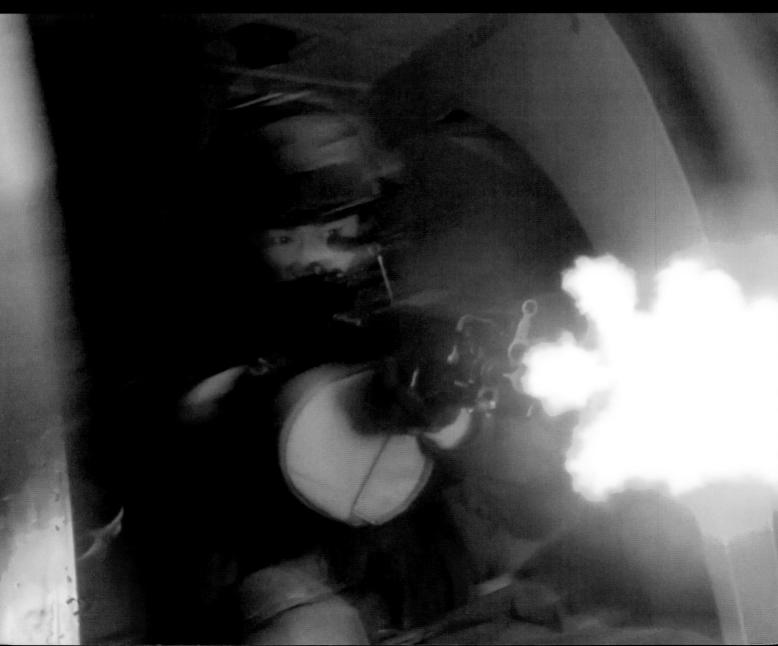

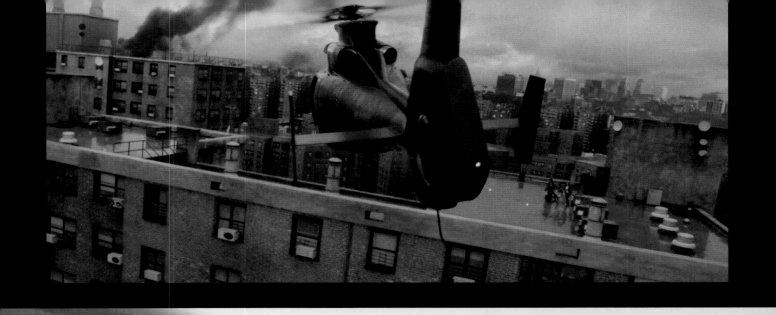

"[WE SPENT] TWO YEARS BLENDING AND ANIMATING THE ZS"

SCOTT FARRAR, VISUAL EFFECTS SUPERVISOR

Titan Books would like to thank everyone who helped with this project:
the entire cast and crew of World War Z; all the artists and designers who
worked on the film; and the entire team at
Paramount Licensing.

Illustrator
Seth Engström

Photography
Kim Frederikson

Storyboards
Robbie Consing CKS

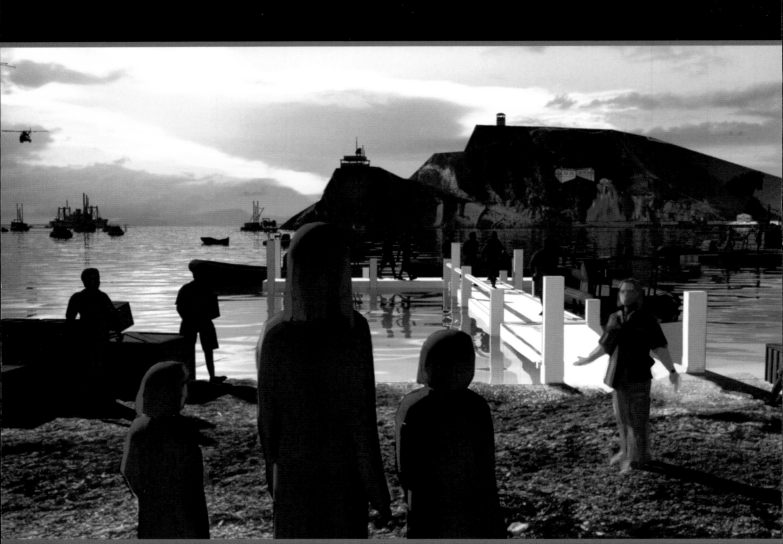